Master Paintings in the Art Institute of Chicago

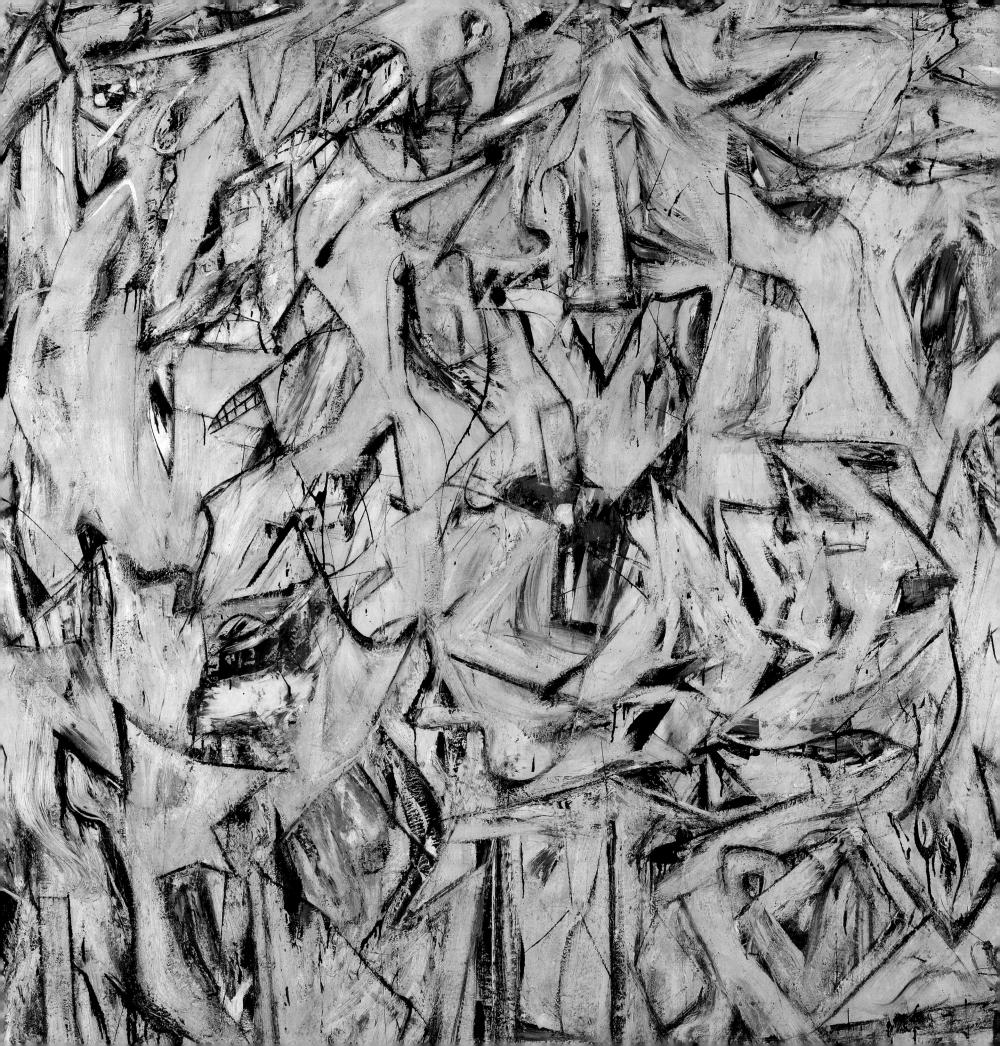

Master Paintings

IN THE ART INSTITUTE OF CHICAGO

Selected by James Cuno

The Art Institute of Chicago Yale University Press, New Haven and London © 1988, 1999, 2003, 2006, 2009 The Art Institute of Chicago

All rights reserved. No part of this publication may be reproduced, transmitted, or utilized in any form or by any means, electronic or mechanical, including photocopy, digital recording, or any other information storage and retrieval system, without prior written permission from the Publications Department of the Art Institute of Chicago, except by a reviewer, who may quote brief passages in a review.

Third edition
Printed in Singapore

Library of Congress Control Number: 2008939536 ISBN: 978-0-300-15103-9

Published by The Art Institute of Chicago 111 South Michigan Avenue Chicago, Illinois 60603-6404 www.artic.edu

Distributed by Yale University Press 302 Temple Street P.O. Box 209040 New Haven, Connecticut 06520-9040 www.yalebooks.com

Produced by the Publications Department of the Art Institute of Chicago, Susan F. Rossen, Executive Director

Edited by Susan F. Rossen, Elizabeth Stepina, Susan Weidemeyer, and Talia Ullmann

Production by Sarah Guernsey, Carolyn Ziebarth, and Kate Kotan

Photography research by Joseph Mohan

Designed and typeset by Renate Gokl, Chicago, Illinois

Printing and binding by CS Graphics, Singapore

This book was produced using paper certified by the Forest Stewardship Council.

Jacket front cover: Giovanni Battista Tiepolo, *Rinaldo Enchanted by Armida* (detail) (p. 36)

Jacket back cover: Henri Matisse, *Bathers by a River* (p. 108)

Frontispiece: Willem de Kooning, *Excavation* (detail) (p. 146)

All photographs of the works in this book were made by the Department of Imaging of the Art Institute of Chicago, Christopher Gallagher, Associate Director, and are copyrighted by the Art Institute of Chicago. The following credits apply to all images for which separate acknowledgment is due. They are arranged alphabetically by artist and are keyed to page numbers.

Unless otherwise noted, all photographs of the works in the catalogue were made by the Department of Imaging of the Art Institute of Chicago, Christopher Gallagher, Associate Director, and are copyrighted by the Art Institute of Chicago.

Every effort has been made to contact and acknowledge copyright holders for all reproductions; additional rights holders are encouraged to contact the Art Institute of Chicago.

The following credits apply to all images in this catalogue for which separate acknowledgement is due. They are arranged alphabetically by artist and are keyed to page numbers.

Bacon, Francis, © 2009 Estate of Francis Bacon/Artists Rights Society (hereafter referred to as "ARS"), New York/DACS, London (p. 150); Balthus (Balthasar Klossowski de Rola), © 2009 ARS, New York/ADAGP, Paris (p. 138); Beckmann, Max, © 2009 ARS, New York/VG Bild-Kunst, Bonn (p. 134); Blume, Peter, Art © 2009 Educational Alliance, Inc./Estate of Peter Blume/ Licensed by VAGA, New York, N.Y. (p. 140); Bonnard, Pierre, © 2009 ARS, New York/ADAGP, Paris (p. 116); Braque, Georges, © 2009 ARS, New York/ADAGP, Paris (pp. 102 and 103); Celmins, Vija, Courtesy McKee Gallery, New York (p. 155); Chagall, Marc, © 2009 ARS, New York/ADAGP, Paris (p. 121); Chirico, Giorgio de, © 2009 ARS, New York/SIAE, Rome (p. 113); Dali, Salvador, © 2009 Salvador Dali, Gala-Salvador Dali Foundation/ARS, New York (p. 132); De Kooning, Willem, © 2009 Willem de Kooning Foundation/ARS, New York (p. 146); Dove, Arthur, © Estate of Arthur

York/VG Bild-Kunst, Bonn (p. 106); Golub, Leon, Art © Leon Golub /Licensed by VAGA, New York. Courtesy Ronald Feldman Fine Arts (p. 163); Gorky, Arshile, © 2009 ARS, New York (p. 145); Guston, Philip, Courtesy McKee Gallery, New York (p. 162); Hockney, David, © David Hockney (p. 157); Johns, Jasper, Art © Jasper Johns/Licensed by VAGA, New York, N.Y. (p. 166); Kandinsky, Wassily, © 2009 ARS, New York/ADAGP, Paris (p. 112); Kelly, Ellsworth, © 2009 Ellsworth Kelly (p. 149); Klee, Paul, © 2009 ARS, New York/VG Bild-Kunst, Bonn (p. 123); Lawrence, Jacob, © 2009 Jacob and Gwendolyn Lawrence Foundation, Seattle/ARS, New York (p. 143); Léger, Fernand, © 2009 ARS/New York/ ADAGP, Paris (p. 118); Lichtenstein, Roy, © Estate of Roy Lichtenstein (p. 160); Magritte, René, © 2009 C. Herscovici, London/ARS, New York (p. 135); Marden, Brice, © 2009 Brice Marden/ARS, New York (p. 158); Marshall, Kerry James, Courtesy the Artist and Jack Shainman Gallery, New York (p. 165); Martin, Agnes, © 2009 Agnes Martin/ARS, New York (p. 159); Matisse, Henri, © 2009 Succession H. Matisse/ARS, New York (pp. 108, 117); Matta (Roberto Matta Echuarren), © 2009 ARS, New York/ADAGP, Paris (p. 133); Miró, Joan, © 2009 Succession Miró/ARS, New York/ADAGP, Paris (p. 122); Mitchell, Joan, © 2009 The Estate of Joan Mitchell (p. 151); Motley, Archibald John, Jr., © Valerie Gerrard-Browne (p. 137); Mondrian, Piet (see p. 119); Munch, Edvard, © 2009 The Munch Museum/The Munch-Ellingsen Group/ARS, New York (p. 68); Nutt, Jim, © 2009 Jim Nutt (p. 156); Orozco, José Clemente, © 2009 ARS, New York/SOMAAP, Mexico City (p. 128); Picabia, Francis, © 2009 ARS, New York/ADAGP, Paris (p. 110); Picasso, Pablo, © 2009 Estate of Pablo Picasso/ARS, New York (pp. 101, 104, and 120); Polke, Sigmar, © Sigmar Polke (p. 164); Pollock, Jackson, © 2009 Pollock-Krasner Foundation/ARS, New York (p. 147); Richter, Gerhard, © 2009 Gerhard Richter (p. 154); Rothko, Mark, © Kate Rothko Prizel & Christopher Rothko/ARS, New York (p. 148); Severini, Gino, © 2009 ARS, New York/ADAGP, Paris (p. 109); Still, Clyfford, © Clyfford Still Estate (p. 152); Twombly, Cy, © Cy Twombly (p. 153); Vuillard, Edouard, © 2009 ARS, New York/ADAGP, Paris (p. 72); Warhol, Andy, © 2009 Andy Warhol Foundation for the Visual Arts/ARS, New York (p. 161); Wood, Grant, all rights reserved by Estate of Nan Wood Graham/Licensed by VAGA, New York, N.Y. (p. 127).

G. Dove (p. 125); Feininger, Lyonel, © 2009 ARS, New

Contents

Acknowledgments / 6
Introduction / 7
European Paintings to 1900 / 11
American Paintings to 1906 / 73
Modernism to 1948 / 99
Modern and Contemporary to 2003 / 141
Index of Artists / 167

Acknowledgments

This third revised edition of *Master Paintings in the Art Institute of Chicago*, like its predecessors, features not only many of the Art Institute's outstanding European and American paintings but also an overview of some of the artistic eras represented in the museum. Between the first edition, which appeared in 1988, and this one, the collections of the Art Institute have grown dramatically in breadth and depth. Several reorganizations and rehangings of the galleries have also resulted in discoveries within the museum's historic holdings, many of which have influenced the choices made for this publication. While it is impossible to produce a definitive group of the 149 greatest paintings in our collection, we hope that the process by which we decided on our list, including the additions and deletions to this edition, has resulted in a balanced view of the museum's long-acknowledged paintings collection and of our recent acquisition activities.

A number of individuals have supported this project: In the Department of Medieval through Modern European Painting and Sculpture, I thank Martha Wolff, Curator of Painting before 1750; Gloria Groom, David and Mary Winton Green Curator of Nineteenth-Century Paintings; and Stephanie D'Alessandro, Gary C. and Frances Comer Curator of Modern Art, all of whom helped determine the images and reviewed both the revised and new texts. In the Department of American Art, I am grateful to Judith A. Barter, Field-McCormick Chair; Sarah E. Kelly, Henry and Gilda Buchbinder Family Associate Curator; and Ellen Roberts, Assistant Curator. I wish also to thank James Rondeau, Frances and Thomas Dittmer Chair of Contemporary Art, and Nora Tobbe Riccio, Collection Manager and Research Assistant in the Department of Contemporary Art.

I am equally grateful to Ginny Voedisch and Whitney Moeller, both former Art Institute employees, for the new entries they contributed to this book. The individuals responsible for entries in previous editions are Catherine Bock-Weiss, Courtney Donnell, Thomas Frederickson, Jean Goldman, Mary Gray, Sally Ruth May, Ann Morgan, Dennis Nawrocki, Terry Ann R. Neff, Susan F. Rossen, Steve Sennott, Thomas L. Sloan, Malcolm Warner, Lynne Warren, Martha Wolff, and James Yood.

In the Publications Department, I wish to thank Susan F. Rossen, Executive Director, Elizabeth Stepina, Special Projects Editor, and Susan Weidemeyer, Labels Editor, for organizing, editing, and preparing the book's text. Associate Director Sarah Guernsey, Production Manager Carolyn Ziebarth, and Production Assistant Kate Kotan were responsible for its production. Photo editor Joseph Mohan obtained photography rights. The elegant redesign is that of Renate Gokl, Chicago. Photography was provided by the Department of Imaging Services; I am grateful to its director, Christopher Gallagher, and his staff. Finally, I extend my gratitude to my predecessor, James N. Wood, for his involvement in the initial selection of works and for the informative and succinct introduction that appeared in the last two editions, upon which mine is based.

JAMES CUNO
President and Eloise W. Martin Director
The Art Institute of Chicago

Introduction

In the years after the Great Fire of 1871, a group of citizens came together to form a board of trustees for the floundering Academy of Design, which had been established in 1866. By 1879 debts completed the demise of the institution, but out of that failure came the Chicago Academy of Fine Arts, which accomplished "the founding and maintenance of schools of art and design, the formation and exhibition of collections of objects of art, and the cultivation and extension of the arts by any appropriate means." To help establish the city as a major cultural center, William M. R. French (brother of sculptor Daniel Chester French) was selected as the institution's first director.

In December 1882, the Academy of Fine Arts changed its name to the Art Institute of Chicago, and banker Charles L. Hutchinson was elected the first president of the board of trustees. Hutchinson's standing in the community and his generosity and vision established a model for the future leadership of the Art Institute. In 1887 the museum and school moved from rented rooms on the southwest corner of State and Monroe into a building designed by the Chicago firm Burnham and Root. This Romanesque structure, located on the southwest corner of Michigan Avenue and Van Buren Street, housed school studios, lecture halls, galleries for the Society of Decorative Arts (later the Antiquarian Society), and a display of plaster casts presenting a "comprehensive illustration of the whole history of sculpture," which formed the core of the museum's collection at that time.

The Art Institute soon outgrew its quarters. As chairman of the Committee of Fine Arts for the 1893 World's Columbian Exposition, Hutchinson arranged for the Art Institute and the exposition to the jointly finance a building that would serve as the hall for the World's Congresses during the fair and afterward become the new Art Institute. Designed by the Boston firm Shepley, Rutan and Coolidge, the building, on Michigan Avenue between Jackson and Monroe streets, was completed in May 1893, in time for inauguration of the fair. In December the Art Institute opened in the Beaux-Arts-style building, which it continues to occupy.

From the beginning, it was intended that the Art Institute collect actual masterpieces in all periods and styles. Lacking funds, it had to rely upon gifts and loans of art and money from private collectors and patrons. Fortunately, a number of Chicagoans were blessed with the means and the taste to assemble some of the finest private collections in the United States at that time. In 1890 Hutchinson, Martin A. Ryerson, and other donors seized the opportunity to make a purchase specifically for the museum. Among the work acquired was Meindert Hobbema's *Watermill with the Great Red Roof* (p. 33). A second seminal acquisition occurred just over a decade later, in 1906. Convinced by the enthusiasm of artist Mary Cassatt (see p. 93) for the central portion of an early altarpiece by El Greco that had come on the market, Hutchinson and Ryerson arranged to buy *The Assumption of the Virgin* (p. 22) with private contributions. A gift in 1915 from Nancy Atwood Sprague allowed the temporary donors to be reimbursed. El Greco's *Assumption* is still considered by many to be the greatest single work in the museum.

The Friends of American Art was founded in 1910 with the goal of purchasing the work of living American artists. Soon, however, the organization was acquiring examples

of all styles from all periods. Purchases include Cole's *Distant View of Niagara Falls* (p. 80), Homer's *Croquet Scene* (p. 84), and Eakins's *Mary Adeline Williams* (p. 95).

The Art Institute continued its support of contemporary art when, in 1913, it hosted the landmark "International Exhibition of Modern Art," known as the Armory Show. It inspired Chicagoan Arthur Jerome Eddy (see p. 94) to buy works for what was to become a pioneering collection, part of which entered the museum in 1931. Included was Vasily Kandinsky's *Improvisation No. 30 (Cannons)* (p. 112). The Art Institute's commitment to modern art intensified in the 1920s. In 1921 Joseph Winterbotham, a Chicago businessman, donated \$50,000 to be invested and used as capital for the purchase of European paintings. The unique stipulation of the Winterbotham plan was that only thirty-five paintings could be purchased; once this number was reached, a painting in the group could be sold or exchanged to acquire something of superior quality or significance. This farsighted gift has resulted in the acquisition of some of the museum's most important late nineteenth- and early twentieth-century works, including Van Gogh's *Self-Portrait* (p. 63), Feininger's *Carnival in Arcueil* (p. 106), Delaunay's *Champs de Mars: The Red Tower* (p. 107), Léger's *Railway Crossing* (Sketch) (p. 118), Magritte's *Time Transfixed* (p. 135), and Balthus's *Solitaire* (p. 138).

In 1922 one of the first major bequests from a private collector entered the museum. The interests of Mr. and Mrs. Potter Palmer were always resolutely modern. They had begun in the 1880s to purchase works by living American artists. Mrs. Palmer's attention turned to French painting and examples by Jean-Baptiste Corot, Eugène Delacroix, and others; eventually, she discovered the Impressionists. On annual trips to France between 1888 and 1895, she acquired the majority of the Impressionist works in her collection. The Palmers loaned many to the Art Institute; after Mrs. Palmer's death in 1916, the museum selected a group of paintings, according to the generous terms of her will. This gift, which helped to establish the Art Institute's pre-eminence in nineteenth-century French art, included Corot's *Interrupted Reading* (p. 51) and Pierre-Auguste Renoir's *Acrobats at the Cirque Fernando (Francisca and Angelina Wartenberg)* (p. 56).

The Helen Birch Bartlett Memorial Collection was given to the Art Institute late in 1926 by Frederic Clay Bartlett in memory of his second wife. It contained what is perhaps the museum's most famous work, Georges Seurat's Sunday on La Grande Jatte—1884 (p. 61). Many other signal paintings accompanied the Seurat into the museum, among them Pablo Picasso's Old Guitarist (p. 101) and Amedeo Modigliani's Jacques and Berthe Lipchitz (p. 115). A few years later, Bartlett added such masterpieces as Van Gogh's Bedroom (p. 65) and Paul Cézanne's Basket of Apples (p. 71). With this extraordinary group of paintings mounted in a single room, the Art Institute became the first American museum to feature a gallery of Post-Impressionist art, three years before the opening of the Museum of Modern Art, New York, in 1929. Another benefactor who greatly augmented the museum's collection of nineteenth-century French art was Mrs. Lewis Larned Coburn, whose 1933 bequest included Edgar Degas's Henri Degas and His Niece Lucie Degas (The Artist's Uncle and Cousin) and The Millinery Shop (pp. 52 and 58), Édouard Manet's Woman Reading (p. 57), and Paul Gauguin's Arlésiennes (Mistral) (p. 64).

Also in 1933 the Art Institute received the bequest of Mr. and Mrs. Martin A. Ryerson. Their collection ranks as the greatest gift ever to enter the museum. Unlike the other private collections, that of the Ryersons reflected the breadth of all of Western art. The bequest included textiles, European decorative arts and sculpure, prints and drawings, and over 227 European and American paintings. Among them are a suite of panels by Giovanni di Paolo (see pp. 14–15), Hey's *Annunciation* (p. 17), Monet's *Arrival of the Normandy Train*, *Gare Saint-Lazare* (p. 55), and Homer's *Herring Net* (p. 87).

Charles H. and Mary F. S. Worcester built their collection in response to the Art Institute's needs. Among the works by German and Italian masters that the Worcesters gave to the museum between 1925 and 1947 are Giovanni Battista Moroni's *Gian Lodovico Madruzzo* (p. 21), Bartolomeo Manfredi's *Cupid Chastised* (p. 25), and Giovanni Battista Piazzetta's *Pastoral Scene* (p. 35). The fund established by the Worcesters has resulted in such purchases as Frans Snyders's *Still Life with Dead Game*, *Fruits*, *and Vegetables in a Market* (p. 26) and Gustave Caillebotte's *Paris Street*; *Rainy Day* (p. 54).

For many years, paintings had been hung in the galleries according to the collector who had loaned or given them, regardless of historical or stylistic considerations, an approach that foregrounded the role of the individual patron. In 1933 and 1934, the Art Institute hosted two large-scale exhibitions that changed this policy. Organized by director Robert B. Harshe and comprising works not only from the Art Institute but from private and public collections around the world, the shows were held in concert with the "Century of Progress" exposition in Chicago. They proved to be the museum's first real international success, attracting over seven hundred thousand visitors. Their lasting significance for the Art Institute, however, lay in the purely geographical and chronological manner in which the works of art were grouped in the galleries. Directing the museum during the decade when many of the most important collections came to the museum, and playing a critical role in assuring their arrival, Harshe nonetheless orchestrated a redistribution that demonstrated the effectiveness of a historical arrangement of the museum's holdings and ended the era of the Art Institute as an assembly of private collections.

In 1940 a new auxiliary organization, the Society for Contemporary American Art, was formed in response to the success of the Winterbotham Fund (which acquired only works by foreign artists) and to the demise of the Friends of American Art. The organization's original intent was to purchase only contemporary American paintings for the permanent collection; in 1968 its members voted to embrace European art as well and changed its name to the Society for Contemporary Art. Among the paintings it has acquired for the museum are Jackson Pollock's *Greyed Rainbow* (p. 147) and Leon Golub's *Interrogation II* (p. 163). Another important source for the Art Institute's collections has been right within its walls: the School of the Art Institute. Among the artists who attended the school, maintained a close relationship with the museum, and whose art later assumed a prominent place in the collection are O'Keeffe (see pp. 124 and 129), Albright (see p. 126), Wood (see p. 127), and Golub (see p. 163).

For the first seventy-five years of the Art Institute's existence, the director of the museum also acted as a curator of paintings, reflecting the primacy of the medium. After joining

the museum staff in 1927, Daniel Catton Rich was named director in 1938. Rich's distinguished tenure included outstanding scholarship (his monograph on Seurat's Grande Jatte was one of the first books devoted to a single work), important exhibitions (O'Keeffe, 1943; Cézanne, 1952; Seurat, 1956), and significant acquisitions (he was primarily responsible for forming the Coburn and Worcester collections). In the 1950s, the growth of the museum's holdings, increasing specialization in the art world, and greater interest in modern art led to a number of changes. In 1954 Katharine Kuh was appointed Curator of Modern Painting and Sculpture. Kuh acquired for the museum such important works as Picasso's Mother and Child (p. 120), Picabia's Edtaonisl (Ecclesiastic) (p. 110), Matisse's Bathers by a River (p. 108), and Beckmann's Self-Portrait (p. 134). By the end of the 1960s, an autonomous Department of Twentieth-Century Painting and Sculpture had been formed. The division of the paintings collection into three branches was established in 1975 with the formation of a Department of American Art. The most recent reorganization of the collection's management occurred in 2003, when, under the leadership of James N. Wood, European art from the first half of the twentieth century was transferred to a newly named Department of Medieval to Modern European Art and Sculpture. The Department of American Art took over modernist American painting and sculpture, leaving the second half of the twentieth century to the newly defined Department of Contemporary Art.

The Art Institute carries on the tradition of acquiring the finest paintings available, sustained by the generosity of a new generation of collectors and donors. This edition of *Master Paintings* features twenty-three recent acquisitions. In the area of Old Master paintings, in 2005 we acquired Fra Bartolommeo's *Nativity* (p. 19). A significant addition to our renowned nineteenth-century European holdings is the collection's first oil painting by the great Norwegian artist Edvard Munch, the haunting *Girl Looking out the Window* (p. 68), a generous gift of the Searle Family Trust. Our already outstanding holdings of early twentieth-century European art have been strengthened by the acquisition of Gino Severini's *Festival in Montmartre* (p. 109), received from the estate of Richard S. Zeisler. And the Department of Contemporary Art's active purchasing program is represented here by five works: Kelly's *Red*, *Yellow*, *Blue*, *White*, *and Black* (p. 149), Celmins's *Explosion at Sea* (p. 155), Lichtenstein's *Mirror in Six Panels* (p. 160), Martin's *Untitled #12* (p. 159), and Johns's *Near the Lagoon* (p. 166). The Kelly and Lichtenstein were both purchased thanks to the Anstiss and Ronald Krueck Fund for Contemporary Art.

The works contained in *Master Paintings* reflect the vision and ambition—shaped and maintained by Chicago collectors and museum curators, directors, and trustees—that have helped the Art Institute grow, since its founding more than a century ago, from an outpost of culture on the midwestern prairie to one of the world's great museums.

EUROPEAN PAINTINGS TO 1900

			el .	
		rar .		
			•	

BERNAT MARTORELL

Spanish, c. 1400-1452

Saint George Killing the Dragon, 1434/35

Tempera on panel 155.6 × 98.1 cm (61 ½ × 38 ½ in.)

Gift of Mrs. Richard E. Danielson and Mrs. Chauncey

B. McCormick, 1933.786

As a model of Christian knighthood, Saint George was a very popular figure in the late Middle Ages. The most frequently represented scene from his legend was the episode in which he saved a town threatened by a dragon, at the same time rescuing the beautiful princess who was to be sacrificed to the beast. Bernat Martorell, the greatest Catalan painter of the first half of the fifteenth century, included a wealth of details in his version of the scene: animal and human bones litter the foreground; lizards—or perhaps baby dragons—crawl around the crevice in which the dragon lives; the princess's parents and throngs of onlookers crowd the town's battlements to view the action; neatly cultivated fields provide a sense of orderliness in contrast with the chaos of the slaying.

Saint George Killing the Dragon was the central panel of an altarpiece devoted to the saint and was originally surrounded by four smaller narrative panels showing his martyrdom (Paris, Musée du Louvre). Saint George incorporates Flemish, French, and Northern Italian currents of the International Gothic Style; this eclecticism reflects the receptiveness of Catalonia, the region of Spain on the Mediterranean bordering France, to outside influences. Spanish paintings often feature raised stucco decoration, which Martorell applied here with wonderful inventiveness to model the armor and halo of Saint George and the scaly body of the dragon. Yet the panel's rich narrative detail is unusual for a Spanish altarpiece, since, more typically, the central figure in an altarpiece was depicted in a rigid, frontal manner.

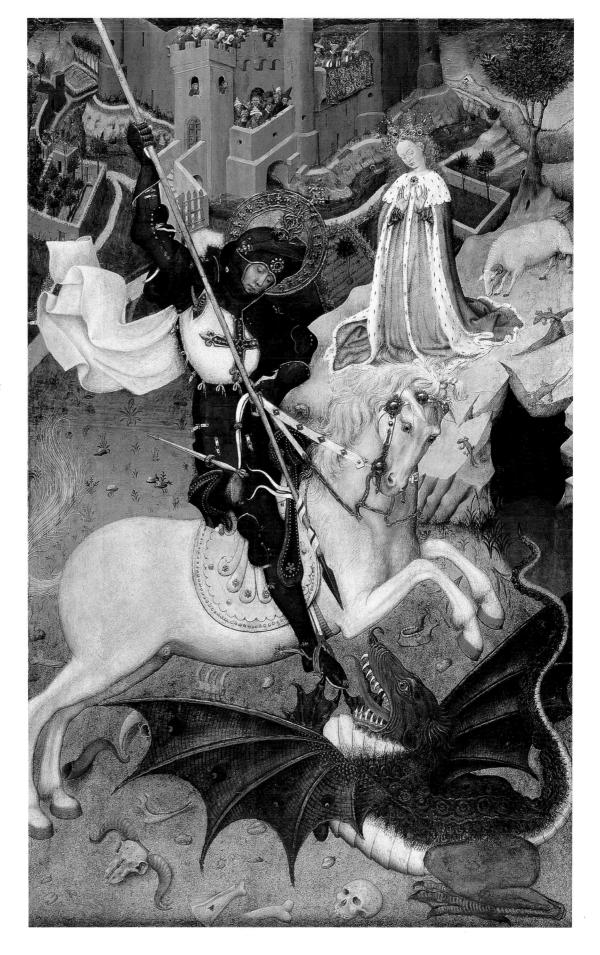

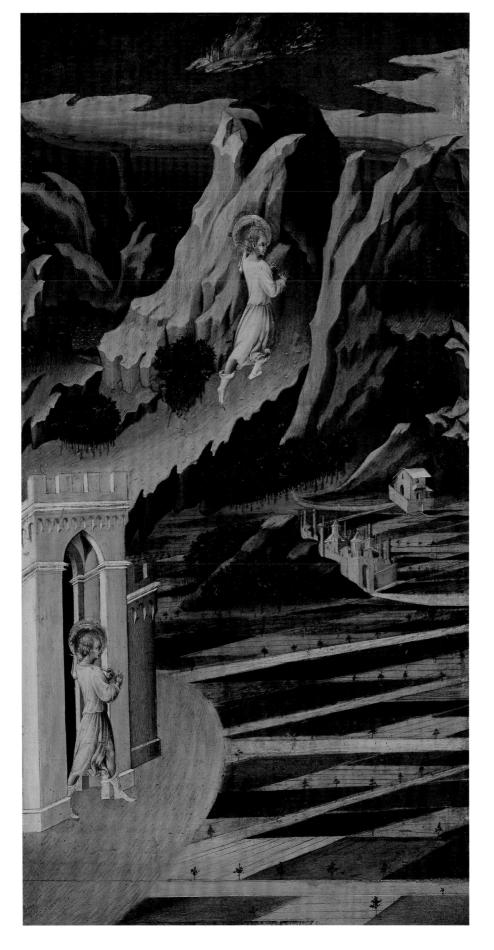

GIOVANNI DI PAOLO

Italian, active c. 1417-82

Saint John the Baptist Entering the Wilderness, 1455/60

Tempera on panel 68.5×36.2 cm ($27 \times 14^{-1/4}$ in.); painted surface: 66.3×34 cm ($26^{-1/16} \times 13^{-7/16}$ in.)

Mr. and Mrs. Martin A. Ryerson Collection, 1933.1010

The Beheading of Saint John the Baptist, 1455/60

Tempera on panel 68.6×39.1 cm $(27 \times 15^{-3}/8 \text{ in.})$; painted surface: 66.3×36.6 cm $(26^{-1}/16 \times 14^{-7}/16 \text{ in.})$ Mr. and Mrs. Martin A. Ryerson Collection, 1933.1014

Giovanni di Paolo was the leading painter working in Siena in the fifteenth century. The combination of emotion and decorative poetry in his work is an individual extension of the great tradition of fourteenth-century Sienese painting. Saint John the Baptist Entering the Wilderness and The Beheading of Saint John the Baptist are two of a sequence of twelve scenes from the life of the saint that are masterpieces of Giovanni's narrative style.

Eleven of the original twelve panels survive: six in the Art Institute and the remainder scattered in various European and American collections. From the shape and condition of the panels, it is clear that they were arranged in two large, movable wings. Four panels with arched tops were placed in an upper row; the other eight were placed below them in two registers. Thus, four vertical columns of panels were divided horizontally into three registers. The function of these wings is not clear: they may have been framed in a niche with a sculpted figure of John the Baptist, or they may have formed the doors of some sort of reliquary cupboard containing a sacred relic or effigy of the saint.

John the Baptist was the cousin of Jesus and the last in a long line of prophets who, according to the Gospel account, foretold Christ's coming. With a wonderful feeling for detail and for the unfolding of the story, Giovanni represented John's birth to the elderly Elizabeth, his departure for a hermit's life in the wilderness, his prophesy of Christ's coming, his baptism of Jesus, and his beheading as a result of the scheming of Queen Herodias and her daughter, Salome (see also Guido Reni's depiction of Salome [p. 30]). These scenes are enacted in complex settings that exploit the tall, slender proportions of the panels and accentuate the elegant poses of the figures. In the panel at the left, the artist deftly combined two aspects of the story. The lower half shows the saint renouncing the comfort and safety of buildings and tilled fields for the rugged emptiness of the wilderness, depicted in the upper half, where he will trust his survival to his faith in God.

To unite the narrative, the artist made masterful use of repeated figures and settings throughout the series. Thus, the geometrically patterned fields and jagged mountains of *Saint John the Baptist Entering the Wilderness* extend across two other panels from the same wing. The prison in which John is confined is repeated in another of the Art Institute's panels. The beheading, which takes place in an urban setting, gains intensity from such exaggerated effects as the elongated neck and spurting blood of the decapitated prophet. The pathos of this scene is underscored by the lack of emotion of the executioner and his coworkers as they carry out their deadly duties.

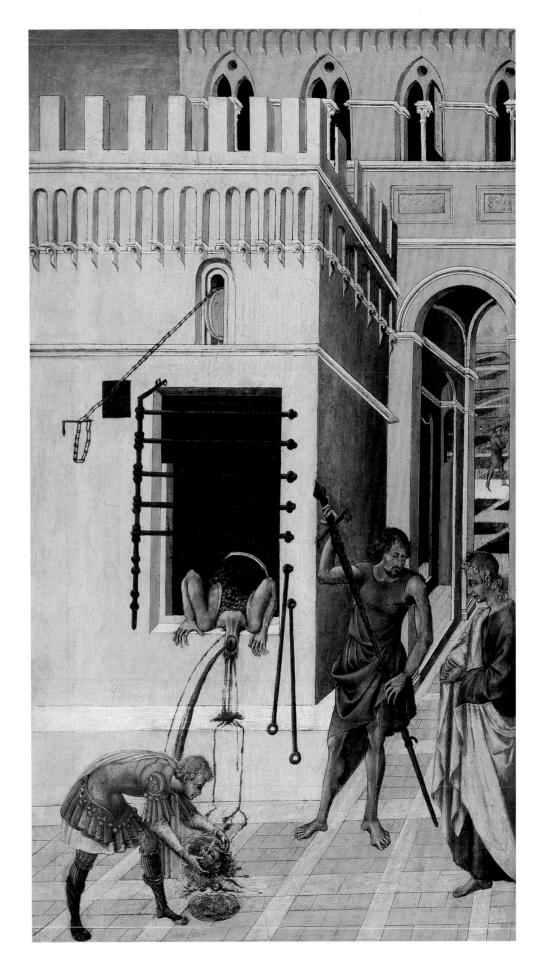

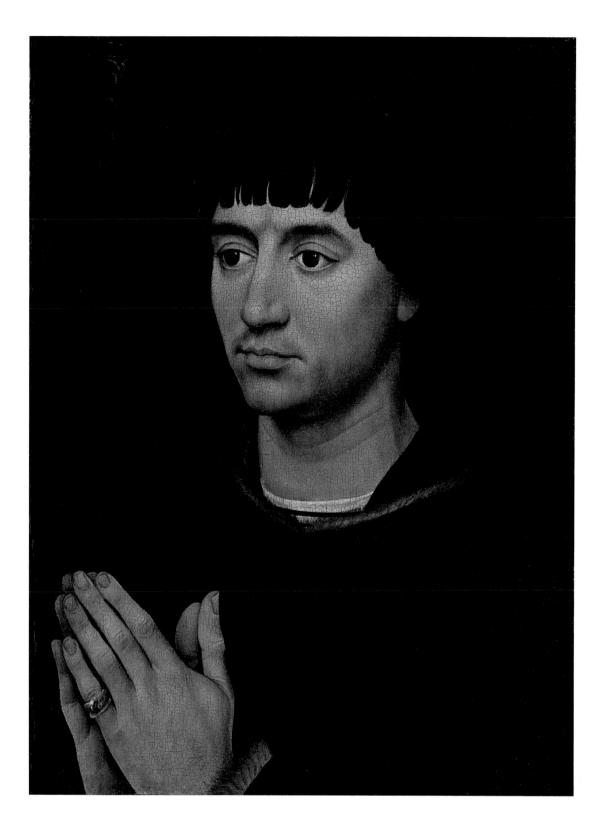

ROGIER VAN DER WEYDEN AND WORKSHOP

Netherlandish, c. 1399-1464

Jean Gros, 1460/64

Oil on panel 38.5×28.8 cm ($15^{-3}/16 \times 11^{-3}/8$ in.); painted surface: 36.5×27 cm ($14^{-3}/8 \times 10^{-5}/8$ in.)
Mr. and Mrs. Martin A. Ryerson Collection, 1933.1051

Rogier van der Weyden was one of the most influential artists of the fifteenth century. He settled in Brussels, where he was named official town painter in 1436 and maintained a busy workshop. He executed altarpieces and portraits for religious institutions, court functionaries, and the powerful dukes of the Burgundian Netherlands.

The coat of arms, motto, and personal device of a pulley painted on the back of the Art Institute's portrait identify the sitter as Jean Gros, an official of the Burgundian court. This portrait depicts him at the outset of a successful career, during which he amassed a large fortune and led a privileged life. Rogier presented the half-length figure against a plain, dark background, which accentuates the sitter's features and the prayerful gesture of his eloquent hands. This gesture indicates that the panel was once part of a diptych, a folding, portable altarpiece used for private devotion: Gros's devout, abstracted gaze was in fact directed at another panel bearing the image of the Madonna and Child, a painting now in the Musée des Beaux-Arts, Tournai, France. Gros's coat of arms is on the back of that panel as well.

This type of diptych, which was intended to suggest continuous prayer and to record the donor's features, was probably first made for princes around 1400, but Rogier revitalized the form, giving a striking focus and elegance to examples he produced for members of the Burgundian court.

JEAN HEY (THE MASTER OF MOULINS)

French, active c. 1475-c. 1505

The Annunciation, 1490/95

Oil on panel 72×50.2 cm ($28^{-5}/_{16} \times 19^{-3}/_{4}$ in.); painted surface: 71.7×49.2 ($28^{-1}/_{4} \times 19^{-3}/_{8}$ in.) Mr. and Mrs. Martin A. Ryerson Collection, 1933.1062

Jean Hey was probably trained in the Netherlands, but worked for the regents of France, Pierre, duke of Bourbon and Anne of France, at their court in Moulins. He treated religious subjects in a traditional manner, but introduced classical elements into the setting, probably as a reflection of his patron's emerging interest in Renaissance form. In this painting, the archangel tells Mary the news of Christ's coming birth; the setting is the Virgin's vaulted bedchamber, but the shell decoration in the niche behind Gabriel recalls the architectural vocabulary of antiquity. The elegant features of Gabriel and Mary and their controlled gestures link them to Hey's portraits of French princes and princesses. At the same time, his Flemish training is evident in the careful rendering of Gabriel's silk robes and in his use of shadow.

The Annunciation is not an independent work. Rather, it formed the right end of a long panel with scenes honoring the Virgin Mary, including depictions of her parents, Joachim and Anne (London, National Gallery); the central section was probably a representation of the Virgin and Child enthroned (now lost). This form explains an awkwardness in the composition of the Art Institute's panel: Hey compressed the action so that Mary looks and gestures modestly toward what would have been the focus of the altarpiece, the image of herself and Jesus enthroned. The glowing colors, complex light effects, and elegantly observed figures of The Annunciation and other works by Hey demonstrate why he is considered the finest painter working in France at the end of the fifteenth century.

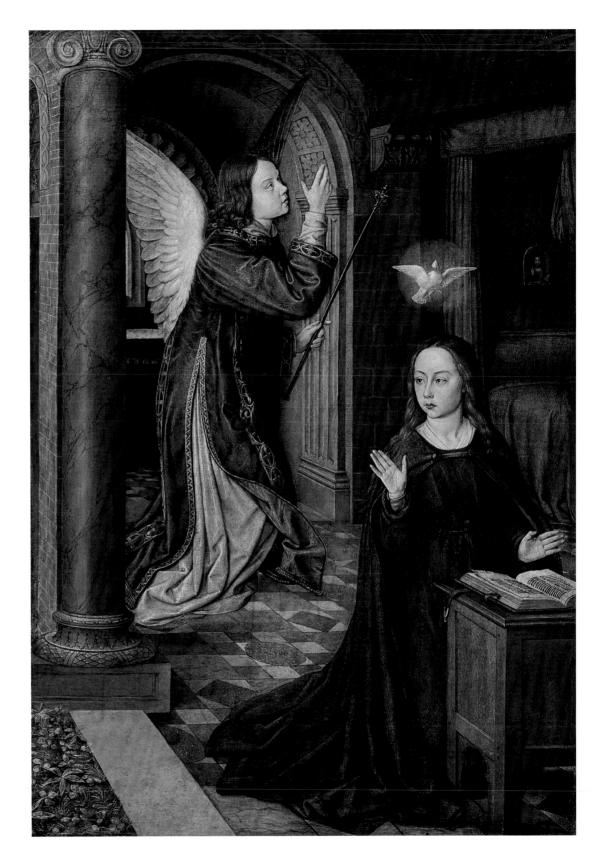

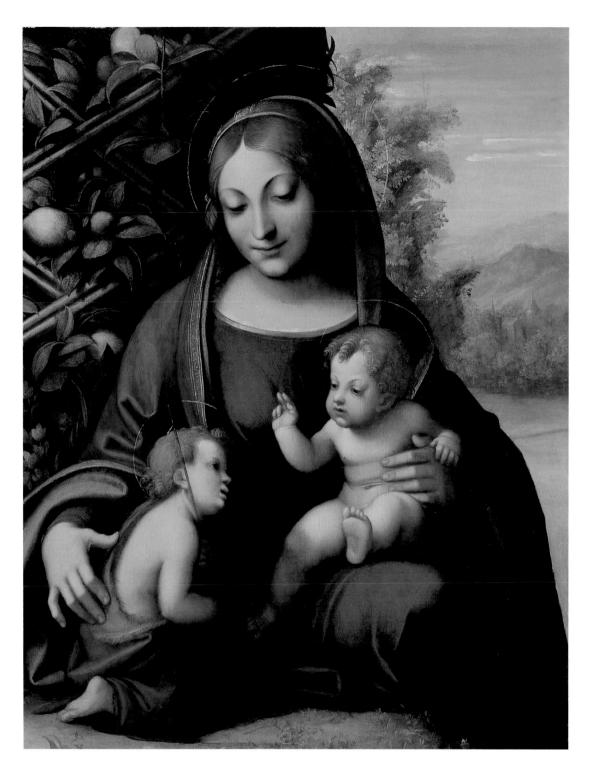

CORREGGIO (ANTONIO ALLEGRI)

Italian, c. 1489-1534

Virgin and Child with the Young Saint John the Baptist, c. 1515

Oil on panel 64.2 × 50.2 cm (25 ¹/₄ × 19 ³/₄ in.) Clyde M. Carr Fund, 1965.688

Correggio lived and worked in Parma, executing a body of work that is remarkable for its inventiveness and sophistication, given his remoteness from the great artistic centers of Renaissance Italy. This small panel, executed when Correggio was only about twenty-five years of age, is in his earliest style, but already exhibits some of the delicacy of illumination for which he would become renowned.

The pyramidal structure of the figures and the softness and fullness of the forms show the influence of the pioneering High Renaissance style of Leonardo and Raphael. Correggio's own sensibility can be seen in the tender interaction of the figures—conveyed through glance and gesture—the gentle sensuousness of the forms, and the overall poetic mood.

Adding to the charm of the panel is the exquisite painting of the details and the landscape beyond. The expressive and idyllic quality of this painting would become more pronounced in Correggio's mature work.

FRA BARTOLOMMEO (BACCIO DELLA PORTA)

Italian, 1472-1517

Nativity, 1504/07

Oil on panel

 34×24.5 cm (13 $^{3}/8 \times 9$ $^{5}/8$ in.)

Ethel T. Scarborough Fund; L. L. and A. S. Coburn, Dr. and Mrs. William Gilligan, Mr. and Mrs. Lester King, John and Josephine Louis, Samuel A. Marx, Alexander McKay, Chester D. Tripp, and Murray Vale endowment funds; restricted gift of Marilynn Alsdorf, Anne Searle Bent, David and Celia Hilliard, Alexandra and John Nichols, Mrs. Harold T. Martin, Mrs. George B. Young in memory of her husband, and the Rhoades Foundation; gift of John Bross and members of the Old Masters Society in memory of Louise Smith Bross; through prior gift of the George F. Harding, Mr. and Mrs. W. W. Kimball, Mr. and Mrs. Martin A. Ryerson, and Charles H. and Mary F. S. Worcester collections, 2005.49

The young Baccio della Porta came under the spell of the charismatic Dominican friar Girolamo Savonarola, joining his monastic order as Fra (Friar) Bartolommeo and forsaking his artistic career for several years. Returning to painting in 1504, he looked to the most lyrical and harmonious recent works of Leonardo, Michelangelo, and Raphael to form his own personal style, characterized by a calm and gentle spirit and deep piety.

In this very intimate interpretation of the Nativity, the Virgin kneels humbly on the ground gazing at the Christ Child, while Joseph assumes a pose of restrained wonderment, as if suddenly aware of the infant's divine nature. The joy of his birth, celebrated by angels above and below, is tempered by a reference to his death. Lying on a rock behind the infant is a piece of wood, probably intended as a reference to the cross on which he would be crucified at Golgotha. Shelter for the family is provided by a rustic stall, erected within the ruins of an edifice that, following conventional iconography, is to be identified as the palace of David at

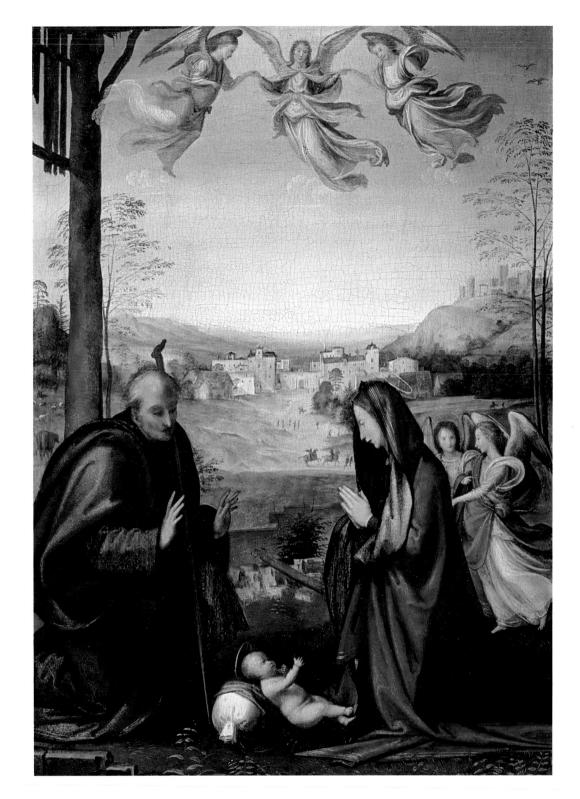

Bethlehem. This juxtaposition of old and new symbolizes Christ's establishment of his new faith on the foundations of the Old Testament.

Fra Bartolommeo's chief contribution to this traditional subject is the landscape, at once ethereal and vast, that provides the setting for the interaction of Mary, Joseph, and the Christ Child. The artist's exquisitely observed rendering of the Tuscan countryside serves to ground sacred events in everyday life, albeit an idealized version of the natural world.

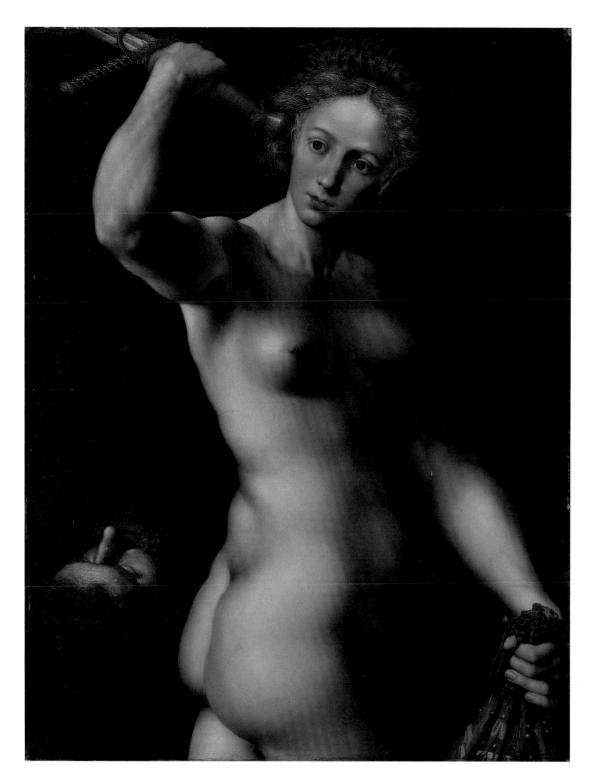

JAN SANDERS VAN HEMESSEN

Netherlandish, c. 1519-1556

Judith, c. 1540

Oil on panel

99.1 × 77.2 cm (39 × 30 3/8 in.)

Wirt D. Walker Fund, 1956.1109

Judith was considered one of the most heroic women of the Old Testament. According to the biblical story, when her city was besieged by the Assyrian army, the beautiful young widow gained access to the quarters of the Assyrian general Holofernes. After winning his confidence and getting him drunk, she took his sword and cut off his head, thereby saving the Jewish people. Although Judith was often shown richly and exotically clothed, Jan Sanders van Hemessen chose to present her as a monumental nude figure, aggressively brandishing her sword even after severing Holofernes's head.

Van Hemessen was one of the chief proponents of a style, popular in the Netherlands in the first half of the sixteenth century, that was deeply indebted to the monumental character of classical sculpture, as well as of the art of Michelangelo and Raphael. Judith's muscular body and her elaborate, twisting pose reflect these influences. Yet the use of the nude figure here also suggests a certain ambivalence on the part of the artist and his audience toward the seductive wiles Judith may have employed to disarm Holofernes. In this work, Van Hemessen combined an idealized form with precisely rendered textures, as in the hair and beard of Holofernes, Judith's gauzy headdress, and her brocaded bag. The interplay between the straining pose of the figure, the dramatic lighting, and the fastidiously recorded surfaces serve to heighten the tension of this composition.

GIOVANNI BATTISTA MORONI

Italian, 1520/24-1578

Gian Lodovico Madruzzo, 1551/52

Oil on canvas 199.8 \times 116 cm (78 $^5/8$ \times 45 $^5/8$ in.) Charles H. and Mary F. S. Worcester Collection, 1929.912

Giovanni Battista Moroni was one of the great portrait painters of the sixteenth century. He spent much of his career depicting the distinguished citizens of his native Bergamo, Italy. The young man in the Art Institute's portrait—from the high-placed Madruzzo family—became a cardinal and achieved fame for his funeral sermon for Charles V at the Diet of Augsburg. He succeeded his uncle, Cardinal Cristoforo Madruzzo, as prince-bishop of Trent in 1567.

Moroni's portraits are characterized by a naturalism tempered by restraint. While he sought to present objective likenesses of his sitters, he kept them at a certain psychological distance through the austerity of his compositions and colors. As in many of Moroni's full-length portraits, the figure of Gian Lodovico is posed in a simply constructed, narrow space. The severe composition is enlivened by the contrast of the flat, architectural forms and floor patterns with the curved, hanging drapery and undulating hem of the subject's ecclesiastical garment. Madruzzo's aristocratic status is signaled by the choice of this full-length format, traditionally reserved for images of emperors and princes, and by the inclusion of his hunting dog, a symbol of privilege. Madruzzo's steady, yet reserved, gaze aptly suggests his ease in this role.

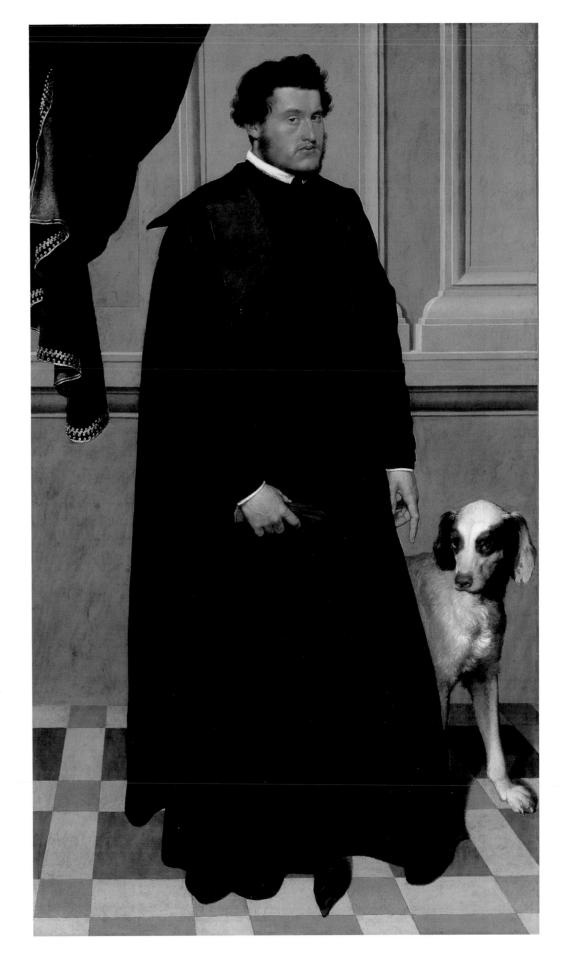

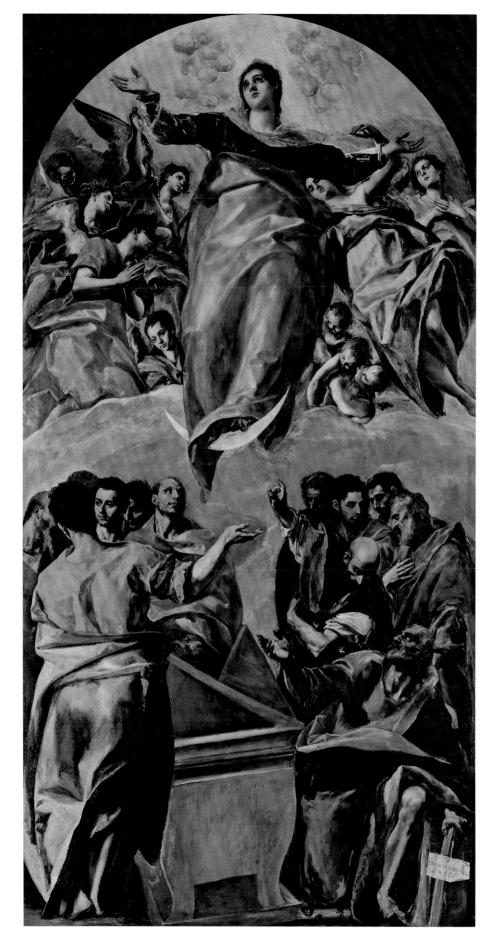

EL GRECO (DOMENIKOS THEOTOKOPOULOS)

Spanish, born Greece, 1541-1614

The Assumption of the Virgin, 1577-79

Oil on canvas

403.2 × 211.8 cm (158 3 /4 × 83 3 /4 in.); original image approximately: 396.4 × 202.5 cm (156 1 /16 × 79 3 /4 in.) Gift of Nancy Atwood Sprague in memory of Albert Arnold Sprague, 1906.99

The art of the great Mannerist painter El Greco is a supremely effective synthesis of the traditions of his native Greece, the art of the Renaissance masters of Italy (he spent nearly a decade in Venice and Rome), and the deep spiritualism of the Counter Reformation, which was particularly strong in Spain, where the artist finally settled.

The Assumption of the Virgin—among the Art Institute's most important Old Master paintings—was part of El Greco's first major commission following his arrival in Spain. The focal point of the high altar of the church of Santo Domingo el Antiguo in Toledo, this monumental canvas is a work of stirring drama and impassioned religious feeling. The composition is divided into two zones: the earthly sphere of the apostles and the celestial sphere of angels, who welcome and celebrate the Virgin as she rises from her grave upon a crescent moon (a symbol of her purity). Into a tall vertical format, El Greco compressed many figures, whose faces and gestures express a range of emotions—confusion, disbelief, excitement, peace, awe. Their elongated bodies, covered with ample, beautifully rendered draperies painted in high-keyed colors, are so filled with energy and feeling that the composition seems to burst from the frame. Here, and in many other works, El Greco used broad, free brushwork, flickering hues, rich color harmonies, brilliant illumination, and bold figural arrangements to arouse mystic fervor in the viewer and impart a deep sense of faith.

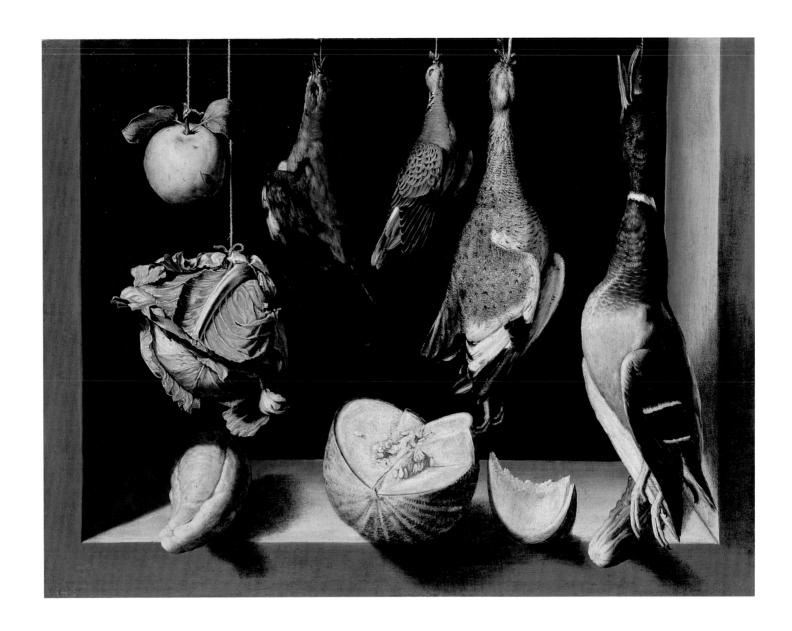

JUAN SÁNCHEZ COTÁN

Spanish, 1560-1627

Still Life with Game Fowl, 1600/03
Oil on canvas
67.8 × 88.7 cm (26 11/16 × 34 15/16 in.)
Gift of Mr. and Mrs. Leigh B. Block, 1955.1203

Still Life with Game Fowl by Juan Sánchez Cotán is the Art Institute's earliest European still-life painting. The rise of still life as an independent subject occurred in the sixteenth century, when artists began to specialize in such categories as landscape, portraiture, and genre scenes. Some, like Sánchez Cotán, became

interested in displaying their skill at depicting inanimate objects, in part as an expression of the order and variety of the natural world. The painter's focus changed in 1603, however, when he left the Spanish city of Toledo and a successful artistic career of some twenty years to become a lay brother of the Carthusian order at the Charterhouse of Granada. Accordingly, he changed his focus from still lifes to religious images.

The Art Institute's example dates from the period just before Sánchez Cotán left Toledo. It follows the conventional format of his still lifes: precisely rendered forms are displayed in a shallow, windowlike space. In some canvases, he depicted few objects; in others, such as the Art

Institute's, he filled the space with them. The artist organized the composition with extreme rigor. The perfect symmetry with which the objects are positioned is echoed in the precise geometry of their shapes: the quince, cabbage, and melon are spherical; the birds are conical. A strong, raking light creates a lively play of light and shadow over each form. This design is further enlivened by a subtle compositional device—the hanging objects are arranged not just perpendicularly to the bottom edge of the painting, but also on a diagonal. In these ways, Sánchez Cotán was able to infuse simple objects in a minimal setting with great presence and drama.

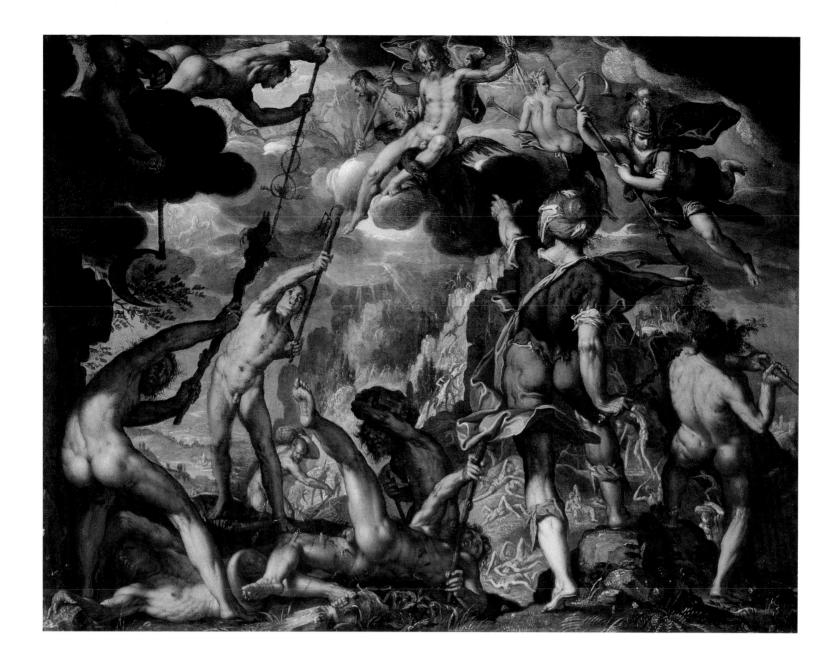

JOACHIM ANTONISZ. WTEWAEL

Dutch, c. 1566-1638

The Battle between the Gods and the Giants, c. 1608 Oil on copper

 15.6×20.3 cm $(6^{1/8} \times 8$ in.)

Through prior acquisition of the George F. Harding Fund, 1986.426

The two decades after 1585 saw a flowering in Holland of the refined, courtly style known as late Mannerism, an international movement growing out of earlier developments in the

courts of Florence, Rome, and the Holy Roman Empire. Joachim Wtewael was probably the most accomplished painter of the Dutch Mannerists. After several years of study in Italy and France, he established himself as an artist in his native Utrecht in 1592. In addition to large canvases, Wtewael executed a number of exquisite cabinet pictures on copper or wood aimed at the sophisticated collectors who were the chief audience for works in this style.

In the foreground of Wtewael's small painting on copper at the Art Institute, the doomed ancient race of Giants struggles with crude clubs and rocks against the gods of Olympus, who

recline in relative security in the heavens. The gods are identified by the attributes that they brandish against the Giants: Jupiter's thunderbolts, Neptune's trident, and Mercury's caduceus (a winged staff entwined by serpents). The action and drama of the battle, recounted in *Metamorphoses*, the ancient Roman text by Ovid, provided Wtewael with an opportunity for a bravura, self-conscious display of skill. The painting's exquisite finish, dramatic poses, and manipulation of space make *The Battle between the Gods and the Giants* emblematic of the late Mannerist style.

BARTOLOMEO MANFREDI

Italian, 1582-c. 1622

Cupid Chastised, 1613

Oil on canvas $175.3\times130.6~cm~(69\times51~^3/8~in.)$ Charles H. and Mary F. S. Worcester Collection, 1947.58

Following the example of the revolutionary early Baroque artist Michelangelo Merisi da Caravaggio, Bartolomeo Manfredi chose not to interpret the stories of the Bible and classical mythology as the actions of idealized protagonists. Caravaggio had shown Manfredi and an entire generation of European artists that such lofty themes could be transformed into events experienced by ordinary people. Employing dramatic light effects and locating the action directly before the viewer, these artists were able to endow their narratives with great immediacy and power.

Cupid Chastised depicts a moment of high drama: Mars, the god of war, beats Cupid for having caused his affair with Venus, which exposed him to the derision and outrage of the other gods; the goddess of love attempts in vain to intervene. Surrounded by darkness, the three figures are lit by a beam of light that breaks across faces, torsos, limbs, and drapery, intensifying the dynamism and impact of the composition. The sheer physicality of the figures—the crouching Venus, whose broad, almost coarse, face is far from any classical ideal; the powerful Mars, whose musculature and brilliant red drapery seem to pulsate with rage; and Cupid, whose naked flesh and prone position render him particularly vulnerable—conveys the violence of the scene. On one level a tale of domestic discord, the story also symbolizes the eternal conflict between love and war, and the helplessness of love in the face of wrath.

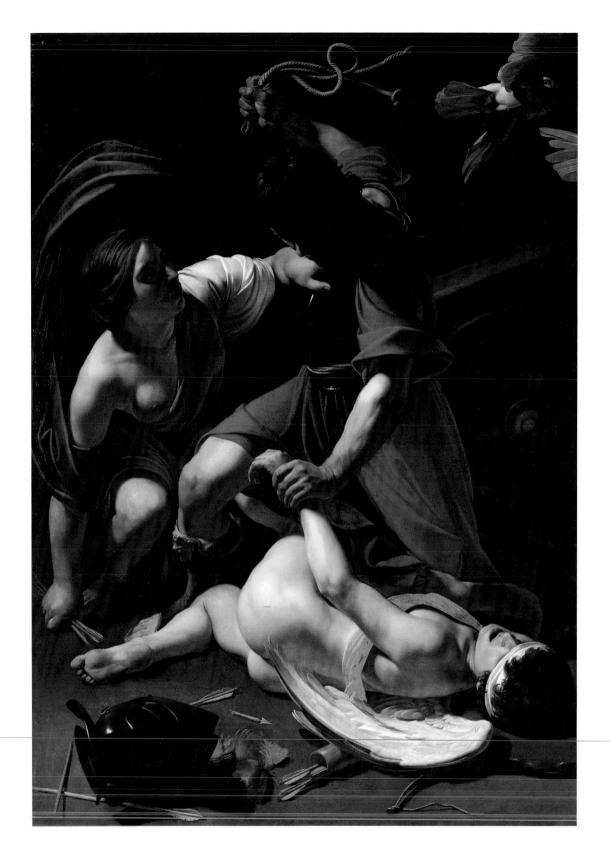

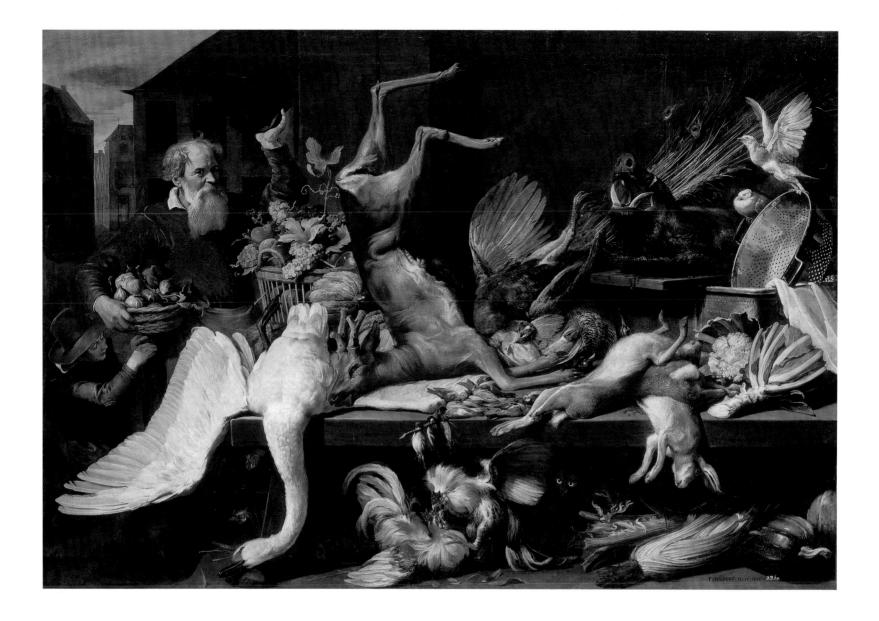

FRANS SNYDERS

Flemish, 1579-1657

Still Life with Dead Game, Fruits, and Vegetables in a Market, 1614

Oil on canvas 212×308 cm $(83^{1}/2 \times 121^{1}/4$ in.) Charles H. and Mary F. S. Worcester Collection, 1981.182

Antwerp, with its long tradition of trade, especially in luxury items, was an active artistic center in the seventeenth century. A number of artists, including Peter Paul Rubens (see p. 27),

made the first half of the century a golden age of painting in the city. Among them was Frans Snyders, who brought a new level of drama to his still lifes. His almost life-size compositions depicting living and dead creatures in a market setting seem to have been stimulated by collaboration with Rubens in 1613. However, from 1614 on, beginning with the Art Institute's painting, the theme of the overflowing market stall became Snyders's specialty.

In Still Life with Dead Game, Fruits, and Vegetables in a Market, the pulsing vitality of the market stall is achieved with a series of opposing diagonals and contrasting groups of animals. A dead peacock's rich plumage contrasts

with the white dove flying into the scene from the right. The languid lines of a hanging deer and swan are set off by the frenzied motion of roosters fighting below them. The drama is intensified by a cat that waits with glowing eyes to pounce on the weaker of the two birds. Meanwhile, an old stallkeeper, who, by his gesture and glance, invites the viewer to enter his stall, has his pocket picked by a darting boy.

Snyders's large-scale compositions were much in demand to decorate Flemish town houses and rural hunting lodges, and established a type of still-life painting that would remain popular throughout the seventeenth century.

PETER PAUL RUBENS

Flemish, 1577-1640

The Holy Family with Saints Elizabeth and John the Baptist, c. 1615

Oil on panel 114.5 × 91.5 cm (45 ½ × 36 in.) Major Acquisitions Fund, 1967.229

By the beginning of the seventeenth century, it was the custom for young Flemish painters to complete their education in Italy. Peter Paul Rubens, who went to Italy in 1600, was exceptional in the length of time he stayed there (eight years) and in the degree to which he assimilated what he saw. He absorbed the art of the great Renaissance painters in Rome and Venice, as well as the most recent advances in early Baroque painting in Rome, and then dominated the artistic scene when he returned to his native Antwerp. The paintings Rubens completed after his return, with their flashing light and dramatic movement, show the influence of Michelangelo Merisi da Caravaggio's revolutionary work, but his style soon became more classical. A series of paintings of the Madonna and the Holy Family, undertaken between 1610 and 1620-of which this work is a fine example—reflect this development in their balanced compositions, clearly defined forms, and crisply rendered surfaces.

The figure of the Virgin dominates *The Holy Family with Saints Elizabeth and John the Baptist* through the brilliant red of her dress, the emphatic curves of her body, and the solid and contained profile view in which she is presented. The bold, diagonal movement of the two infants—John the Baptist eagerly leans toward Jesus, who twists away from him—provides a counterbalance to the Madonna's solid, anchored form. The caring figures of Joseph and Elizabeth frame this pyramidal group.

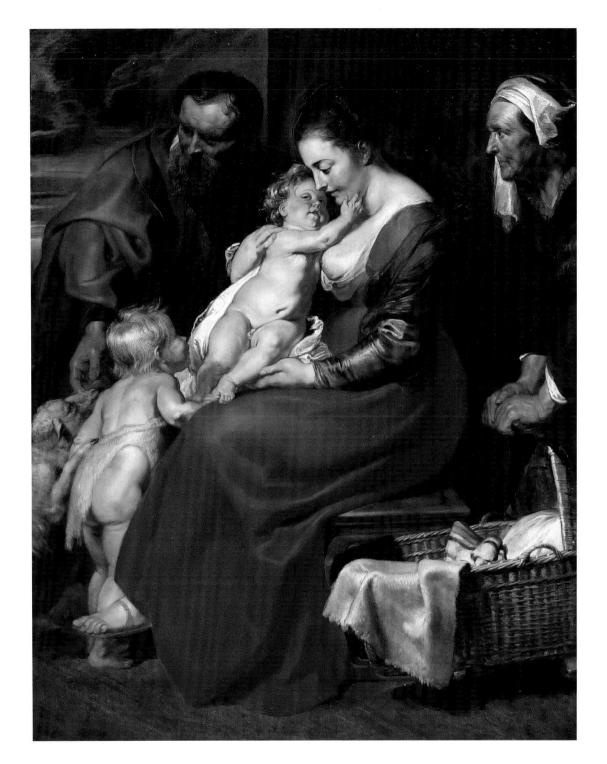

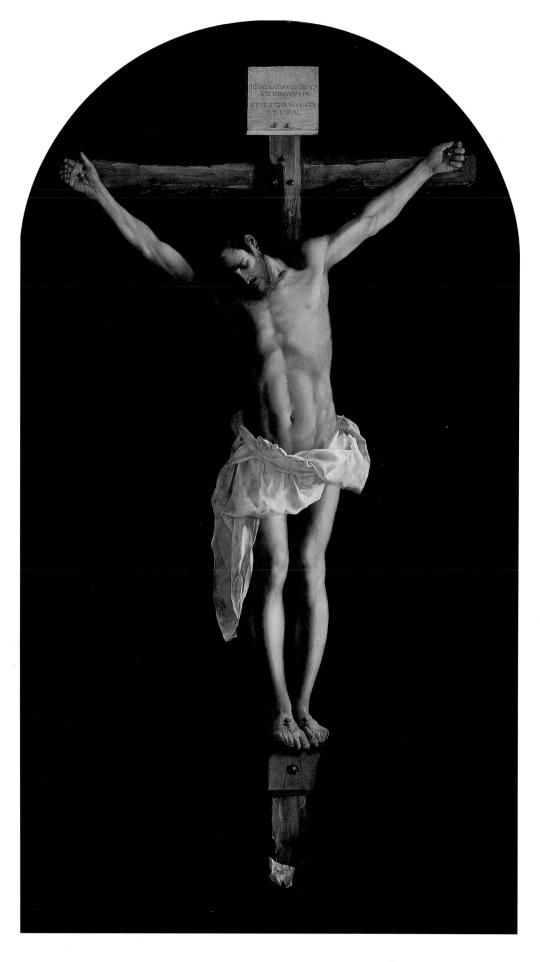

FRANCISCO DE ZURBARÁN

Spanish, 1598-1664

The Crucifixion, 1627
Oil on canvas
290.3 × 165.5 cm (114 5/16 × 65 3/16 in.)
Robert A. Waller Memorial Fund, 1954.15

Beginning in the mid-sixteenth century, the Catholic Church clarified and reaffirmed its doctrine and practices in an effort to combat the impact of the Protestant Reformation. This effort, known as the Counter Reformation, recognized the educational and inspirational value of visual images and required artists to work in a style of easy readability and dramatic fervor.

In 1627 Francisco de Zurbarán, then living and working in the provincial Spanish town of Llerena, painted this Crucifixion for the monastery of San Pablo el Reale in prosperous Seville. In the dimly lit sacristy where it was installed, the image of Christ awed the faithful. Later commentators noted that it appeared to be a sculpture rather than a painting. Zurbarán envisioned the crucified Christ suspended outside of time and place. Conforming to Counter Reformation dictates, the artist depicted the event occurring not in a crowd but in isolation. Emerging from a dark background, the austere figure has been both idealized, in its quiet, graceful beauty and elegant rendering, and humanized by the individualized face and insistent realism. Strong light picks out anatomical detail, the delicate folds of the white loincloth, and a curled scrap of paper on which the artist's name and the date of the painting are inscribed.

REMBRANDT HARMENSZ. VAN RIJN

Dutch, 1606-1669

Old Man with a Gold Chain, c. 1631

Oil on panel $83.1\times75.7~cm~(32~^{3/4}\times29~^{3/4}~in.)$ Mr. and Mrs. W. W. Kimball Collection, 1922.4467

Rembrandt van Rijn was very much a product of the Protestant, city-dwelling culture of seventeenth-century Holland. Yet he stands apart from other Dutch artists of his time because of the deep humanity and individuality that he brought to his paintings of religious and historical subjects, and because of the rich and suggestive treatment of color and light that he developed over his long career. Although it is an early work, probably executed when Rembrandt left his hometown of Leiden in 1631 to become a fashionable portrait painter in Amsterdam, Old Man with a Gold Chain treats a subject that was to occupy him for the rest of his life—a character penetratingly observed through dramatic contrast of light and shade and through fanciful costume.

Old Man with a Gold Chain is not a portrait as such. The sitter was a favorite model of Rembrandt, so frequently represented that he has been considered, without any evidence, to be the artist's father. He appears in many biblical scenes, but the subject here is the implied character of the model himself. The proud, old man is ennobled by a chain of office, a soldier's steel gorget, and a plumed beret. Rembrandt set the silhouette of the bulky form against a light background to convey a sense of the subject's active watchfulness and stability. At the same time, there is a flourish to the figure in the twist of the body and in the flamboyant outline of the hat, revealing the ambition of the youthful artist as much as the character of the sitter.

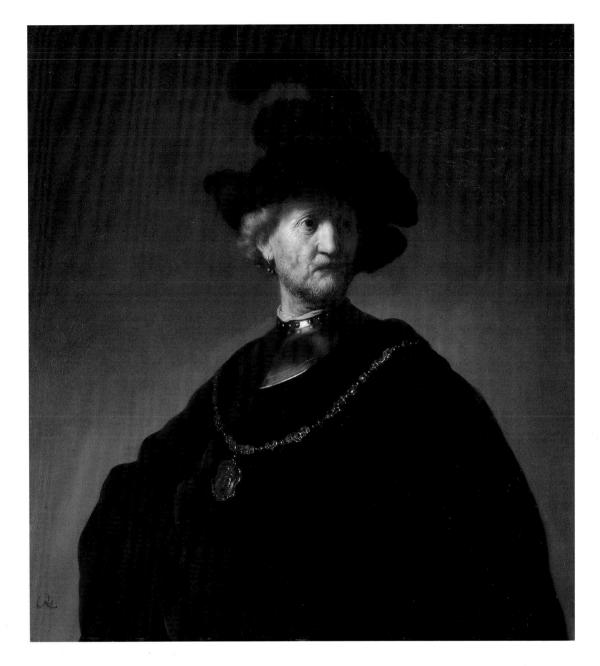

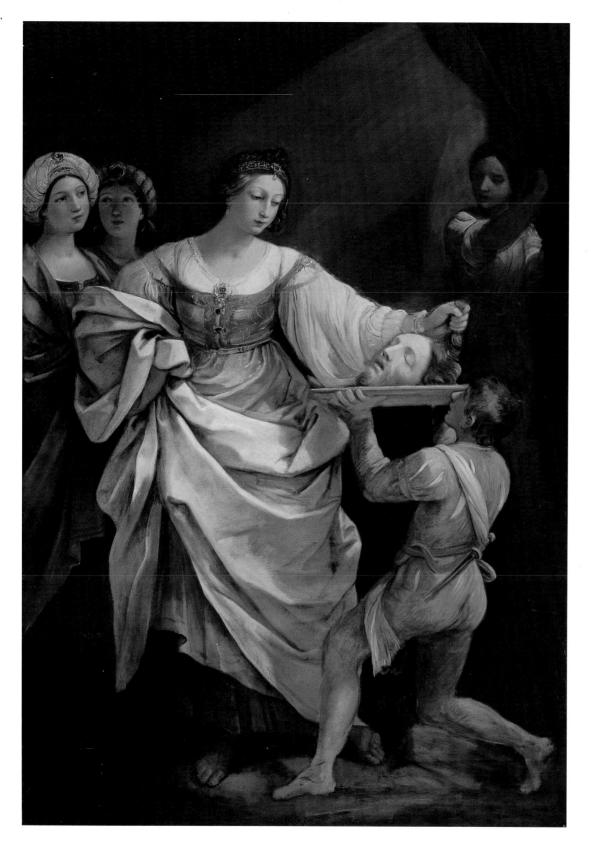

GUIDO RENI

Italian, 1575-1642

Salome with the Head of Saint John the Baptist, 1639/42

Oil on canvas

 $248.5 \times 174 \text{ cm} (97^{-3}/4 \times 68^{-1}/2 \text{ in.})$

Louise B. and Frank H. Woods Purchase Fund, 1960.3

The elegant figures that fill this large canvas enact one of the New Testament's most macabre stories, the death of Saint John the Baptist. The imprisoned prophet had earned the wrath of Herodias because he had reprimanded her new husband, King Herod, for having married her, his sister-in-law. A dance presented by Herodias's daughter, the beautiful Salome, so pleased Herod that he offered her whatever she wanted. Prompted by her vengeful mother, she asked for the head of Saint John. In this striking composition, Guido Reni depicted the moment when the decapitated head is presented to Salome.

Salome with the Head of Saint John the Baptist is a prime example of Reni's late manner. He achieved fame in Rome early in his career, working in a dramatic Baroque style for popes and princes, but subsequently settled in his native Bologna. In Salome, as in other works from the end of his life, Reni lightened his palette, restricting himself to a narrow range of cool illumination and color. The broad handling of the forms and paring down of unnecessary details of costume and setting add to the monumental, contemplative quality of the painting.

The central, unresolved issue of Reni's late work is whether or not a painting was completed. The Art Institute's work is extremely sketchy in the definition of areas such as the legs of the page and the feet of Salome—so much so that these parts may have been left unfinished.

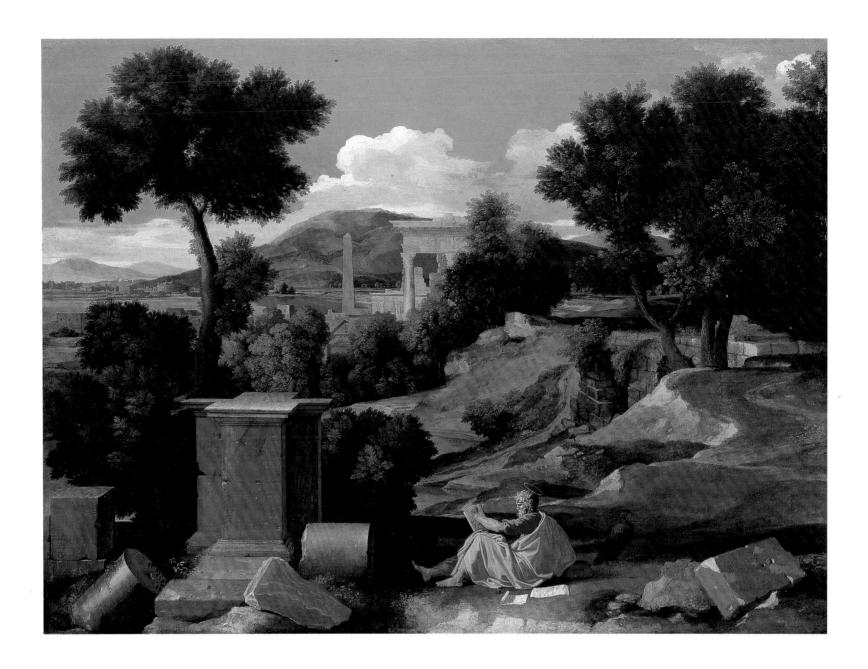

NICOLAS POUSSIN

French, 1594-1665

Landscape with Saint John on Patmos, 1640

Oil on canvas 100.3 × 136.4 cm (39 ½ × 53 5/8 in.) A. A. Munger Collection, 1930.500

The art of Nicolas Poussin, more than that of any other seventeenth-century artist, has come to be regarded as synonymous with the notion of classicism. Although French in origin and training, Poussin spent almost his entire career in Rome painting calm, legible works for a group of highly cultivated connoisseurs.

Landscape with Saint John on Patmos formed a pair with Landscape with Saint Matthew (Berlin, Gemäldegalerie), and was possibly part of a projected series on the four evangelists. In these and other works, Poussin carefully constructed an idealized landscape, reshaping and adjusting natural and man-made forms according to geometric principles, and arranging them parallel to the picture plane to reinforce the measured order of the scene. Saint John the Evangelist was thought to be the youngest of Christ's twelve disciples and

to have retired to the Greek island of Patmos toward the end of his life. In addition to writing one of the four Gospels, he was the author of the visionary Book of Revelation. Here the aged saint, identified by his attribute of an eagle, is seated in a serene and solemn landscape, replete with references to Greco-Roman civilization, including an obelisk, a temple, and column fragments. These are signs of the importance of the ancient world in which the new faith took root. For Poussin and his friends and patrons, Christianity and the principles of stoic philosophy were linked, making order and calm, as in this landscape, into guiding principles.

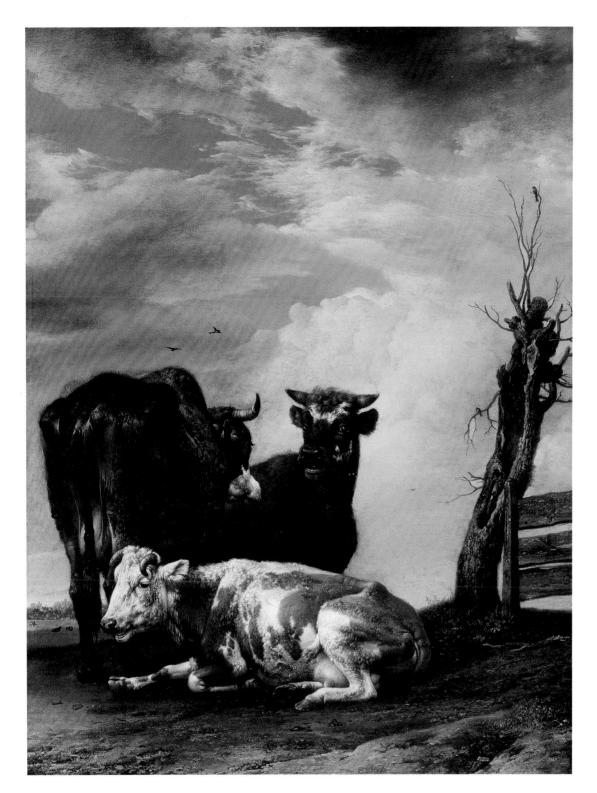

PAULUS POTTER

Dutch, 1625-1654

Two Cows and a Young Bull beside a Fence in a Meadow, 1647

Oil on panel

 49.5×37.2 cm $(19^{1/2} \times 14^{3/4}$ in.)

In loving memory of Harold T. Martin from Eloise W. Martin, wife, and Joyce Martin Brown, daughter; Charles H. and Mary F. S. Worcester Collection; Lacy Armour Endowment; through prior gift of Frank H. and Louise B. Woods, 1997.336

In a career of less than ten years, Paulus Potter produced a range of exquisitely finished works in the narrow field in which he specialized—the painting of animals, especially cattle, in pastoral settings. In 1647, when he was barely out of his teens, Potter executed twelve outstanding paintings, including his masterpiece, the life-size *Young Bull* (The Hague, Mauritshuis), and the Art Institute's *Two Cows and a Young Bull beside a Fence in a Meadow*.

This small, beautifully preserved panel reveals Potter's powers of observation and his masterful technique. The artist meticulously rendered the texture of the animals' hides and such details as their bulging eyes. To emphasize the splendid livestock, he reduced the landscape to a tiny vignette in the left corner, while the dramatic windswept sky conveys the moist atmosphere of the Dutch countryside. Potter's highly finished pictures were much sought after by the Dutch elite, who valued the life of the country gentleman. A bucolic scene such as this, in which the alert, young bull seems to assert his claim to the light-colored cow lying languidly in the foreground, would appeal to the collectors' pride in the land, while also making playful reference to the more formal conventions of the history and genre painting they acquired. The dynamic grouping of the animals, conveying an almost human interconnection, was no doubt intended to delight and amuse Potter's patrons.

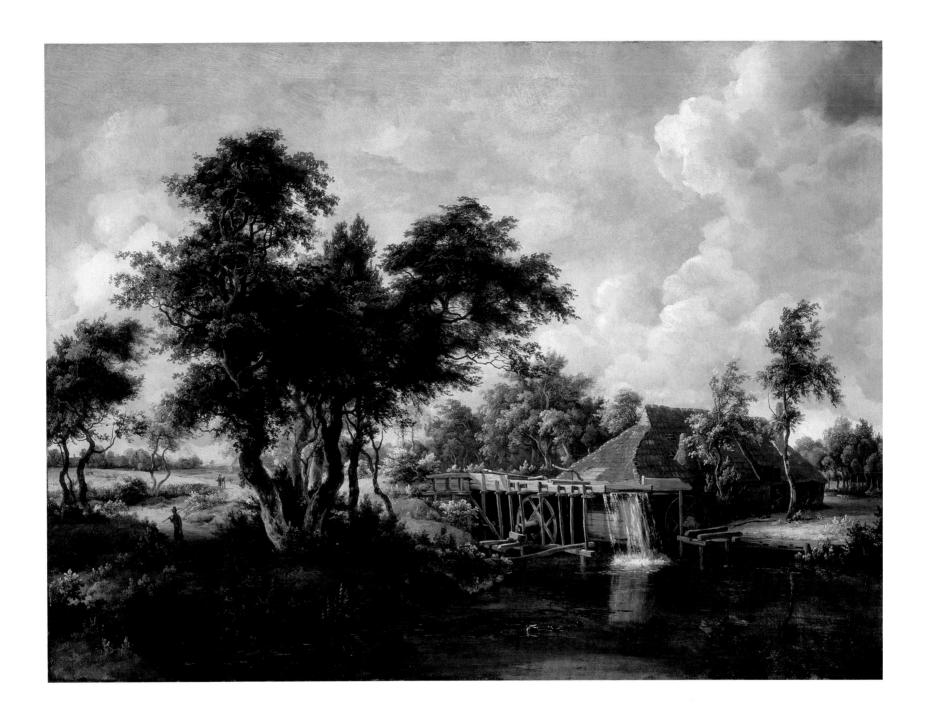

MEINDERT HOBBEMA

Dutch, 1638-1709

The Watermill with the Great Red Roof, 1662/65 Oil on canvas 81.3×110 cm $(32 \times 43^{1/4}$ in.) Gift of Mr. and Mrs. Frank G. Logan, 1894.1031

The seventeenth century was a period of extraordinary artistic production in the Netherlands, both in terms of the number

of painters working and the level of quality they achieved. The dunes, waterways, forests, and fields of Holland, as well as more exotic Scandinavian mountains and Italian hills, furnished subjects for a wealth of often highly specialized landscape painters. Meindert Hobbema focused almost exclusively on woodland scenes, painting them with a breadth and grandeur that are characteristic of Dutch art in general at mid-century and with a serenity and openness that are his own, distinct contribution.

The Watermill with the Great Red Roof is

among the artist's finest works. It treats one of his favorite subjects, a picturesque and somewhat dilapidated mill in a wooded setting. The composition is anchored by the still expanse of pond in the foreground and by the dappled sunlight that plays across the fine spray of water over the mill, silhouettes the trees, and draws the viewer's eye back along the twisting path into the distance at the left. The dominant silver tonality and the lively, almost decorative, treatment of leaves and tree trunks are characteristic of Hobbema's art.

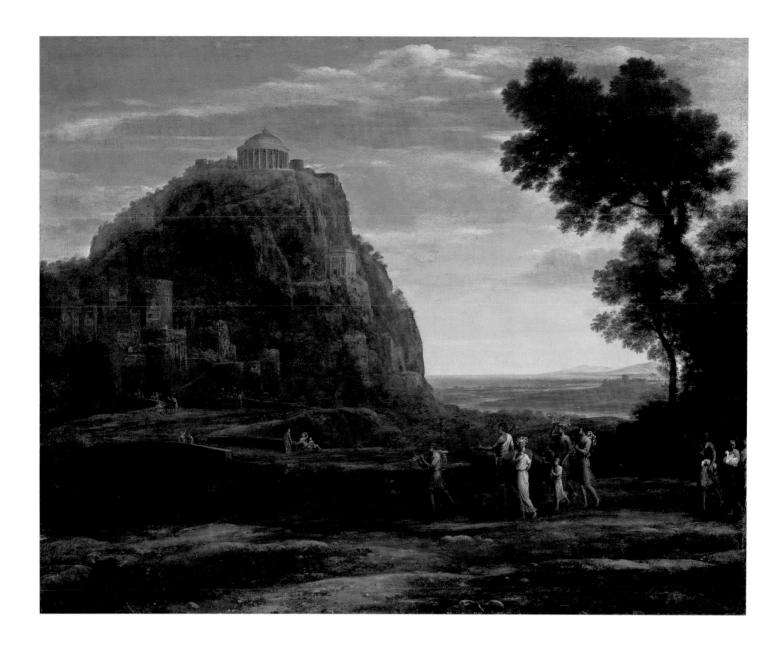

CLAUDE LORRAIN (CLAUDE GELLÉE)

French, 1600–1682

View of Delphi with a Procession, 1673
Oil on canvas
101.6 × 127 cm (40 × 50 in.)
Robert A. Waller Memorial Fund, 1941.1020

Although Claude Gellée was a native of the duchy of Lorraine in present-day France, it was in Rome that he earned his reputation as the greatest classical landscape painter of his time. A learned clientele of aristocrats and clerics, largely from France and his adopted city of

Rome, was eager to acquire his poetic, idealized depictions of landscape.

In keeping with Claude's frequent practice, View of Delphi with a Procession was intended as one of a pair of landscapes, along with Coast View with Perseus and the Origins of Coral (England, private collection). The pair was commissioned by the erudite Cardinal Carlo Camillo Massimi and may have hung with another pair, which Massimi had ordered earlier from Claude. While the links between Claude's paired paintings often remain mysterious, they share a quiet balance of cool and warm light and the motif of grand trees serenely framing distant views.

Claude often introduced biblical, literary, or mythological subjects into his landscapes. Here the fanciful depiction of the ancient Greek city of Delphi and the site of its famous oracle are based on the descriptions of the third-century Roman historian Marcus Justinus. In the foreground, a procession of priests leads a sacrificial bull to the oracle with somber dignity. Suffusing this idyllic vision is a remarkable, limpid illumination, an effect refined by the artist from his lifelong study of the *campagna*, the countryside around Rome. The light unifies the composition, producing an ethereal continuity of space that harmonizes with the delicate, attenuated figures characteristic of Claude's late style.

GIOVANNI BATTISTA PIAZZETTA

Italian, 1682-1754

Pastoral Scene, 1740

Oil on canvas $191.8\times143~cm~(75^{-1/2}\times56^{-1/4}~in.)$ Charles H. and Mary F. S. Worcester Collection, 1937.68

The Venetian Giovanni Battista Piazzetta's dark colors and brooding, shadowy figures are a continuation of Baroque sensibility rather than an expression of the Rococo taste for chromatic brilliance and light, airy compositions. Pastoral Scene and its companion piece, Figures on the Shore (Cologne, Wallraf-Richartz Museum), are unusual among Piazzetta's scenes of everyday life in their scale and complexity. Both were commissioned by the avid collector Marshal von der Schulenburg. The enigmatic interaction of the figures, their melancholy demeanor, and the unusually large size of both paintings suggest a more serious intent than the representation of rustic life: Why do the two male figures behind the rock whisper together? Why does the young woman, her arm outstretched and her dress slipping enticingly from her shoulder, seem to engage the viewer so wistfully? And what is the meaning of the half-nude child and dogs chasing a duck? The possibility of a deeper meaning has been frequently and inconclusively debated. Pastoral Scene appears to be an image of amorous dalliance. Whether it has a larger meaning as a poetic allegory or a form of social commentary is still unclear.

Interestingly, when Piazzetta himself prepared the inventory of von der Schulenburg's collection in 1741, he discussed this painting by describing the disposition of the figures, which suggests that, if he intended any more elaborate meanings, he wished them to be subjective and allusive. Nevertheless, *Pastoral Scene* and its pendant are among the most commanding and evocative of Piazzetta's works.

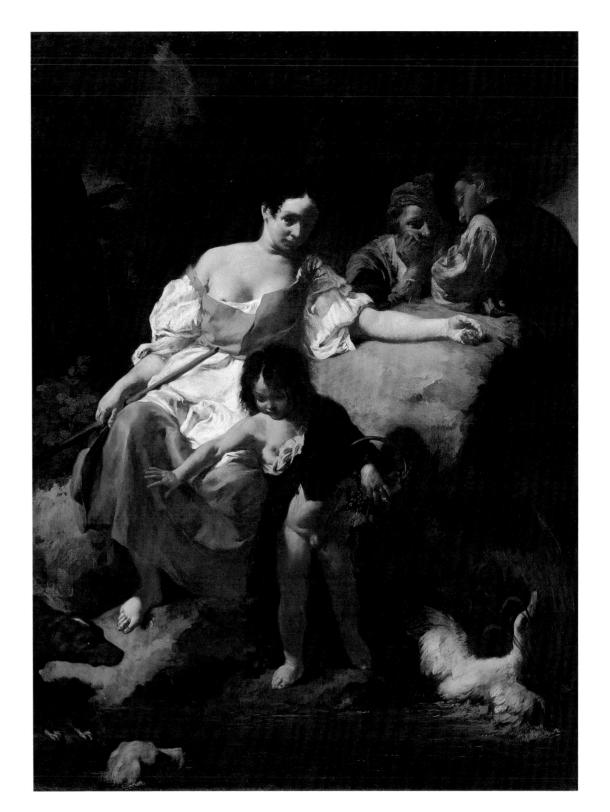

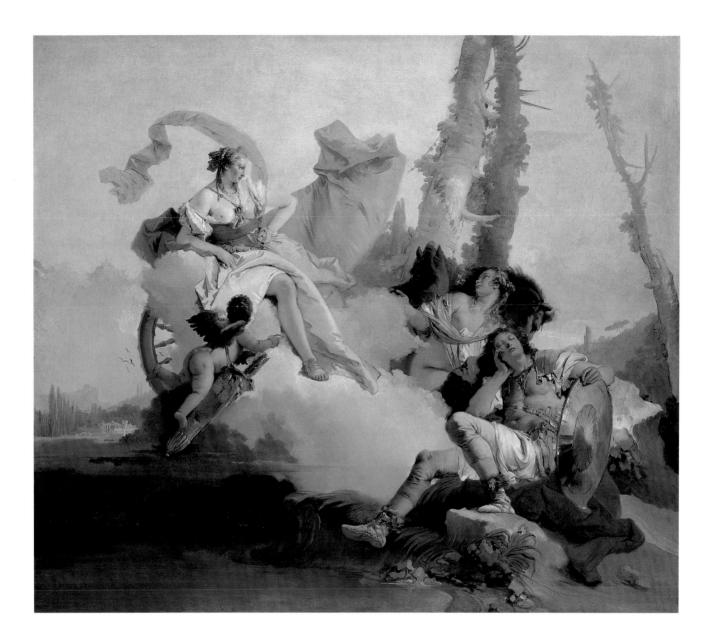

GIOVANNI BATTISTA TIEPOLO

Italian, 1696-1770

Rinaldo Enchanted by Armida, 1742/45 Oil on canvas $187.5 \times 216.8 \text{ cm} (73^{-13}/_{16} \times 85^{-3}/_{8} \text{ in.})$ Bequest of James Deering, 1925.700

Giovanni Battista Tiepolo was one of the eighteenth century's greatest artists. His high-keyed palette, virtuoso drawing, speed and spontaneity of execution, along with his mastery of perspective and illusionism, were perfectly suited to the large-scale architectural spaces he decorated in

rapid succession in Italy, Germany, and Spain.

The Art Institute's suite of four canvases relating the story of Rinaldo and Armida exemplifies the exuberant style Tiepolo had evolved by the 1740s. These four canvases were the main narrative components of a pictorial ensemble that once decorated a salon, designated as a cabinet of mirrors, in a Venetian palace belonging to the powerful Cornaro family. In the first canvas of the narrative, illustrated here, Rinaldo, the hero of Tasso's epic poem *Gerusalemme liberata (Jerusalem Liberated)* (1581), is diverted by the beautiful sorceress Armida from the crusade to take back the Holy Land from the infidels. In this imaginative version of the seduction,

Armida, suspended on a billowing cloud, happens upon the sleeping crusader, her shawl and drapery wafting behind her, as if a gentle wind had blown this mirage to Rinaldo. The painting's luminous, airy atmosphere is created by a vast, open expanse of sky and scenery behind the protagonists. The complex and elaborate arrangement of figures, draperies, and clouds, and the gentle diagonals of the trees, landscape, and other details further animate the composition. Thick, creamy paint surfaces enhance the extraordinary pictorial beauty of this magical, pastoral world. With seemingly effortless facility, Tiepolo achieved here one of his most poetic works.

FRANÇOIS BOUCHER

French, 1703-1770

Are They Thinking about the Grape?, 1747

Oil on canvas $80.8 \times 68.5 \text{ cm } (31^{-3}/4 \times 27 \text{ in.})$ Martha E. Leverone Endowment, 1973.304

No art epitomizes the light-hearted sensuality, fancifulness, and grace of the Rococo style better that that of François Boucher. The nineteenthcentury critics the Goncourt brothers described him as "one of those men who typify the tastes of a century, who express it, personify it, and incarnate it." In a period that valued decorative ensembles and encouraged artists to design for many media, Boucher worked with an eye to every branch of the decorative arts and painting. Championed by Madame de Pompadour, mistress of Louis XV (r. 1715-74), he became first painter to the king in 1765. His sure sense of design and ability to use color, texture, and linear rhythms to create images of a pleasing world somewhere between fantasy and reality endeared him to his sophisticated patrons.

Are They Thinking about the Grape? was inspired by a contemporary pantomime (Boucher had a close association with the theater, working frequently as a set and costume designer). In this stage piece, the love of a shepherd and shepherdess overcomes the small obstacles of life. Boucher showed them feeding each other grapes as the shepherd gazes ardently at his beloved. The tongue-in-cheek title underscores the gentle voluptuousness of the scene. While the arrangement of the landscape elements may appear contrived, the animals more toylike than realistic, the figures too opulently dressed and aristocratic in their gestures for their humble origins, this rustic genre pioneered by Boucher resonated with the patrons of his day. Included along with a probable pendant (The Flageolet Player; Belgium, private collection) in the 1747 Salon, the official exhibition of the French Academy, this popular bucolic fantasy was reproduced in an engraving and a tapestry.

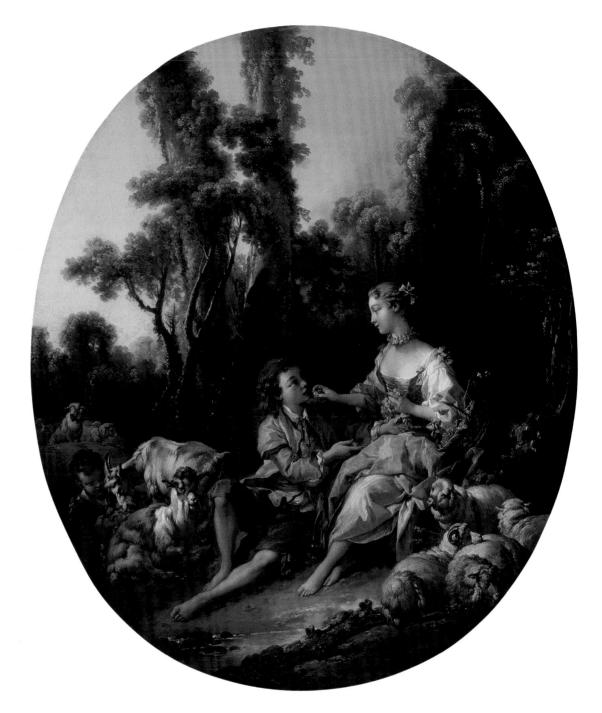

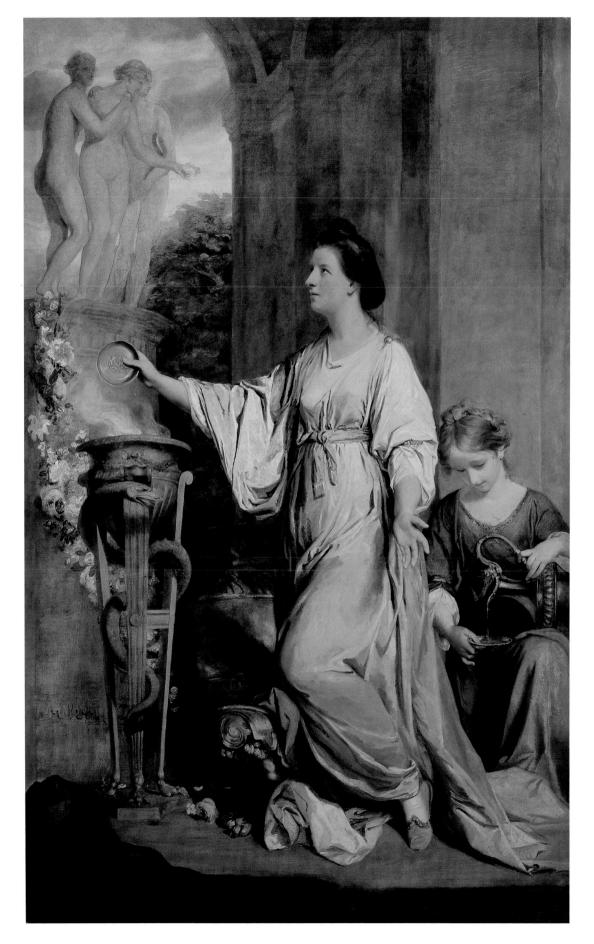

SIR JOSHUA REYNOLDS

English, 1723-1792

Lady Sarah Bunbury Sacrificing to the Graces, 1763–65
Oil on canvas

 $242.6 \times 151.5 \text{ cm} (95^{-1}/2 \times 59^{-3}/4 \text{ in.})$

Mr. and Mrs. W. W. Kimball Collection, 1922.4468

With its subject dressed in a loose, vaguely Greek or Roman costume and surrounded by architecture, sculpture, and artifacts of antiquity, Lady Sarah Bunbury Sacrificing to the Graces was the grandest expression to date of Joshua Reynolds's full-length, classically inspired portraits. The artist cast Lady Sarah here as a priestess of the Three Graces, mythical followers of the goddess Venus who symbolized the blessings of generosity—both the giving and receiving of gifts. They are normally represented with the central Grace turned away from her companions, but Reynolds showed them all facing Lady Sarah and returning her sacrifice with their own tribute to her: a wreath. It is as if the sculpture has miraculously come to life and the Graces themselves, recognizing the beauty and good nature of Lady Sarah, are inviting her to join them.

Although only eighteen when this portrait was begun and twenty when it was finished, Lady Sarah was already a famous aristocratic beauty. The young King George III (r. 1760– 1820) had fallen in love with her, but political considerations had prevented him from taking her as his queen. Her marriage, the year before this portrait, to Sir Charles Bunbury, a baronet, was to end in divorce after she had a love affair with her cousin Lord William Gordon, eloped with him, and bore his child. At the age of thirtysix, she married Colonel George Napier and had another eight children. About her zest for life, one contemporary remarked that she "never did sacrifice to the Graces; her face was gloriously handsome, but she used to play cricket and eat beefsteaks on the Steyne at Brighton."

JEAN-HONORÉ FRAGONARD

French, 1732-1806

Portrait of a Man, 1768/70

Oil on canvas $80.3 \times 64.7 \text{ cm } (31^{-5/8} \times 25^{-1/2} \text{ in.})$ Gift of Mary and Leigh Block in honor of John Maxon, 1977.123

One of the most brilliant eighteenth-century French artists, Jean-Honoré Fragonard painted mythological subjects, sweeping landscapes, and witty scenes of everyday life among the privileged as well as the humble. His paintings rarely attained the degree of finish then deemed appropriate for a carefully prepared and executed work. Instead, he applied his pigment richly and impetuously, so that his compositions often have the character of quick sketches.

Portrait of a Man belongs to a series of fantasy portraits that, in many ways, summarizes Fragonard's highly personal art. He executed these images in rapid, virtuoso strokes—two carried a declaration that they were painted in an hour. While a few of the sitters can be identified as Fragonard's patrons and friends, their features are never very specific. They are treated not only as portraits, but also as vibrant types—an old soldier, a coquette, a singer. The seventeenthcentury costumes reflect Fragonard's fascination with earlier painting and his appropriation of the style and subjects of his great predecessors, notably Peter Paul Rubens (see p. 27). In fact, in Portrait of a Man (which used to be called Don Quixote, without basis), the sitter's beard and mustache and the striped garment with extended shoulders relate to the fashions of the early Baroque period. The restricted color range gives added force to the man's head, silhouetted against a luminous background. His large, worldweary eyes dominate the image and, in their stillness, contrast poignantly with the undulating contours of his costume.

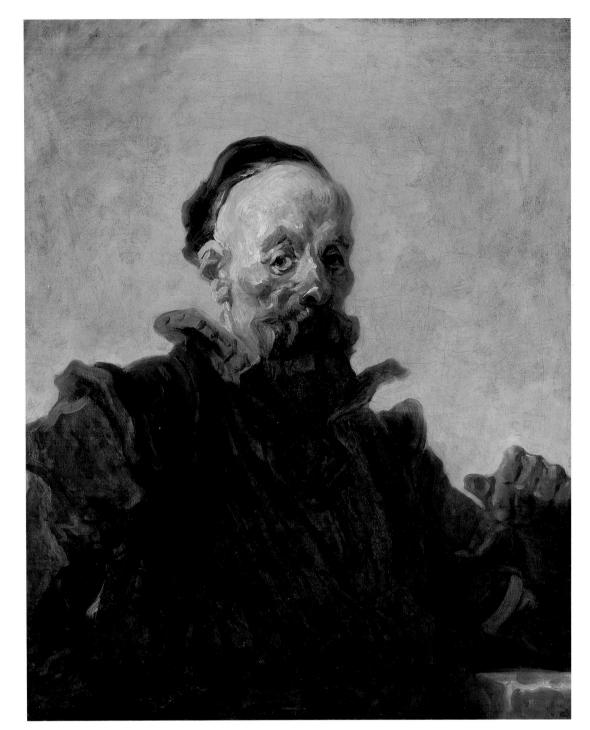

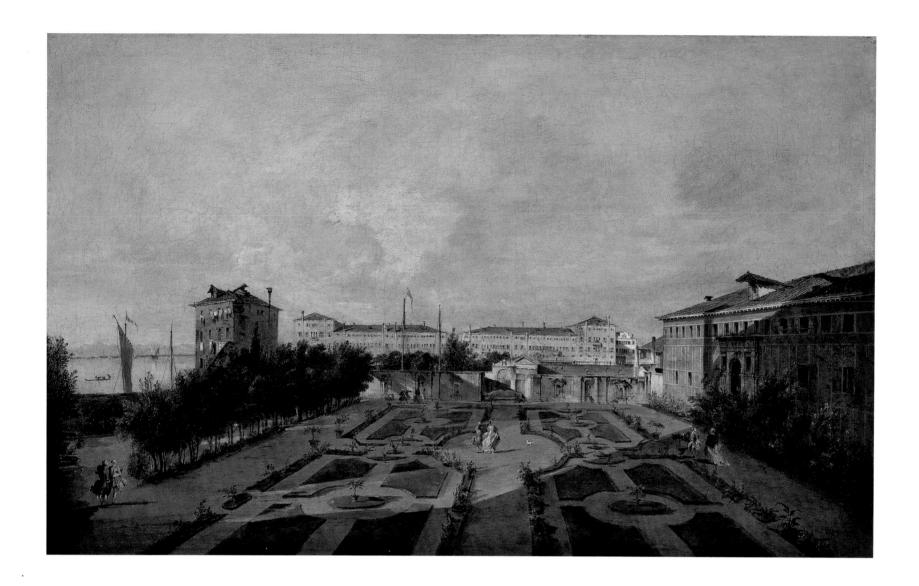

FRANCESCO GUARDI

Italian, 1712-1793

The Garden of the Palazzo Contarini dal Zaffo, Venice, late 1770s

Oil on canvas 48 x 78 cm (19 x 30 ⁵/s in.) Gift of Marion and Max Ascoli Fund, 1991.112 A member of a family of painters in Venice, Francesco Guardi is renowned for his spirited views of the most recognizable monuments of this picturesque city and for his architectural fantasies or *capricci*. Wealthy travelers making the Grand Tour of Europe, which was considered essential to an upper-class education, provided an important market for such views. In this case, however, the patron was not a foreigner passing through Venice, but John Strange, who lived in the city on the lagoon as the British "resident" or representative.

This view of the garden of a private house in Venice is highly unusual for Guardi. On the right is the back of the Palazzo Contarini dal Zaffo, not the front, which faces on the Grand Canal. For the artist's main subject here is the palace's formal garden, a luxury in Venice's

crowded urban environment. Elegant couples stroll through the garden's geometric parterres. Guardi's attention to the play of light further animates the scene—a shadow cast by an unseen building in the foreground divides the composition and contrasts with the bright light reflected off the façade of the residence and distant, shimmering lagoon on the left.

These observations of light and place probably reflect the aesthetic interests of John Strange, who commissioned the painting from Guardi as one of a set of four remarkably original views. Two of the four paintings show Strange's own villa on the mainland, and all share the same festive domesticity. What connection Strange may have had to the Palazzo Contarini dal Zaffo is unclear.

FRANCISCO JOSÉ DE GOYA Y LUCIENTES

Spanish, 1746-1828

Boy on a Ram, 1786/87

Oil on canvas 127.2 × 112.1 cm (50 ½16 × 44 ½8 in.) Gift of Mr. and Mrs. Brooks McCormick, 1979.479

Francisco Goya had just been appointed painter to Charles III of Spain (r. 1786–88) in 1786 when he was asked to produce a series of designs for tapestries to decorate the dining room of the Palacio del Pardo. Goya's full-scale paintings, called cartoons, served as the models from which weavers made the final tapestries. The tapestry based on *Boy on a Ram* hung over a door, as part of a series with other, larger decorations featuring the activities of each of the four seasons.

The series for the dining room at the Palacio del Pardo was one of three major commissions to design tapestries that Goya received between the mid-1770s and the early 1790s. Executed strictly for the weavers at the royal tapestry factory at Santa Barbara, these painted scenes of eighteenth-century popular life were not intended for public viewing. They stayed in the possession of the royal tapestry factory, until most of them passed into the Museo del Prado, Madrid, where they remain to this day. Goya's tapestry designs show the evolution of his acute powers of observation of daily life and his bold technique, qualities that he would shortly develop even further under the stress of war and insurrection, when Napoleon briefly made Spain part of his empire.

This charming depiction of a boy implies the potential of youth, while his whimsical mount may refer to the zodiacal sign of Aries, the ram, associated with spring. Exuding the lighthearted gaiety of the Rococo era, this painting also exhibits Goya's highly original style and technique. With an unerring eye and active, flickering brushwork, the artist imbued his fanciful image of an elegantly dressed child with a sense of vitality and light.

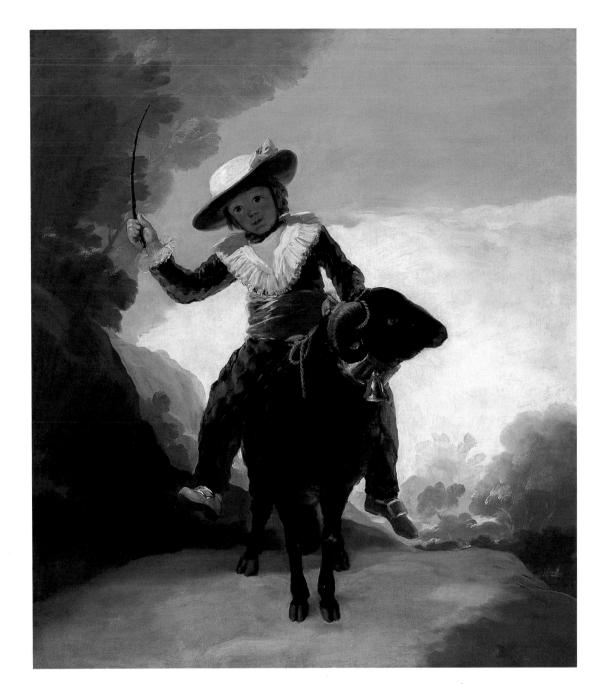

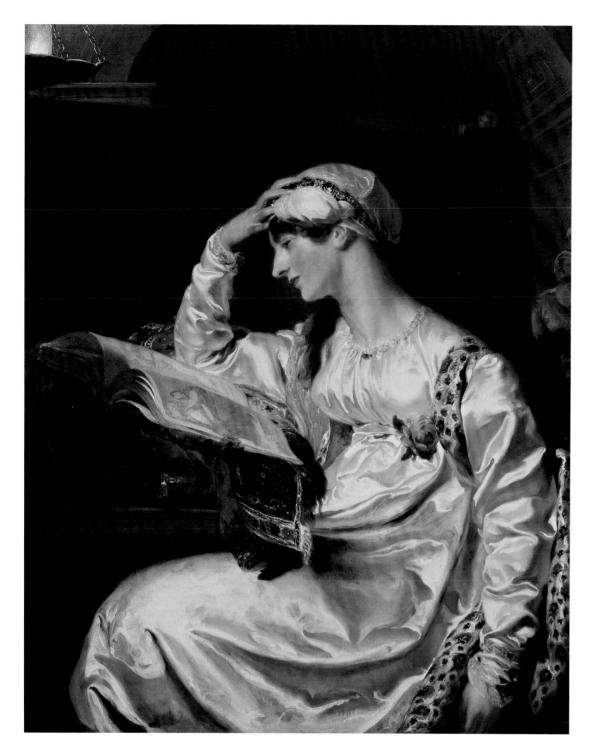

SIR THOMAS LAWRENCE

English, 1769-1830

Mrs. Jens Wolff, 1803, 1814-15

Oil on canvas

 128.2×102.4 cm (50 $^{1}/_{2} \times 40$ $^{5}/_{16}$ in.)

Mr. and Mrs. W. W. Kimball Collection, 1922.4461

Deep in thought, their costumes brilliant with sheens and glints, the sitters in Thomas Lawrence's paintings are the very image of Romantic heroes and heroines. Lawrence was well acquainted with Isabella Wolff, the subject of this portrait, and was rumored to have had a love affair with her. When he began this painting, she was living near London with her husband, a wealthy Anglo-Danish timber merchant and ship broker. But the work was left unfinished in the studio for over ten years, and, by the time the artist took it up again, in 1814, the couple had separated and Mrs. Wolff was living with one of her sisters in a village in Kent.

In this portrait, Wolff contemplates the figure of the Delphic Sibyl from the Sistine Chapel ceiling in a book of engravings after Michelangelo, and her pose ingeniously echoes that of another Sibyl in the same work. The Sibyls were priestesses of classical legend who made enigmatic judgments and prophecies. They are often depicted in exotic costumes and settings, a tradition Lawrence followed in the turban, shawl, and Asian textile on the desk. Over the sitter's shoulder, we glimpse another noble figure of the ancient world: Niobe, who turned to stone bewailing the loss of her children (here Lawrence invoked the famous classical sculpture of this tragic figure in the Museo degli Uffizi, Florence). The artist's intention was clearly to represent Mrs. Wolff as a present-day embodiment of the feminine ideal celebrated in classical and Renaissance art.

JEAN-AUGUSTE-DOMINIQUE INGRES

French, 1780-1867

ments, 1971.452

to classical ideals.

Amédée-David, Comte de Pastoret, 1823-26

Oil on canvas 103×83.5 cm $(40^{-1}/2 \times 32^{-3}/4$ in.) Estate of Dorothy Eckhart Williams; Robert Allerton, Bertha E. Brown, and Major Acquisitions endow-

The aesthetic competition between the two painters who dominated French art in the first half of the nineteenth century is one of the legends of art history: Eugène Delacroix (see p. 44), the great Romantic whose canvases are celebrations of color, movement, and passion, rivaled Jean-Auguste-Dominique Ingres, master of the eloquent line, whose exacting eye and love of precise, measured details indicated his devotion

Ingres preferred to think of himself as a painter of epic moments in history and of the heroes and stories of the Bible and classical mythology. Yet, for many years, the artist's livelihood came from his portraits, whether paintings or drawings, and it is these works that account for the great esteem in which he is held today. The young count Amédée-David, who later was to assume his father's position as Marquis de Pastoret, is believed to have assisted Ingres in becoming a member of the French Academy. From the nobleman's elegant silhouette to the precisely rendered details of his sword hilt and medal of the Legion of Honor, everything about Ingres's portrait indicates the fastidiousness and sensitivity to detail that characterize his art. The count's slightly swaggering pose, elegant costume, long fingers, and even the tilt of his head proclaim his aristocratic status, along with something of the arrogance of his personality. The accompanying objects—expensive kid gloves, gold and enameled snuff box, bicorne hat—further reinforce the sitter's presentation of himself as a distinguished member of the upper class.

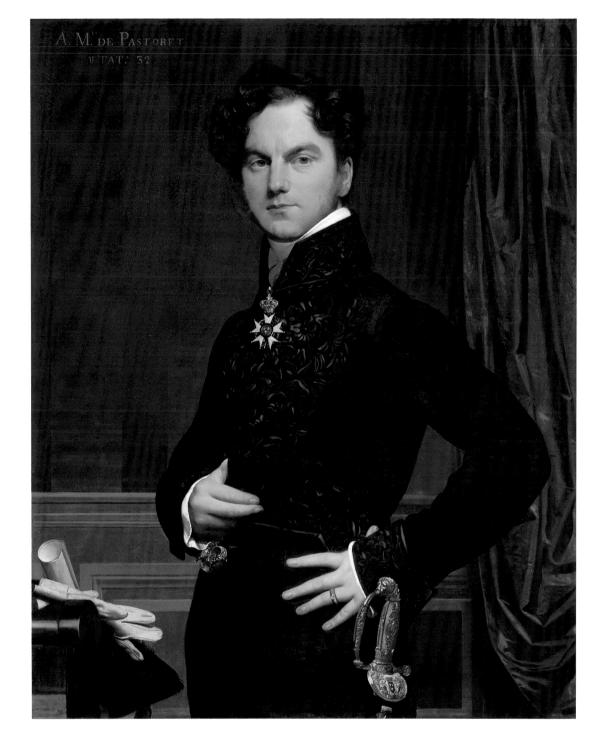

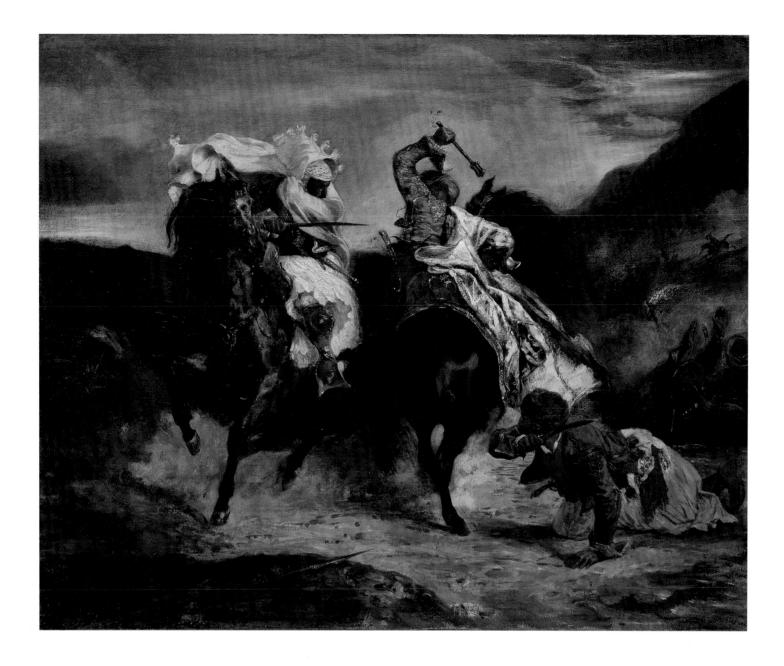

EUGÈNE DELACROIX

French, 1798-1863

The Combat of the Giaour and Hassan, 1826

Oil on canvas

 59.6×73.4 cm $(23^{1}/2 \times 28^{7}/8$ in.)

Gift of Bertha Palmer Thorne, Mrs. Rose Movius Palmer, Mr. and Mrs. Arthur M. Wood, Mr. and Mrs. Gordon Palmer, 1962.966 Admiration for Lord Byron's poem "The Giaour" (written in 1813 and translated into French in 1824) inspired the Romantic painter Eugène Delacroix to interpret visually its themes of adventure and love. In *The Combat of the Giaour and Hassan*, he depicted the dramatic climax of the story related in Byron's poem: a Venetian known as the "Giaour" (a Turkish word for Christian infidel or non-Muslim) seeks to avenge his mistress' death at the hands of a Turk called Hassan, from whose harem she had fled. Set on a Greek battlefield, the painting focuses on the two men, mounted on spirited horses, facing each other in mirror-image poses,

their weapons raised. Delacroix executed the Art Institute's painting, one of two versions of the subject based on Byron's poem, two years after the writer died fighting for Greek independence from the Turks. It was first shown in Paris in 1827 at an exhibition to benefit the Greek cause.

The vigorous interaction of glowing colors, forms in motion, and dramatic subject are characteristic of Delacroix's art. The numerous Greek and Turkish battle scenes he executed in his early years represent not only his identification with the Greek war of liberation, but also his lifelong preoccupation with exotic lands and themes of passion.

CARL BLECHEN

German, 1798-1840

The Interior of the Palm House on the Pfaueninsel near Potsdam, 1834

Oil on canvas

 135×126 cm $(52^{1/2} \times 50$ in.)

Through prior acquisitions of the George F. Harding Collection; L. L. and A. S. Coburn and Alexander A. McKay endowments; through prior gift of William Wood Prince; through prior acquisitions of the Charles H. and Mary F. S. Worcester Collection, 1996.388

The short career of Carl Blechen, a pivotal figure in nineteenth-century German painting, marked the transition from Romanticism to a more realistic view of nature. Inspired in part by his encounter with the Italian landscape and light during a trip he made around 1828 or 1829, Blechen developed a fluid technique that enabled him to capture fleeting atmospheric effects. He often used his brilliantly observed landscapes as settings for exotic or mysterious figures, reflecting his early contact with Romantic painting and theater.

A commission from Friedrich Wilhelm III of Prussia (r. 1797–1840) to execute two views of an exotic pleasure building recently constructed near Potsdam constituted a major opportunity for the young artist. After completing a pair of exquisite small paintings for the king, Blechen made this single, grand version for public viewing. The Interior of the Palm House of the Pfaueninsel near Potsdam was to be one of his most ambitious statements. Unfortunately, soon after, he succumbed to melancholy and madness.

The architect Karl Friedrich Schinkel designed the Palm House to contain the king's collection of palms. It was situated on the Pfaueninsel, or Peacock Island, a favorite royal retreat dotted with whimsical buildings such as a tiny castle and a Gothic-style dairy. Blechen's painting is both a record of the appearance of the building, with its lush palms and fragments of an Indian temple, and an evocation of a fantasy world peopled by beautiful Asian women.

JOHN CONSTABLE

English, 1776-1837

Stoke-by-Nayland, 1836

Oil on canvas $126\times169~cm~(49~^5/8\times66~^1/2~in.)$ Mr. and Mrs. W. W. Kimball Collection, 1922.4453

Even after spending many years in London, John Constable continued to portray the countryside dear to him from boyhood. Stoke-by-Nayland lies a few miles from his native village of East Bergholt in Suffolk. In this view, the brilliant,

airy vista toward the village contrasts with the shady, tunnel-like country lane leading off to the right. Constable explained that the time is meant to be an early summer morning, with the earth still dewy and damp from a light rain shower during the night. To suggest the fertility of the land, the artist emphasized the abundance of water, flecking the surface with white highlights to create effects of sparkling wetness. Here the whole scene appears moist, with a stream and puddles in the foreground and a central tree that droops from the weight of rain water.

Painted as much with a palette knife as with brushes, *Stoke-by-Nayland* lacks the finish

that Constable gave the pictures he exhibited publicly. It was either simply left unfinished or meant as a full-scale sketch for a work that he never realized. His delight in freely scribbling and scraping the image into existence is obvious. What is lost in detail is gained in atmosphere and the sense of the changeability of weather. The roughness of the surface evokes the textures of nature, and the fusion of manmade and natural elements in the scene embodies an ideal of harmony indicative of Constable's vision of rural England.

JOSEPH MALLORD WILLIAM TURNER

English, 1775-1851

Fishing Boats with Hucksters Bargaining for Fish, 1837/38

Oil on canvas $174.5\times224.9~cm~(68~^3/_4\times88~^1/_2~in.)$ Mr. and Mrs. W. W. Kimball Collection, 1922.4472

In Fishing Boats with Hucksters Bargaining for Fish, Joseph Mallord William Turner pursued a theme of long-standing personal interest: the sea. Beginning in the 1790s with scenes of

moonlight reflected in water, Turner moved on to depicting boats tossed by raging waters, as well as dramatic marine sunrises and sunsets.

On board the large vessel with billowing sails at the left are a number of roughly painted figures of fishermen, who presumably will do business with a figure (a huckster) who stands in a small boat to the right and gestures with an upraised arm. With these few details, the "bargaining for fish" takes place, in the presence of an ominous sky. The low horizon line, as well as the subject itself, derives from the artist's exposure during his formative years to seventeenth-century Dutch sea paintings. *Fishing*

Boats with Hucksters Bargaining for Fish dates from an important transitional phase of Turner's style in the mid-1830s, when he was increasingly absorbed in rendering dramatic effects of atmosphere and light.

In a small, yet not insignificant, detail, Turner alluded to the arrival of a new era at sea. Plying the calmer waters of the distant horizon is a steam-driven vessel, emitting a trail of dark smoke. Thus Turner appears to have achieved two notable results in *Fishing Boats*: he subtly commented upon the opposing currents of tradition and progress, while celebrating the moods and vicissitudes of nature.

GUSTAVE COURBET

French, 1819-1877

Mère Grégoire, 1855-59

Oil on canvas 129 × 97.5 cm (50 ³/₄ × 38 ³/₈ in.) Wilson L. Mead Fund, 1930.78

As the undisputed leader of the Realist movement, Gustave Courbet played a crucial role in the development of modern French painting. However, critics and the public did not easily accept his large, naturalistic, and unsentimental depictions of commonplace, often rural subjects; they called him the "apostle of ugliness."

The ample, demurely dressed subject of *Mère Grégoire* was inspired by the heroine of a popular song written in the 1820s by French lyricist Pierre-Jean Béranger. Béranger often penned ribald lyrics; his "Madame Grégoire" was the proprietor of a house of prostitution. Courbet depicted the woman here in the midst of a transaction, with coins scattered on a marble-topped counter and a ledger beneath her right hand. Under her other hand is the small bell she uses to summon one of her female employees. She presumably offers an unseen customer a flower, a symbol of love.

The painting may also have had a political subtext. Béranger and Courbet were fierce opponents of the monarchy and the Second Empire, respectively. In the mid-1850s, when Courbet began his portrait of Mère Grégoire, the government harshly attacked the songs of the popular writer as part of an effort to restrict free expression. Courbet's decision to portray Béranger's "Madame Grégoire," whose flower exhibits the red, white, and blue of the French flag, may represent a protest not only against government censorship, but also against the Second Empire itself, making the subject of this painting into a heroine for embodying the rights to freedom in life and love that were forbidden under a repressive regime.

ÉDOUARD MANET

French, 1832-1883

Jesus Mocked by the Soldiers, 1865

Oil on canvas 190.8 \times 148.3 cm (74 7 /s \times 58 3 /s in.) Gift of James Deering, 1925.703

Throughout his career, Édouard Manet managed to shock and confound the public with his bold technique and unorthodox approach to subject matter. The most startling feature of his great religious composition Jesus Mocked by the Soldiers is that is was painted at all. After the advent of the Realist movement in earlier nineteenth-century French painting, grounded in the here and now, avant-garde artists in France did not pursue religious themes. Yet, while Manet was most certainly a painter of secular subjects-indeed, he was particularly urbane in his themes and lifestyle—he was also interested in the biblical narratives that had compelled artists for many centuries. It is likely that there is a connection between this interest and the popular contemporary biography Vie de Jésus (Life of Jesus) (1863) by French philosopher and historian Joseph-Ernest Renan, a controversial work that emphasizes Christ's humanity.

In this painting, Manet portrayed Jesus as very human and vulnerable by presenting him frontally; by making him seem passive, almost limp; and by surrounding him with rather gruff characters. The canvas's visible brushstrokes and its almost monochromatic tonality create an insistent sense of materiality that further evokes a palpable, unidealized Christ. The work depicts the moment when Jesus's captors mock the "King of the Jews" by crowning him with thorns and covering him with a robe. Although, according to the Gospel story, this taunting is followed by beatings, Manet's would-be tormentors appear ambivalent as they surround the pale, denuded figure. In these ways, Manet managed to present a traditional subject in a contemporary, challenging light.

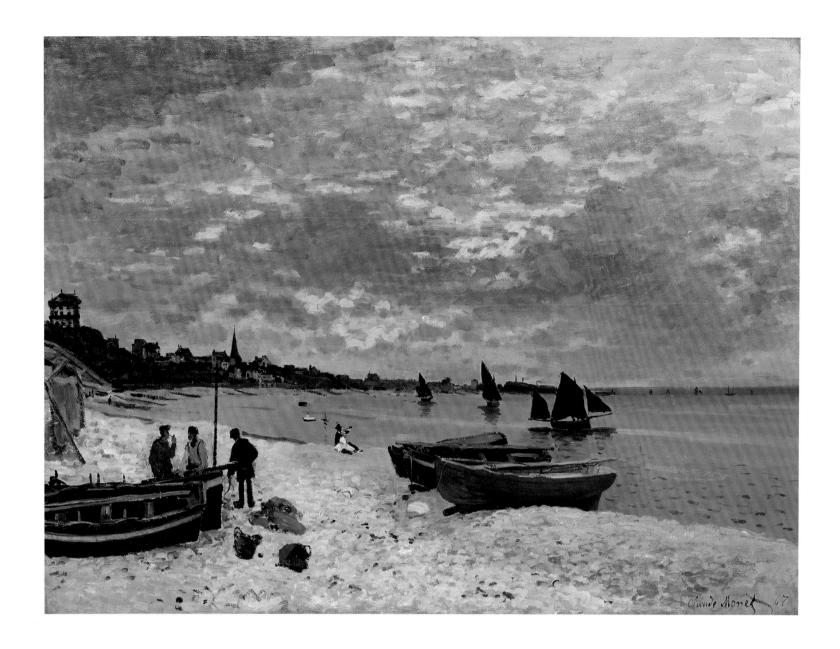

CLAUDE MONET

French, 1840-1926

The Beach at Sainte-Adresse, 1867

Oil on canvas 75.8×102.5 cm (29 $^{13}/_{16} \times 40$ $^{5}/_{16}$ in.) Mr. and Mrs. Lewis Larned Coburn Memorial Collection, 1933.439

The summer of 1867 was a crucial time for Claude Monet. The poor, struggling artist stayed with his aunt at Sainte-Adresse, a well-to-do suburb of the port city of Le Havre near his father's home. The paintings Monet produced

that summer, few of which survive, reveal the beginnings of the revolutionary style that would become known as Impressionism. In his quest to capture the effects of weather and light, Monet painted *The Beach at Sainte-Adresse* out-of-doors on an overcast day. He devoted the majority of the composition to sea, sky, and beach. These he depicted with broad sheets of color, animated by short brushstrokes that articulate gentle, azure waves; soft, white clouds; and pebbled, ivory sand. While fishermen go about their chores, a tiny couple relaxes at the water's edge. Tourism, which had largely "created" Sainte-Adresse, was a popular theme for Monet and many other Impressionists.

Despite its large scale, Monet did not exhibit this work publicly until almost ten years after he completed it. Because of its informal composition, seemingly unfinished character, and straightforward depiction of everyday life, this painting and others like it were frequently rejected by juries for the state-sponsored Salon exhibitions. To combat the official control of artistic standards and sales, Monet banded together with a diverse group of like-minded, avant-garde artists to mount the first of what would be eight independent exhibitions over the years 1874 to 1886. He included *The Beach at Sainte-Adresse* in the second of these unprecedented Impressionist group shows, in 1876.

JEAN-BAPTISTE-CAMILLE COROT

French, 1796-1875

Interrupted Reading, c. 1870

Oil on canvas, mounted on board 92.5 \times 65.1 cm (36 5 /16 \times 25 5 /8 in.) Potter Palmer Collection, 1922.410

Camille Corot devoted his long career to gaining acceptance in France for landscape painting as equal in stature to the traditionally highestranked genres of history, religion, and allegory. In later years, Corot became increasingly interested in showing female figures reading or lost in thought. Interrupted Reading recalls a wellestablished tradition that was especially popular in Romantic art: the reading figure. This motif occurs in other works by Corot, including in his landscapes. The unidentified woman in the Art Institute's painting is pensive, solitary, and melancholic, the very essence of the Romantic sensibility. The inclusion of an open book—which the woman is, for the moment, not reading creates about her an aura of muselike contemplation and meditation.

While the painting's content is traditional, the brushwork is as direct and bold as that of Édouard Manet (see pp. 49 and 57). It is complemented by Corot's obvious love of detail, as seen in the ribbon in the sitter's hair, earrings, and necklace. In this work and in other figural studies, Corot explored the female form as a construction of masses that balance and support one another. Here the curves of the model's upper torso are repeated in the lines of the pleated skirt. A gentle light and harmonized palette of browns and ochers infuse this formal structure with the softness and intimacy that characterize the atmospheric landscapes with which the artist achieved fame.

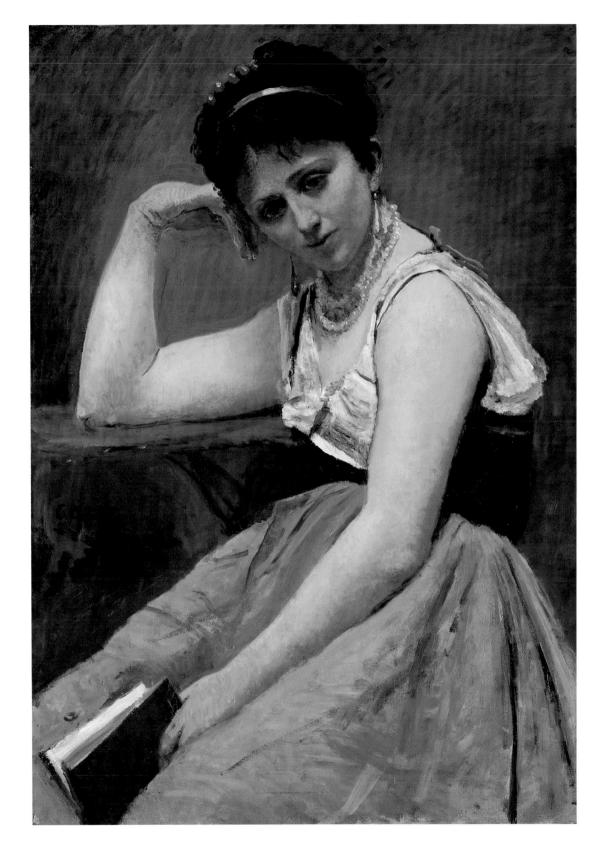

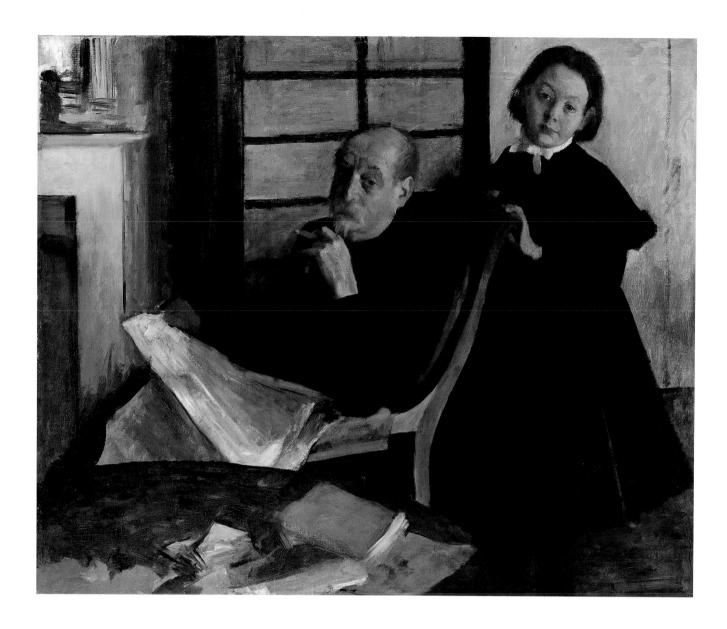

HILAIRE-GERMAIN-EDGAR DEGAS

French, 1834-1917

Henri Degas and His Niece Lucie Degas (The Artist's Uncle and Cousin), 1875/76

Oil on canvas $99.8\times119.9~cm~(39^{1/4}\times47^{3/16}~in.)$ Mr. and Mrs. Lewis Larned Coburn Memorial Collection, 1933.429

Edgar Degas was the most subtle portrait painter in the Impressionist group. His portraits, mostly of family members and close friends, were executed primarily in the period from the late 1850s through the 1870s. During frequent

visits to Florence and Naples, Degas recorded his Italian relatives with great candor. On one of his last trips to Naples, in the mid-1870s, Degas painted this double portrait of his orphaned first cousin, Lucie, and their uncle Henri, in whose care the girl had recently been placed. In this painting, Degas showed two people, separated by many years in age, who are tentatively accepting the circumstances of their new relationship. Degas, having recently lost his own father and witnessed other family misfortunes, addressed subjects such as this with awareness and sensitivity.

Areas of thin paint and unresolved details suggest that the painting was never completed. However, the spare treatment of the background

effectively emphasizes the heads and upper portions of the figures. Their connection is expressed in the similar tilt of their heads and in the black mourning clothes they both wear. But their psychological discomfort is suggested by the contrast of the plain wall behind Lucie and the darker glass-and-wood French door behind Henri, as well as by the curved chair back against which the man sits and on which the girl leans. At once intimate and distant, casual and guarded, these two relatives, and the third relation who paints them from the other side of the paper-laden table, poignantly express the fragility and necessity of family ties.

GUSTAVE MOREAU

French, 1826-1898

Hercules and the Lernaean Hydra, c. 1876 Oil on canvas 179.3×154 cm $(70^{\circ}/_{16} \times 60^{\circ}/_{8}$ in.) Gift of Mrs. Eugene A. Davidson, 1964.231

Gustave Moreau developed a highly personal vision that combined history, myth, mysticism, and a fascination with the exotic and bizarre. Rooted in the Romantic tradition, Moreau focused on the expression of timeless enigmas of human existence rather than on recording or capturing the realities of the material world.

Long fascinated with the myth of Hercules, Moreau gave his fertile imagination full reign in *Hercules and the Lernaean Hydra*. Looming above an almost primordial ooze of brown paint is the seven-headed Hydra, a serpentine monster whose dead and dying victims lie strewn about a swampy ground. Calm and youthful, Hercules stands amid the carnage, weapon in hand, ready to sever the Hydra's seventh, "immortal" head, which he will later bury.

Despite the violence of the subject, the painting seems eerily still, almost frozen. Reinforcing this mysterious quality is Moreau's ability to combine suggestive, painterly passages with obsessive detail. The precision of his draftsmanship and the otherworldliness of his palette are the result of his painstaking methods; he executed numerous preliminary studies for every detail in the composition. In contrast to such exactitude, the artist also made bold, colorful watercolors that eschew detail, as exercises to resolve issues of composition and lighting.

Moreau seems to have intended this mythological painting to express contemporary political concerns. He was profoundly affected by France's humiliating military defeat by the Prussians in 1870–71. Whether or not Hercules literally personifies France and the Hydra represents the Prussians, this monumental work portrays a moral battle between the forces of good and evil, and of light and darkness, with intensity and power.

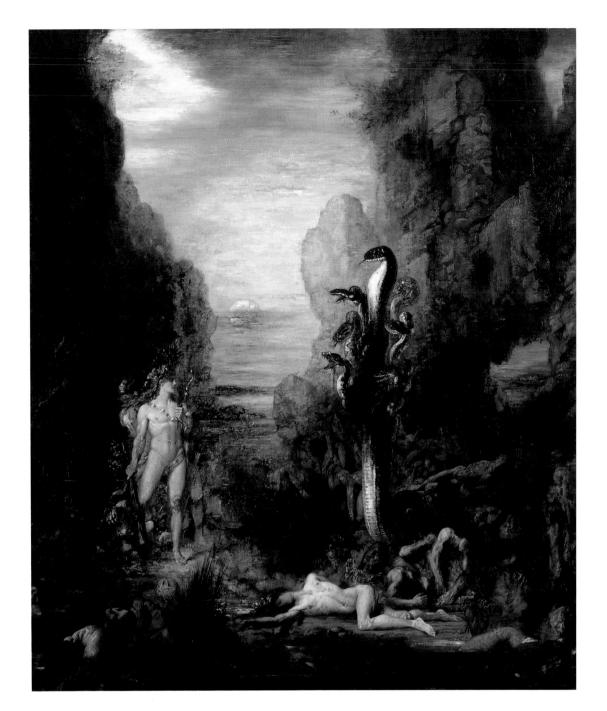

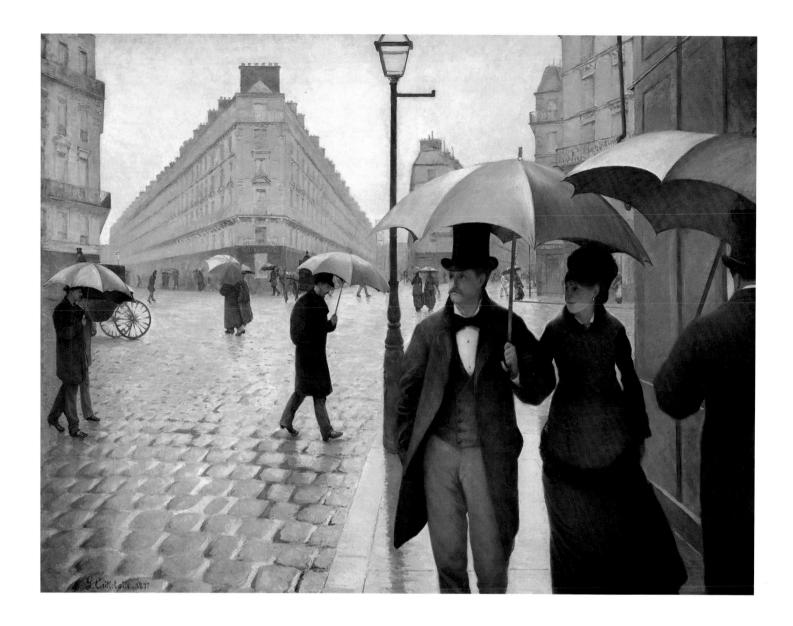

GUSTAVE CAILLEBOTTE

French, 1848–1894

Paris Street; Rainy Day, 1877

Oil on canvas $212.2\times276.2~cm~(83~^{1}/_{2}\times108~^{3}/_{4}~in.)$ Charles H. and Mary F. S. Worcester Collection, 1964.336

Gustave Caillbotte was the major organizing force behind the Impressionist exhibition of 1877. This show was the strongest of the eight the group organized, and it was dominated by Caillebotte's masterpiece, *Paris Street*; *Rainy Day*. The painting hung with Claude Monet's

series of depictions of Gare Saint-Lazare (see p. 55) and Pierre-Auguste Renoir's *Moulin de la Galette* (Paris, Musée d'Orsay).

In *Paris Street; Rainy Day*, the upraised umbrellas, reflections of water on the pavement, and pervasive gray tonalities all convey the artist's interest, shared with the Impressionists, in suggesting atmospheric conditions. Selecting a complex intersection near the Gare Saint-Lazare, the artist changed the size of the buildings and the distance between them to create a wideangle view. While the painting's panoramic sweep perhaps reflects new ways of seeing that resulted from advances in photography, it also captures the equally modern development of Paris's grand, new boulevards. Caillebotte's

fascination with perspective can be seen in the composition's careful structure, which makes calculated use of the lamppost to separate the foreground from the middle and distant views.

While *Paris Street*; *Rainy Day*'s highly crafted surface, monumental size, geometric order, and elaborate perspective are more academic than Impressionist in character, Caillebotte clearly employed all these elements to portray the modern realities that absorbed his Impressionist colleagues; notably, none of the figures interacts, suggesting a sense of urban alienation. Caillebotte also captured the momentary quality of everyday life: it is easy to imagine that, if we blink our eyes, everyone in the painting will have moved and nothing will be the same.

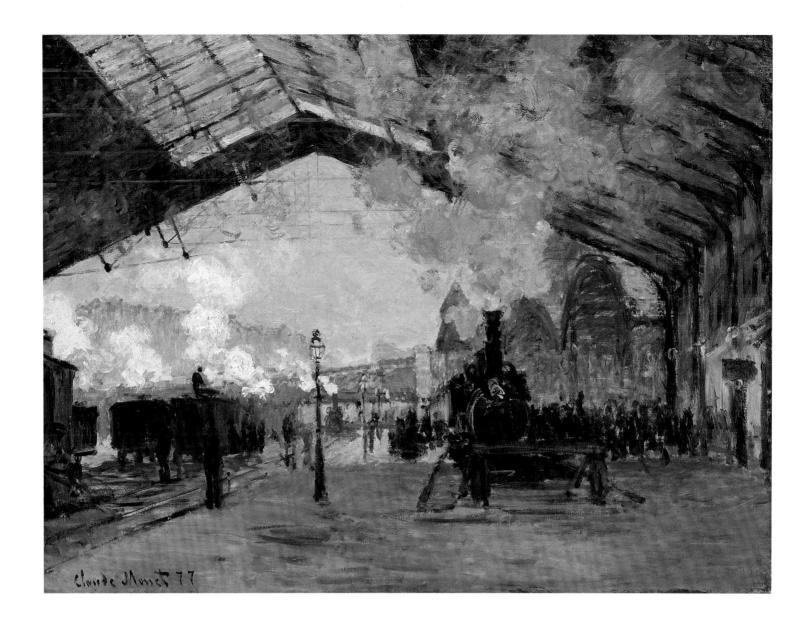

CLAUDE MONET

French, 1840-1926

Arrival of the Normandy Train, Gare Saint-Lazare, 1877 Oil on canvas $59.6\times80.2~\text{cm}~(23^{-1}/2\times31^{-1}/2~\text{in.})$ Mr. and Mrs. Martin A. Ryerson Collection, 1933.1158

The Impressionists frequently paid tribute to the modern aspects of Paris. Their paintings abound with scenes of grand boulevards and elegant, new blocks of buildings (see p. 54), as well as achievements of modern construction, such as iron bridges, exhibition halls, and train sheds.

Arrival of the Normandy Train, Gare Saint-Lazare was an especially appropriate choice of subject for Claude Monet in the 1870s. The terminal, linking Paris and Normandy, where Monet's technique of painting out-of-doors had been nurtured in the 1860s (see p. 50), was also the point of departure for towns and villages to the west and north of Paris frequented by the Impressionists. Monet completed eight of his twelve known paintings of Gare Saint-Lazare in time for the third Impressionist exhibition, in 1877, probably placing them in the same gallery.

Monet chose to focus his attention here on the glass-and-iron train shed, where he found an appealing combination of artificial and natural effects: the rising steam of locomotives trapped within the structure, and daylight penetrating the large, glazed sections of the roof. Monet's depictions of the station inaugurated what was to become for him an established pattern of painting a specific motif repeatedly, in order to capture subtle and temporal atmospheric changes (see p. 67). However, the series also represented his last attempt to deal with urban realities: from this point on in his career, Monet would be a painter of landscapes.

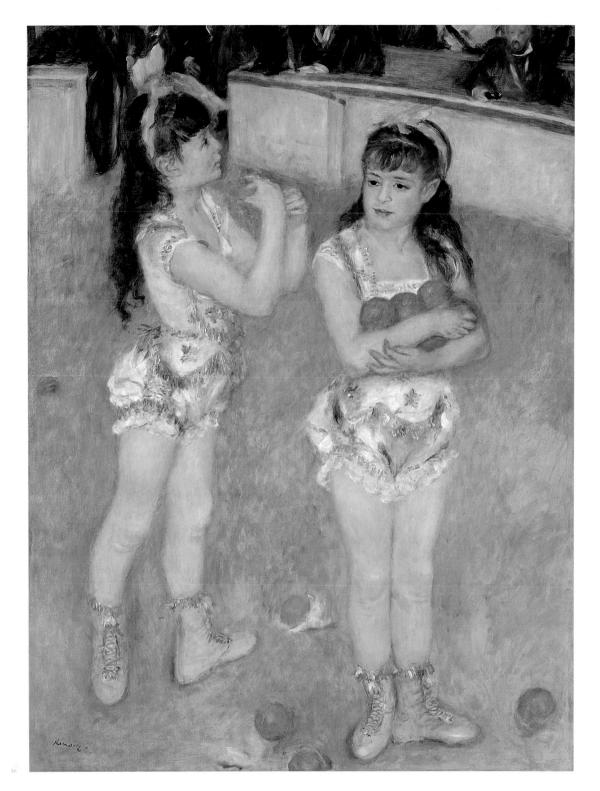

PIERRE-AUGUSTE RENOIR

French, 1841-1919

Acrobats at the Cirque Fernando (Francisca and Angelina Wartenberg), 1879

Oil on canvas 131.5 × 99.5 cm (51 ³/₄ × 39 ¹/₈ in.) Potter Palmer Collection, 1922.440

Acrobats at the Cirque Fernando depicts a favorite Parisian pastime in the late nineteenth century: a circus whose enthusiastic audiences included men on the prowl in a world of available female entertainers. But Pierre-Auguste Renoir barely alluded to the unwholesome aspects of this environment, relegating a group of dark-suited men, seated in the front row, to the very top of the composition. "For me a picture . . . should be something likeable, joyous, and pretty," Renoir insisted. "There are enough ugly things in life for us not to add to them."

Reflecting Renoir's worldview, this engaging work focuses on German acrobats Francisca and Angelina Wartenberg taking their bows and receiving tributes of oranges from the crowd. The artist painted his models in his studio, since he feared that the circus's harsh gas lighting would turn "faces into grimaces." He also imparted a sense of innocence to the sisters by depicting them as younger than they actually were—seventeen and fourteen, respectively. Here Renoir banished shadows and used delicate, multi-directional brushwork so that the figures seem to blend into the surrounding space. Finally, he enveloped the acrobats in a virtual halo of pinks, oranges, yellows, and whites. A comparison of this picture with the disturbing, even cruel representation of the same circus by Henri de Toulouse-Lautrec (p. 62) reinforces the "rose-colored" lens through which Renoir looked when painting "likeable, joyous" works. The painting's undeniable charm appealed to its owner, Chicago collector Bertha Honoré Palmer, who became so enamored of it that she kept it with her at all times, even on her travels abroad.

ÉDOUARD MANET

French, 1832-1883

Woman Reading, 1879/80

Oil on canvas $61.2\times50.7~cm~(24^{-1}/16\times19^{-7}/s~in.)$ Mr. and Mrs. Lewis Larned Coburn Memorial Collection, 1933.435

During the late nineteenth century, Parisian cafés were the gathering places of artists and writers and were ideal locations for observing the urban scene. Many Impressionist paintings depict the Café Nouvelle-Athènes on the rue Pigalle, where two tables were reserved for Édouard Manet and his circle—a group that included the painters Degas, Monet, Pissarro, and Renoir, and the writers Baudelaire and Zola.

Manet could well have passed by this fashionably dressed young woman on his way into his favorite café. The illustrated magazine attached to the wooden bar she holds would have been taken from the establishment's reading rack. It is undoubtedly one of the popular French periodicals of the day, like *La vie moderne*, begun in April 1879, in which Manet's drawings sometimes appeared. The woman's heavy clothing and kid gloves suggest that she is seated at an outdoor table and that the weather is cool. The colorful garden view behind her is thus probably a painted backdrop.

Woman Reading is one of the most Impressionist of Manet's images; the quick, free brushstrokes and light colors are characteristic of his technique late in his career. Painted only a few years before his death, this work admirably captures a fleeting moment, the sense of modern life that Manet and his contemporaries sought to represent.

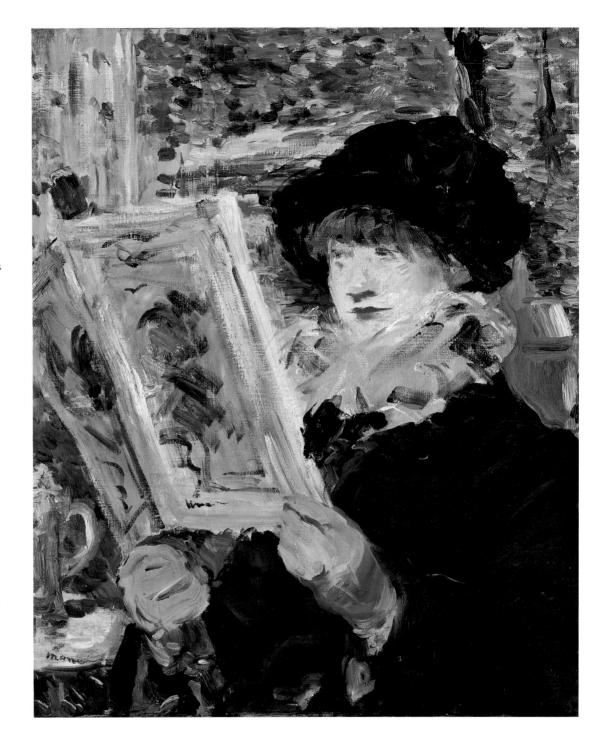

57

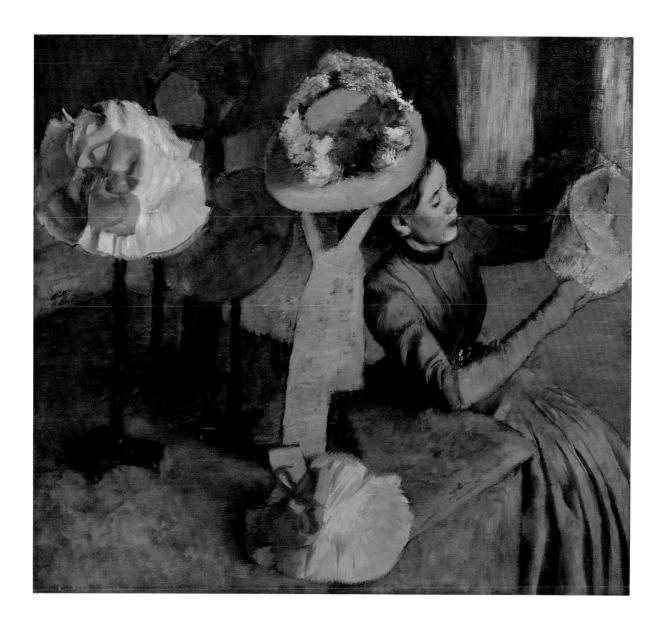

HILAIRE-GERMAIN-EDGAR DEGAS

French, 1834–1917

The Millinery Shop, 1879/86

Oil on canvas $100\times110.7~cm~(39~^3/8\times43~^9/16~in.)$ Mr. and Mrs. Lewis Larned Coburn Memorial Collection, 1933.428

In contrast to the majority of other Impressionists' interest in the shifting light effects studied out-of-doors, Edgar Degas focused particularly on composition, draftsmanship, and gesture. This often led him to portray carefully constructed interiors, such as that seen in The Millinery Shop. This work portrays either a young female absorbed in the task of creating a hat or a customer admiring a hat-in-progress. Degas explored the theme of hats, their making and their purchase, in at least fifteen pastels and oils, all created in the early 1880s. These inventive examples of changing fashion were for Degas symbolic of the modern bourgeois woman and also allowed him to indulge his interest in contrasting colors.

Degas's fascination with Japanese woodblock prints and their unorthodox compositions, as well as with the newly developing art of photography and its unexpected croppings, inspired him to find new and highly effective ways of drawing the viewer into his pictorial spaces. In *The Millinery Shop*, one assumes the role of potential buyer, perhaps looking down from the street through a window at the display of merchandise. The scene is dominated by hats and stands, which, resembling peonies in full bloom, seem to relegate the figure to the side.

Despite her lateral position, the young woman is pivotal to the painting. She is a picture of industry: her lips are firmly pursed, perhaps around a pin, while her hands—scraped and repainted by Degas to depict kid gloves—convey vivid movement as she examines the hat. Surrounded and deeply absorbed by beautiful creations, she may have symbolized to Degas the role of artistic production, fashion, and consumption in contemporary Parisian society.

PIERRE-AUGUSTE RENOIR

French, 1841-1919

Two Sisters (On the Terrace), 1881

Oil on canvas 100.5 × 81 cm (39 ⁹/₁₆ × 37 ⁷/₈ in.) Mr. and Mrs. Lewis Larned Coburn Memorial Collection, 1933.455

One of the Art Institute's most popular works, Pierre-Auguste Renoir's *Two Sisters (On the Terrace)* is the final painting in a remarkable group of compositions by the artist on a key Impressionist theme: Parisians relaxing in the country. Renoir completed the series in 1880 and 1881 in Chatou, a village in the heart of rowing country that the artist called "the prettiest of all the suburbs in Paris." In the museum's painting, two visually captivating figures (models, not sisters, despite the title) sit at the edge of a terrace. Boats glide along the Seine behind them; the older figure wears the dark-blue flannel dress that female boaters favored.

A compositional and technical tour de force, Two Sisters displays Renoir's variegated brushwork and vibrant palette. The loosely rendered foliage and river contrast with the more carefully defined females, each endowed with a luminous, porcelain complexion. Juxtaposed with their delicate faces are their brightly colored hats—one brilliant red, and the other decorated with richly impastoed flowers. In the foreground, like a painter's palette, the bright balls of yarn in the basket exhibit the exact intense hues Renoir used to compose this image. Somewhat out of context, given the outdoor, nautical setting, the knitting basket may also represent the artist's ironic response to a critic who denigrated his work as "a piece of knitting ... a weak sketch ... constructed of different balls of yarn." Despite such complaints, Two Sisters, one of twenty-five paintings that Renoir exhibited in the seventh Impressionist show, in 1882, was in fact a critical success.

ARNOLD BÖCKLIN

Swiss, 1827-1901

In the Sea, 1883

Oil on panel 87×115.6 cm $(34 \frac{1}{4} \times 45 \frac{1}{2}$ in.) Joseph Winterbotham Collection, 1990.443

Far removed from contemporary trends such as Impressionism, Arnold Böcklin's oeuvre also had little in common with the idealized academic art of his time. Instead, Böcklin's depictions of demigods in naturalistic settings interpret themes from classical mythology in an idiosyncratic, often sensual manner.

In the Sea, part of a series of mythological subjects from the mid-1880s, displays an unsettling, earthy realism. Mermaids and tritons frolic in the water with a lusty energy and abandon verging on coarseness. Occupying the center of the composition is a long-haired, harpplaying triton. Three mermaids have attached themselves to his huge frame as if it were a raft; the one near his shoulder seems to thrust herself upon him. The physicality of the scene is intensified by the way the figures fill the space, and by the strong contrasts between the light sea and sky and the darker figures and shadows. The work's boisterousness is tempered by the ominously shaped reflections of the triton and mermaids on the water's surface, and by the oddness of the large-eared heads that emerge from the sea at the right.

In addition to imaginative, bizarre interpretations of the classical world such as *In the Sea*, Böcklin also painted mysterious landscapes punctuated by an occasional lone figure. These haunting, later works made him an important contributor to the international Symbolist movement. They also appealed to some Surrealist artists, particularly Giorgio de Chirico (see p. 113), who declared, "Each of [Böcklin's] works is a shock."

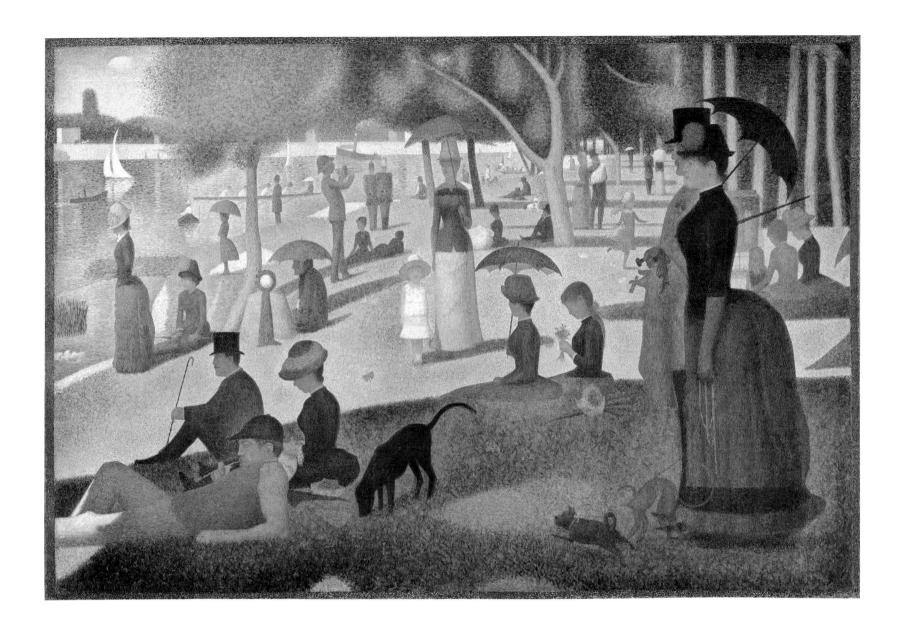

GEORGES-PIERRE SEURAT

French, 1859-1891

A Sunday on La Grande Jatte—1884, 1884–86 Oil on canvas 207.6 × 308 cm (81 ³/₄ × 121 ¹/₄ in.)

Helen Birch Bartlett Memorial Collection, 1926.224

Georges Seurat developed his own, "scientific" approach to painting. He juxtaposed tiny dots and dabs of color to create hues that he believed, through optical blending, are more intense than pure colors mixed with black or white when used to define three-dimensional forms. Remarkable for its unusual technique,

stylized figures, and enormous scale, A Sunday on La Grande Jatte-1884 is generally considered Seurat's masterpiece and one of the greatest paintings of the nineteenth century. Seurat labored over the Grande Jatte, executing numerous black-chalk drawings and oil sketches, which are brightly colored and much freer in handling than the final work. The artist Camille Pissarro, to whom Seurat showed the picture in 1885, seems to have criticized the canvas's extreme formality and lack of freshness, prompting Seurat to rework the painting. He increased the curving contours of the chief figures to make them appear more relaxed and added strokes of vivid color. In a final campaign on the picture, he added more multicolored dots to heighten

the painting's palette even further. Two or three years after it was exhibited in 1886, Seurat restretched the canvas and added the painted border to further isolate the picture from its white frame.

The Grande Jatte is an island in the Seine just west of Paris. In Seurat's day, it was a park that attracted city residents seeking recreation and relaxation. Over the past several decades, many attempts have been made to explain the meaning of this great composition. For some it shows the middle class at leisure; for others it reveals, through its groupings and details, social tensions of modern city dwellers. Ironically, the Art Institute's most famous painting remains one of its most enigmatic.

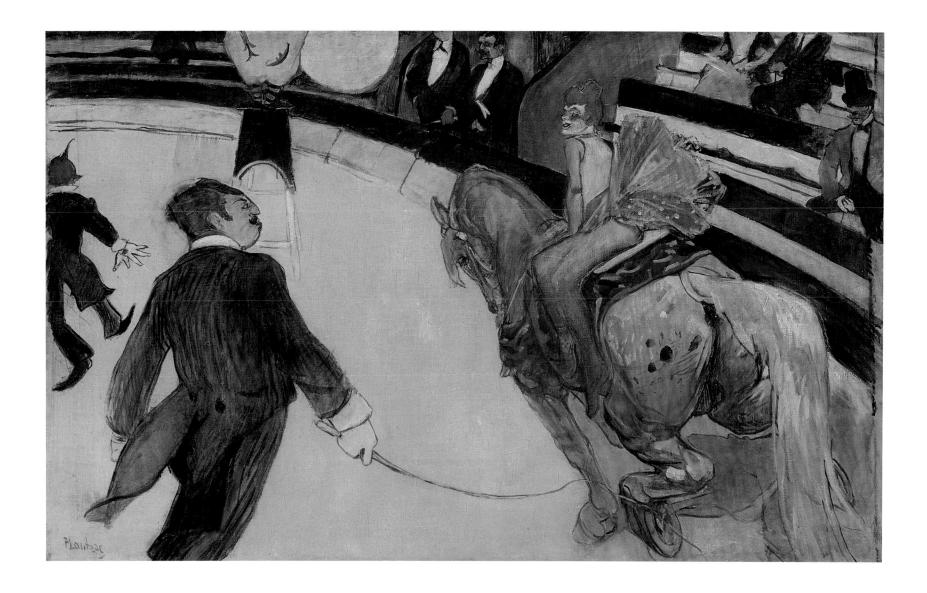

HENRI-MARIE-RAYMOND DE TOULOUSE-LAUTREC

French, 1864-1901

Equestrienne (At the Cirque Fernando), 1887–88 Oil on canvas 100.3×161.3 cm $(39 \frac{1}{2} \times 63 \frac{1}{2}$ in.) Joseph Winterbotham Collection, 1925.523

Born into a noble family and disabled since childhood, Henri de Toulouse-Lautrec turned away from his birthright and sought companionship and excitement in the bawdy nightlife of Paris, of which the Cirque Fernando was a prime attraction. It inspired a number of other French painters, such as Degas, Renoir (see p. 56), Seurat, and later Léger.

With its thin, rapid lines, Equestrienne (At the Cirque Fernando) has the spontaneous quality of a drawing, connecting it with Lautrec's involvement with graphic art. The artist was also inspired by compositional aspects of photography and Japanese prints, interests apparent in this work: for example, the center of the image is empty, and the composition is instead

structured around the sweeping arc of the ring. This curve is repeated continually throughout the scene: in the powerful haunches of the circus horse, the ring and gallery, the billowing trousers of a clown standing on a stool at the top of the picture, and most prominently in the extraordinary Svengali-like profile of the ringmaster. This menacing figure is linked to the rider by the whip in his hand and by his penetrating gaze. From her perch atop the horse, she glances over her shoulder at him, creating a sense of tension. Isolated against the pale ground of the circus ring and striding forward, the ringmaster clearly dominates the scene both psychologically and visually.

VINCENT VAN GOGH

Dutch, 1853-1890

Self-Portrait, 1887

Oil on artist's board, mounted on cradled panel 41×32.5 cm ($16^{1/8} \times 13^{1/4}$ in.) Joseph Winterbotham Collection, 1954.326

Vincent van Gogh's tumultuous career as a painter was actually very brief. After working for an art merchant, he became a missionary. In 1886 he left his native Holland and settled in Paris, where his beloved brother Theo was a dealer in paintings. He actively pursued his art for a period of only five years before his suicide in 1890.

In the two years that Van Gogh spent in Paris, he painted no fewer than two dozen self-portraits. The Art Institute's early, modestly sized example displays the bright palette he adopted in reaction to the bustling energy of Paris and to his introduction to Impressionism. Although dense brushwork would become a hallmark of his style, here he added an overlay of small, even strokes in response to Georges Seurat's *Sunday on La Grande Jatte—1884* (p. 61), and his revolutionary "dot" technique. Van Gogh saw Seurat's masterpiece when it was exhibited in the 1886 Impressionist exhibition.

In the Art Institute's *Self-Portrait*, the direct gaze of the artist, who appears to frown in concentration, initially distracts the viewer from the dazzling array of dots and dashes that animate his shoulders and the background. When one can finally tear one's eyes away from those of the painter, attention shifts to his mouth. Its tightly closed, almost pursed, lips seem to reveal the man's intensity and his ultimately self-destructive sensitivity.

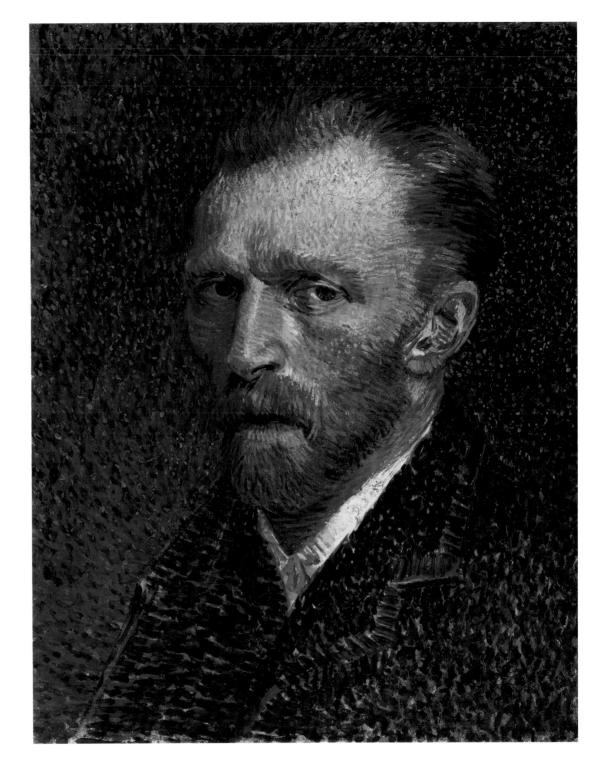

PAUL GAUGUIN

French, 1848-1903

The Arlésiennes (Mistral), 1888

Oil on canvas 73×92 cm ($28^{3}/_{4} \times 36^{3}/_{16}$ in.) Mr. and Mrs. Lewis Larned Coburn Memorial Collection, 1934.391

Paul Gauguin arrived in the southern French city of Arles in October 1888, having accepted an invitation from Vincent van Gogh to join him in establishing an artists' colony. The two months they spent together were difficult and, in

the end, devastating for Van Gogh. The deliberate and willful Gauguin was the antithesis of the fast-working, emotionally expressive Dutch painter. Gauguin's art was becoming increasingly abstract at this time; he used color in large, flat areas and forsook traditional handling of space in paintings such as this in order to inform his work with the visual unity and symbolism he desired.

Set in the garden opposite the house Gauguin shared with Van Gogh, *Arlésiennes (Mistral)* conveys an aura of repressed emotion and mystery. Walking through the garden are four somber women. Their gestures are slight, but distancing; their expressions are withdrawn,

introspective. Other elements in the painting are equally elusive in meaning: the bench on the path at the upper left rises steeply, defying logical perspective, and the conical objects at the right—probably protective straw coverings placed over plants during the winter—are specterlike presences. Another puzzling feature of the painting is what appears to be a face in the bush. Intentionally created by the artist, it conveys the impression of a strange, watchful presence. In this powerful and inscrutable painting, Gauguin explored the capacity of art to express the mysteries, superstitions, and emotions that he believed underlie appearances.

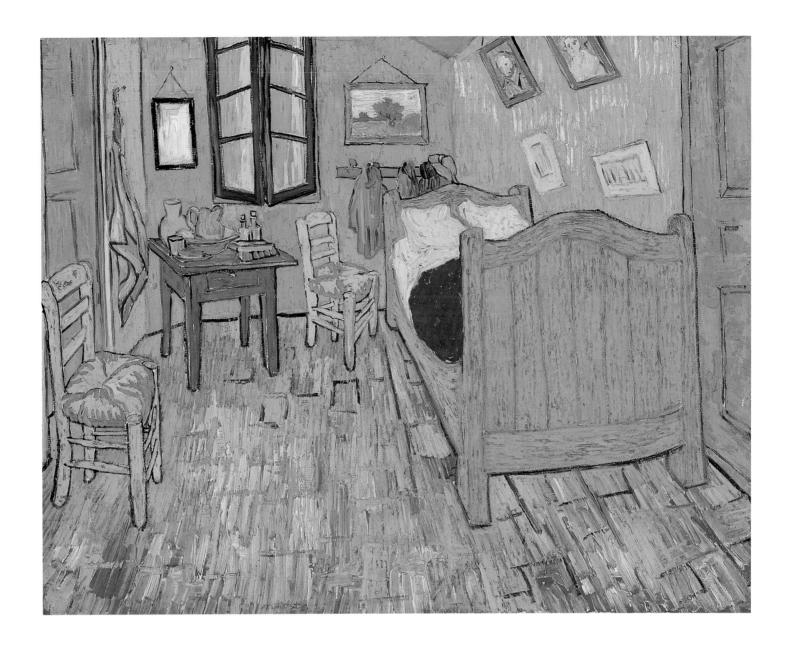

VINCENT VAN GOGH

Dutch, 1853-1890

The Bedroom, 1889

Oil on canvas

 73.6×92.3 cm (29 × 36 $^{5}/8$ in.)

Helen Birch Bartlett Memorial Collection, 1926.417

When Vincent van Gogh left Paris in 1888 for the southern French city of Arles, his intention was to create "the Studio of the South," a colony for artists. He tried repeatedly to convince his brother Theo and his artist friends Paul Gauguin and Émile Bernard to join him in establishing a community there. In anticipation of their arrival, Van Gogh set out to create paintings to decorate his home and studio; these included images of flowers, views of Arles, and deeply revealing depictions of his bedroom. Of the three versions of this famous bedroom composition, the Art Institute's—completed in 1889—is the second (the first, from 1888, is at the Van Gogh Museum, Amsterdam; the third,

from 1889, is at the Musée d'Orsay, Paris). To the artist, the picture symbolized relaxation and peace, despite the fact that, to our eyes, the canvas seems to teem with nervous energy, instability, and turmoil. Although the room looks warm and bathed in sunshine, the very intensity of the palette undermines the intended mood of restfulness, especially when combined with the sharply receding perspective and the inclusion of pictures tilting off the wall. As in all of Van Gogh's paintings, each object seems almost palpable, as solid as sculpture, although modeled in pigment. The result is an overwhelming sense of presence, an assertive vitality that seems to burst out beyond the confines of the canvas.

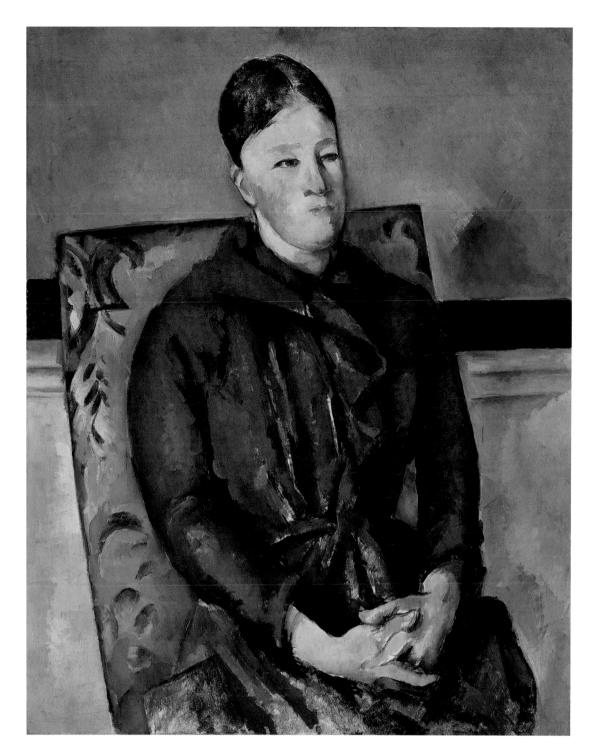

PAUL CÉZANNE

French, 1839-1906

Madame Cézanne in a Yellow Chair, 1888–90

Oil on canvas 80.9 × 64.9 cm (31 ¹³/₁₆ × 25 ⁹/₁₆ in.) Wilson L. Mead Fund, 1948.54

Paul Cézanne is generally hailed today as the father of modern painting, but recognition of the magnitude of his contribution to the history of art came only after his death. In part this was a result of how he chose to live and work. As a student in Paris, he joined the Impressionists and even exhibited with them in 1874 and 1877. Unable to cope, however, with the public ridicule of his art, Cézanne withdrew from the group and opted for a reclusive existence, painting in solitude, mostly in Provence, especially in and around his native Aix-en-Provence.

Although hermitlike by nature, Cézanne did marry. The union seems not to have been very satisfactory for either husband or wife. Our greatest insight into the character of Madame Cézanne comes from the artist's many depictions of her. The Art Institute's Madame Cézanne in a Yellow Chair is one of three portraits of her, in the same chair and pose, from the same period. The simplicity of the portrait is instantly apparent: a three-quarter-length figure sits in a threequarter-turn view; her dress is red, the chair is yellow, the background is blue. The presentation is honest, straightforward, and unadorned, much like the woman herself. Her masklike face and tightly sealed lips reveal nothing. Her hands, although somewhat twisted, lie dormant, completing the serene oval of her arms. Madame Cézanne, who posed for hours, exhibits a sense of deliberation not unlike that shown by the artist in composing this image of her.

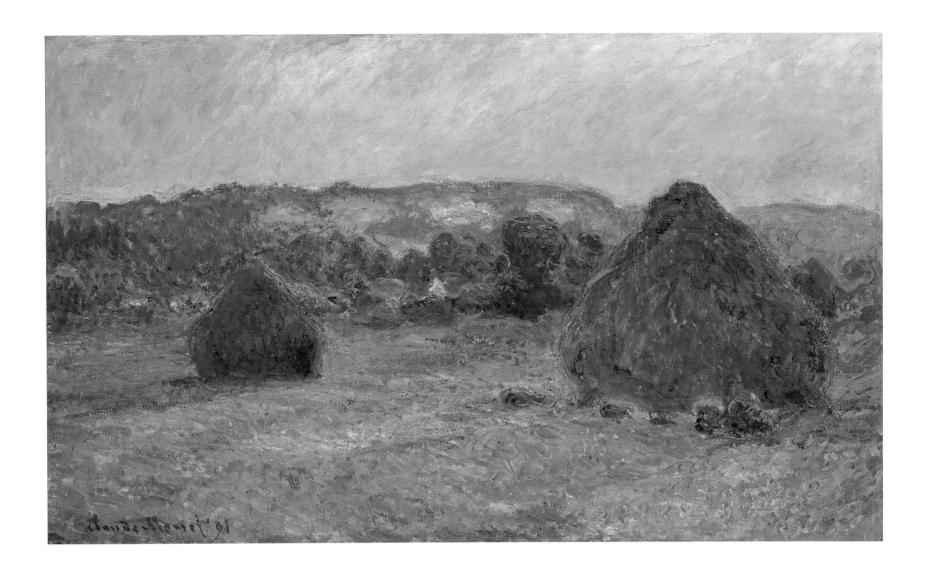

CLAUDE MONET

French, 1840-1926

Stacks of Wheat (End of Summer), 1890-91

Oil on canvas 60×100 cm (23 $^5/8 \times 39$ $^3/8$ in.) Gift of Arthur M. Wood in memory of Pauline Palmer Wood, 1985.1103 Enormous stacks of harvested wheat, rising fifteen to twenty feet in height, stood just outside Claude Monet's farmhouse door at Giverny, his home from 1883 until his death. Monet painted the stacks in 1890 and 1891, both in the field, where he worked on several canvases simultaneously, and in the studio, where he refined them. Only by executing multiple views of the same subject, Monet found, could he truly render, as he put it, "what I experience," in other words, how he perceived and responded to these stacks of grain, defined by light and air as time passed and weather changed.

Constructed by man but created by nature, the stacks were for Monet a resonant symbol of sustenance and survival. While his compositions seem simple, Monet modulated his palette and brushwork to each temporal situation he confronted. In late summer views such as this, as well as in most of the autumn scenes, the pointed tops of the stacks often seem to burst through the horizon into the sky. On the other hand, in the majority of winter views, the long-lasting stacks appear nestled into hill and field, as if hibernating from the cold of the season.

In May 1891, the artist hung fifteen of the wheat-stack compositions next to one another in a small room in his dealer's Paris gallery, thus firmly establishing his famous method of working in series. The Art Institute boasts the largest group of Monet's *Stacks of Wheat* in the world; five of the six in the collection numbered among the canvases he exhibited in 1891.

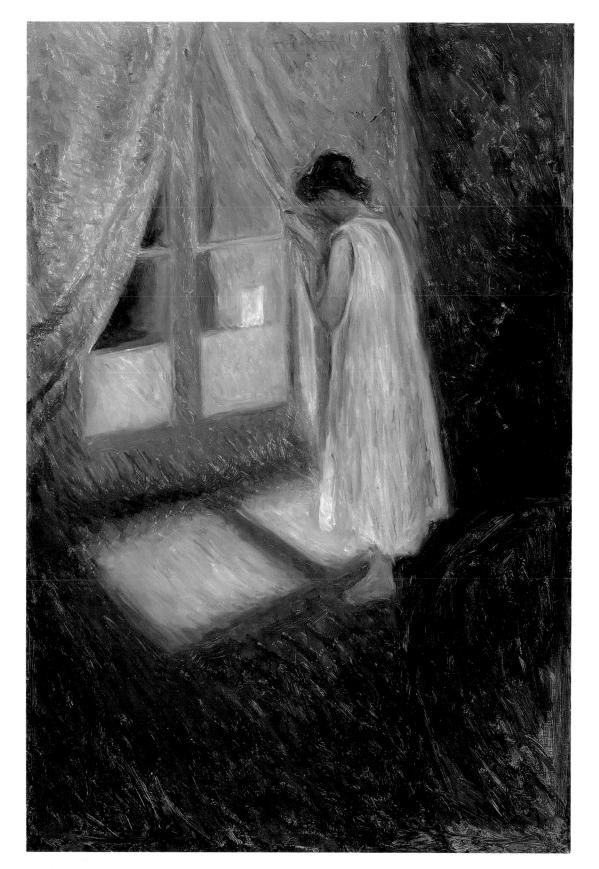

EDVARD MUNCH

Collection, 2000.50

Norwegian, 1863-1944

Girl Looking out the Window, 1893

Oil on canvas $96.5\times65.4~cm~(38\times25^{-3/4}~in.)$ Searle Family Trust and Goldabelle McComb Finn endowments; Charles H. and Mary F. S. Worcester

Edvard Munch's life and art—particularly his iconic work The Scream (1893; Oslo, National Museum)—have come to epitomize modern notions of cultural anxiety. Yet the same year he painted his radical image, Munch was experimenting with other styles and themes. Frequent visits to Paris and Berlin between 1889 and 1893 brought the Norwegian into direct contact with the the Impressionists and Symbolists. These travels encouraged the artist to adopt their bold brushwork, daring compositions, and imagery. But he nonetheless continued to incorporate the Romantic subjects of the northern European artists long familiar to him, such as a lone figure at an open window. This combination is powerfully manifested in Girl Looking out the Window, done soon after his return home to Norway.

In the dead of night, a young girl, in her nightgown, stands in a darkened room gazing out at the city. The steep angle of the floor and the deep shadows that obliterate everything in the room, save a suggestion of a piece of furniture at the lower right, create an unsettling and enigmatic scene. Loosely applied, somber brown tones mingle with violets and blues, evoking a feeling of melancholy and anticipation. The window functions as a symbolic barrier, separating the interior from the outside world. The sense of mystery is deepened and complicated by the fact that we cannot see the expression on the girl's face, nor do we know what she covertly observes. She in turn appears unaware that, as she gazes from behind the curtain at something unknown outside, the artist and implied viewer are in turn watching her.

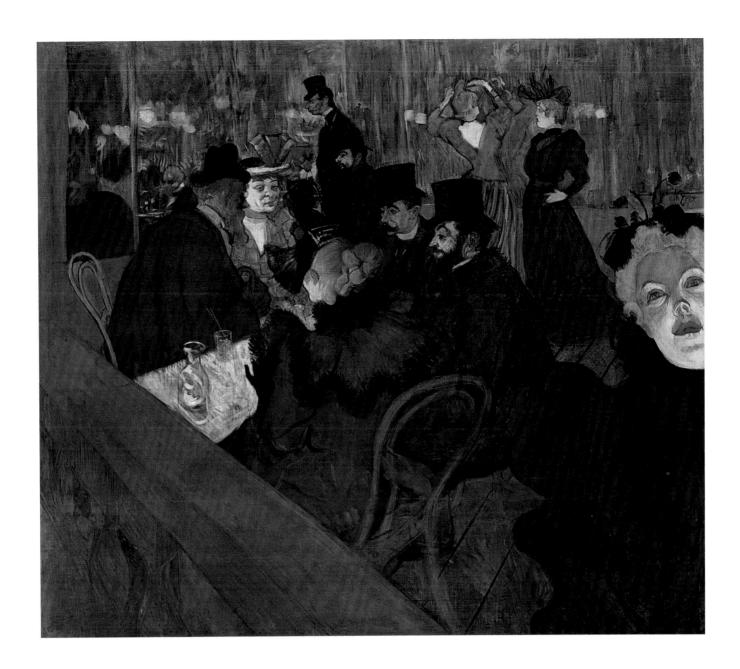

HENRI-MARIE-RAYMOND DE TOULOUSE-LAUTREC

French, 1864-1901

At the Moulin Rouge, 1892/95

Oil on canvas $123\times141~\text{cm}~(48~^{7}/_{16}\times55~^{1}/_{2}~\text{in.})$ Helen Birch Bartlett Memorial Collection, 1928.610

The "café-concert," a place for drinking that provided entertainment, was a popular institution in late-nineteenth-century Paris; the performers and audience alike attracted the

attention of artists such as Henri de Toulouse-Lautrec. The Moulin Rouge was the most famous such establishment in Paris during the 1890s. Lautrec's *Equestrienne* (At the Cirque Fernando) (p. 62) was displayed in its lobby.

In At the Moulin Rouge, Lautrec turned his acute powers of observation onto the café's clientele. Rather than depicting anonymous figures, the artist portrayed actual habitués of latenight Paris—customers and entertainers—whom he counted among his friends and companions. The central group, seated around the table, includes a photographer, poet, vintner, and two entertainers. A third entertainer, whose greenish

face looms eerily at the right edge of the canvas, seems to have just left the group. In the upper right, adjusting her coiffure, is a dancer, accompanied by a friend. The latter seems to stare toward the far left, at two men in the process of departing: the dwarfish figure of Lautrec himself and his very tall cousin.

At the Moulin Rouge has undergone considerable alteration. Apparently it was cut down along the right and bottom to make the composition less radical and more attractive to buyers. The separated section was restored to the painting by 1914, fourteen years before it was acquired for the Art Institute.

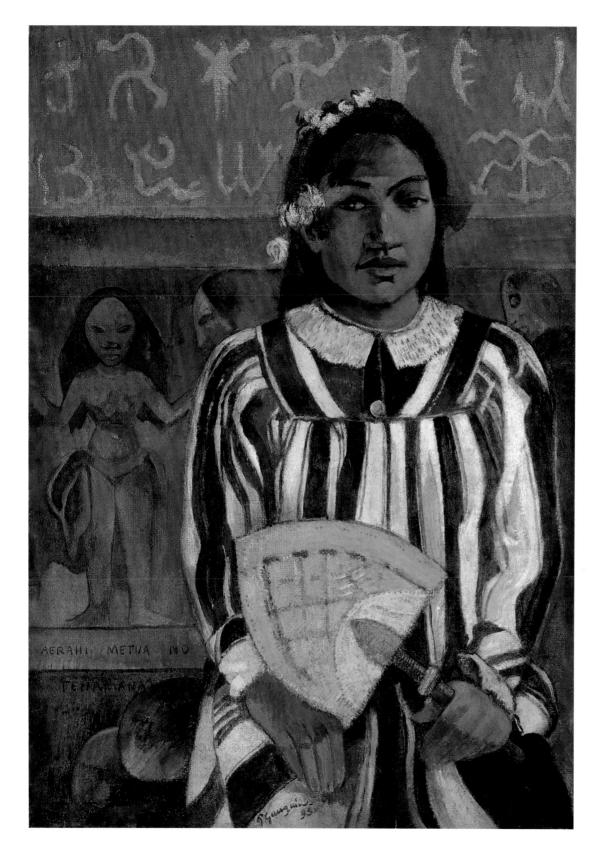

PAUL GAUGUIN

French, 1848-1903

The Ancestors of Tehamana, or Tehamana Has Many Parents (Merahi metua no Tehamana), 1893

Oil on canvas

 76.3×54.3 cm ($30^{-1}/_{16} \times 21^{-3}/_{8}$ in.) Gift of Mr. and Mrs. Charles Deering McCormick, 1980.613

In April 1891, Paul Gauguin set sail for Tahiti, sponsored by the French government to paint the island's "landscape and costumes." The former stockbroker was convinced that he would find a civilization that was more spiritually pure than what he believed to be the spoiled culture of modern-day Europe. This quest for the "primitive" (as well as the need to live frugally) had already led the restless, mainly self-taught artist to Martinique, Brittany, and Provence. He was to spend all but two of the remaining years of his life in the South Seas.

This stately portrait represents Gauguin's teenage Tahitian "wife," Tehamana, whose expressionless face and immobile posture seem to embody the mystery of the exotic "other" that the artist sought in life and art. He placed her in front of a painted frieze on which appear ancient Polynesian symbols. Wearing a crown of flowers, Tehamana holds a fan of plaited leaves, much as a queen bears a scepter. The fan points to Hina, the ancient deity from whom all Tahitians believed they were descended. Two ripe mangoes, perhaps an offering or tokens of fertility, rest beside Tehamana's hip.

This portrayal of a young woman and her ancestry reflects Gauguin's desire to preserve a way of life that, to his despair, was quickly disappearing. "Our missionaries have already imported much hypocrisy," Gauguin lamented, "and they are sweeping away part of the poetry." Indicating this Europeanization, Tehamana—unlike her ancestor—wears the high-necked Mother Hubbard dress that French missionaries imposed upon the Tahitian population for propriety's sake.

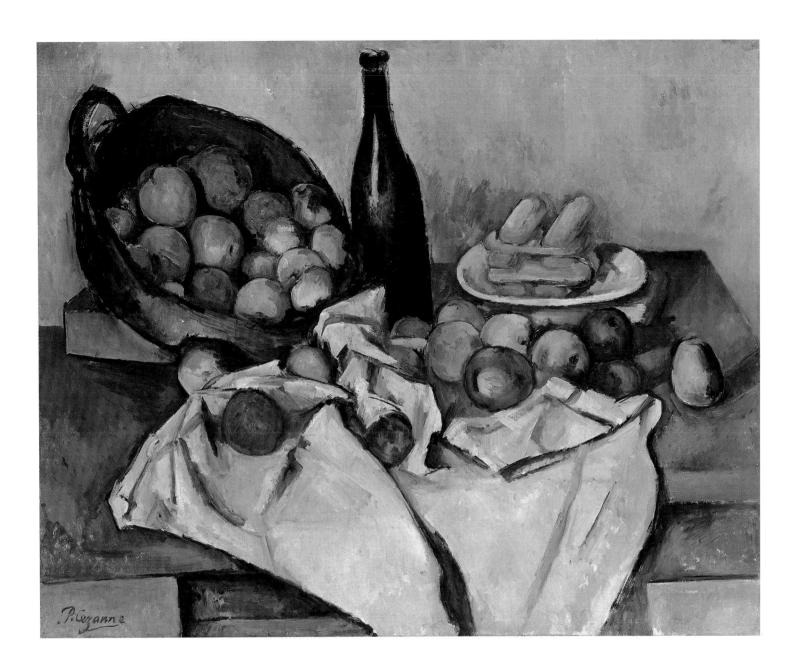

PAUL CÉZANNE

French, 1839-1906

The Basket of Apples, c. 1893

Oil on canvas 65×80 cm (25 $^{7}/_{16} \times 31$ $^{1}/_{2}$ in.) Helen Birch Bartlett Memorial Collection, 1926.252

Although Paul Cézanne withdrew from avantgarde art circles in Paris to paint in virtual isolation in Provence, his work was known by a select few and known of by many more. Thus, when the art dealer Ambroise Vollard finally convinced the artist to show his work in Paris in 1895, the event was very important.

The Basket of Apples, one of Cézanne's so-called "Baroque" still lifes (because it was inspired by seventeenth-century Dutch prototypes), was included in the exhibition. Like other paintings on display, it was signed by the artist, a rare concession probably made to satisfy Vollard. By its very name, the term "still life" suggests an array of inert, or dead, objects; this association is even clearer in the equivalent French term *nature morte* (dead nature). Yet Cézanne interpreted still life in a way that actually animates the objects. On one of his

characteristic tilted tables—an impossible rectangle in which none of the corners lines up with the others—are a cloth, a basket of apples, a plate of neatly stacked cookies, a bottle, books, and more apples. The basket careens forward from a slablike base that appears to upset rather than support it. The apparent precariousness of the objects on the table is tempered by their solid modeling, which gives them great density and weight. Even the white tablecloth possesses sculptural folds that seem to arrest movement and contribute to the sense of permanence with which Cézanne imbued his compositions.

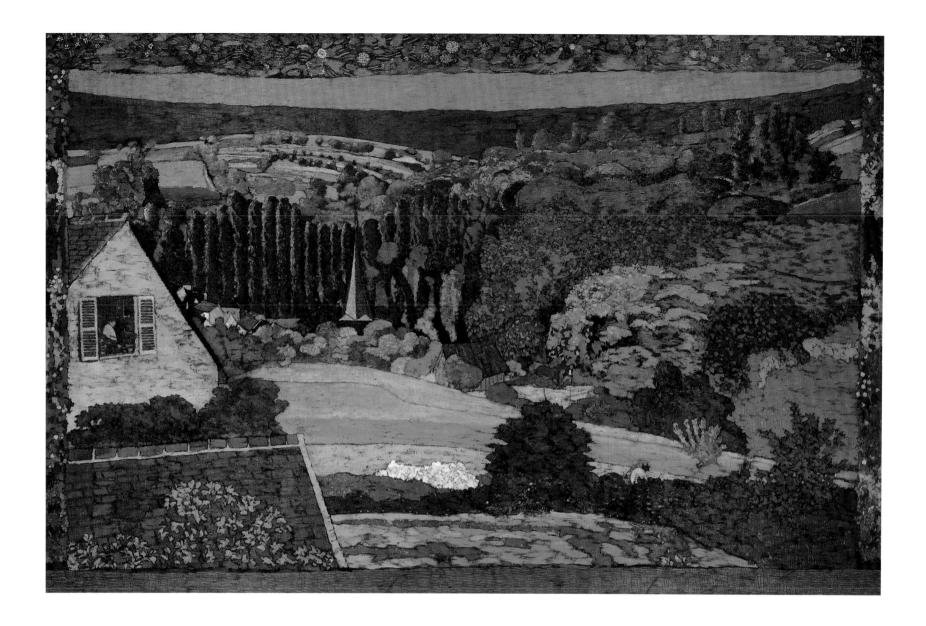

ÉDOUARD VUILLARD

French, 1868–1940

Landscape: Window Overlooking the Woods, 1899
Oil on canvas

249.2 × 378.5 cm (96 ½ × 149 in.)

L. L. and A. S. Coburn, Martha E. Leverone, and Charles Norton Owen funds; anonymous restricted gift, 1981.77

While Édouard Vuillard is known mostly as an Intimist, or painter of small-scale images of domestic interiors, early in his career, his most important works were large paintings commissioned by a devoted circle of Parisian patrons.

Landscape: Window Overlooking the Woods was one of a pair of paintings that Vuillard made for the library of the wealthy investment banker Adam Natanson; its pendant, *The First Fruits* (1899), is now at the Norton Simon Museum, Pasadena. These decorations were Vuillard's largest commission for the Natansons, his greatest supporters for almost a decade. The project was his last for this patron and also marked the end of his most prolific period as a painter-decorator.

The Art Institute's painting shows L'Étangla-Ville, a suburb west of Paris where Vuillard often visited his sister and brother-in-law, the painter Ker-Xavier Roussel. Vuillard conceived the scene as if viewed through an open window, with its ledge indicated at the bottom of the composition. Instead of creating an image one can imagine walking into, he flattened the rolling hills and rustic village into patterned, tawny-colored tiers. He framed the sides and top edge of the work with garland borders, recalling sixteenth- and seventeenth-century tapestries intended to decorate and insulate large interiors. With its muted colors, flattened forms, and harmonious design, this monumental painting also reflects the decorative aims of the Nabis (or "prophets"), a group of French painters in which Vuillard played a prominent part.

AMERICAN PAINTINGS TO 1906

JOHN SMIBERT

American, born Scotland, 1688-1751

Richard Bill, 1733

Oil on canvas 127.6 × 102.2 cm (50 ½ × 40 ½ in.) Friends of American Art Collection, 1944.28

Born in Edinburgh, Scotland, where he was apprenticed as a house plasterer, John Smibert moved to London in 1709. He developed his formal portrait style in Sir Godfrey Kneller's academy in London and through study in Italy. After briefly maintaining a studio in Covent Garden, he left for America in 1728 and eventually settled in Boston, where his marriage into a distinguished family assured him a wealthy clientele. Smibert ran an artist's supply shop and also organized the colonies' first art exhibition, in which he displayed, among other things, his portraits and copies of Old Master works. Accustomed to the products of self-taught painters, colonial viewers were fascinated by Smibert's ability to render detailed textures and light effects.

Dating from early in Smibert's Boston career, *Richard Bill* exemplifies the painter's ability to combine iconographic symbols of English portraiture with direct likenesses of his colonial patrons. The Art Institute's portrait shows a fashionably attired man in a wig and ruffled shirt, underscoring his proud bearing. A letter lying next to the subject's right hand designates him as "Richard Bill, Esq." of Boston. Other elements further identify Bill as an important and powerful shipping merchant: for example, the ship indicates the family's wealth. Smibert probably copied that detail from one of the European maritime prints he sold in his shop.

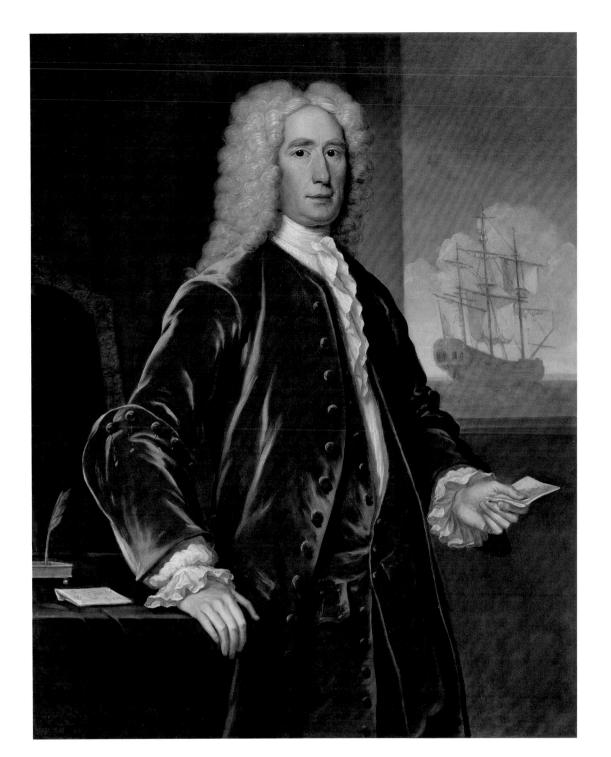

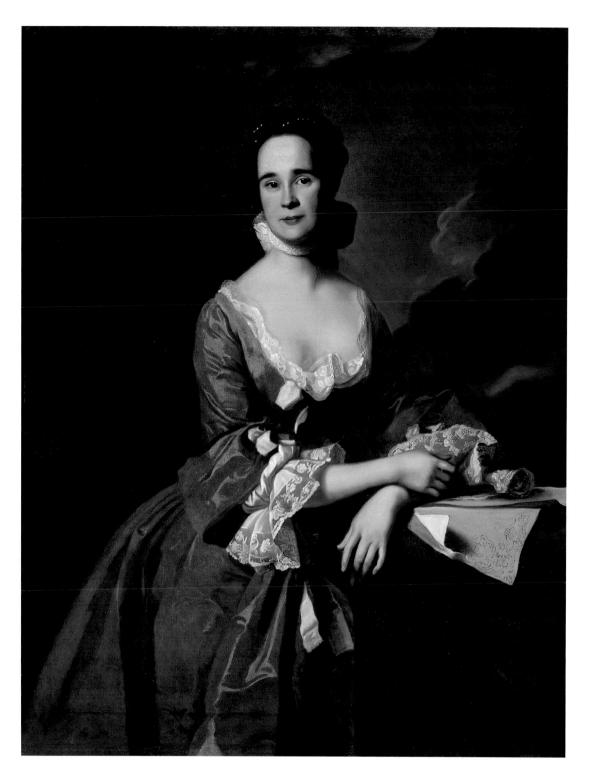

JOHN SINGLETON COPLEY

American, 1738–1815

Mrs. Daniel Hubbard (Mary Greene), c. 1764

Oil on canvas

 $127.6 \times 100.9 \text{ cm} (50^{-1/4} \times 39^{-3/4} \text{ in.})$

The Art Institute of Chicago Purchase Fund, 1947.28

The most famous portrait painter in the American colonies before the Revolutionary War, John Singleton Copley was essentially self-taught. From the print collection of his stepfather, Peter Pelham, a mezzotint engraver, Copley learned the conventions of English portraiture—the poses, accessories, and backgrounds that constituted a fashionable likeness. He developed a sophisticated portrait style that was eagerly sought by the colonial merchant and professional classes. The artist produced a large number of penetrating, precisely detailed portraits between the 1750s and 1774, when his Loyalist sympathies led him to leave Boston for London.

Mrs. Daniel Hubbard (Mary Greene) was inspired by a mezzotint copy of an English portrait. Standing on a terrace, Mary Hubbard leans informally on a pedestal, which also holds several sheets of paper decorated with a floral pattern that echoes the lace on her sleeves. The needlework on the paper suggests her embroidery skills, an appropriate talent for such an upper-class woman. A string of pearls woven into her coiffure adds pinpoints of light to her dark hair. Copley also painted a pendant portrait of Mrs. Hubbard's husband, which is in the Art Institute's collection.

JOSHUA JOHNSON

American, c. 1763-after 1825

Mrs. Andrew Bedford Bankson and Son, Gunning Bedford Bankson, 1803/05

Oil on canvas

 $81.3 \times 71.1 \text{ cm} (38 \times 32 \text{ in.})$

Restricted gifts of Robin and Timm Reynolds and Mrs. Jill Zeno; Bulley and Andrews, Mrs. Edna Graham, Love Galleries, Mrs. Eric Oldberg, Ratcliffe Foundation, and Mr. and Mrs. Robert O. Delaney funds; Walter Aitken, Dr. Julian Archie, Mr. and Mrs. Perry Herst, Jay W. McGreevy, John W. Puth, Stone Foundation, and Mr. and Mrs. Frederick G. Wacker endowments; through prior acquisitions of the George F. Harding Collection and Ruth Helgeson, 1998.315

Joshua Johnson was the first African American to achieve professional standing as an artist. Little is known about him, and his extant oeuvre consists of fewer than one hundred paintings. The son of a white man and a black slave, Johnson was released from slavery in 1782. Although he may have received instruction from members of the Peale family of artists (see p. 79), by 1798 he was advertising his skills as a "self-taught genius" in the *Baltimore Intelligencer*.

In Baltimore Johnson lived in a neighborhood of prominent Abolitionists and formed close ties with members of that community, such as the Bankson family. This portrait of Mrs. Andrew Bedford Bankson and her son, Gunning, is characteristic of the elegance and detail with which Johnson conveyed contemporary fashions. The artist's female subjects often wear jewelry; in this portrait, Mrs. Bankson's hair is bound with a double circlet of light, glass beads. Johnson also depicted her in a stylish light brown garment with a lace ruffle accentuating its low neckline. The child is clothed with an equal sense of fashion; he wears a highwaisted, white-muslin gown and holds in his right hand a strawberry, a brightly colored delicacy that Johnson often included in his portraits.

AMMI PHILLIPS

American, 1788-1865

Cornelius Allerton, 1821/22

Oil on canvas 84.1 × 69.5 cm (33 × 27 ½ in.) Gift of Robert Allerton, 1946.394

As the wealth and population of western New England increased, individuals often wished to record their success by preserving their own or their family members' likenesses for posterity. With this increased demand, talented sign painters such as Ammi Phillips saw new opportunities. Phillips taught himself to be a limner—a painter of portraits. By 1811 he had learned painting techniques from other Connecticut limners, who executed full-length, three-quarter, or bust portraits on canvas, wood, or glass. Phillips began to use conventional poses adopted from European prints and became one of the most successful portraitists of the middle and upper classes in rural New England.

Here Phillips depicted Dr. Cornelius Allerton seated in a painted chair against a somber, gray background. Although the sitter's face is relatively unmodeled, the artist's careful rendering of detail captures a sense of his individuality. The inclusion of a volume of *Parr's Medical Dictionary* conveys Allerton's profession, while a tiny horse in the distance may suggest his financial status. Itinerant painters such as Phillips were often commissioned to portray several members of a family; in this case, Phillips also completed portraits of Allerton's mother (also in the Art Institute's collection) and mother-in-law (Hartford, Connecticut Historical Society).

RAPHAELLE PEALE

American, 1744-1825

Still Life—Strawberries, Nuts, &c., 1822 Oil on wood panel $_{41.1}\times_{57.8}$ cm (16 $_{3}$ /8 × 22 $_{3}$ /4 in.) Gift of Jamee J. and Marshall Field, 1991.100

Now acknowledged as America's first professional still-life painter, Raphaelle Peale experienced little success during his lifetime. The eldest son of the Philadelphia artist and pioneering museum director Charles Willson Peale, Raphaelle was a member of what has been called the founding family of art in the United States. The senior Peale named his children after famous Old Master painters (including

Rembrandt, Titian, and Rubens, as well as Raphael) and encouraged them to achieve artistic greatness. Although Raphaelle Peale was trained in portraiture, the more prestigious genre in which his father excelled, he devoted himself to the less admired and less lucrative genre of still life. In the face of illness, chronic debt, and an unhappy marriage, Peale managed to produce approximately one hundred fifty still lifes, of which only around fifty survive.

This particularly fine, late example typifies Peale's oeuvre and displays his prodigious talent for trompe-l'oeil (fool-the-eye) effects. The artist created a restrained and harmonious display of food, crockery, and glassware against a bare, dark background. He painstakingly balanced horizontal and vertical elements: the dish filled with nuts is offset by the upright compote, for

example. The picture is also typical of Peale's still lifes in its convincing depiction of a variety of textures and in such elegant touches as the raisins that seem to stray from the bowl.

Still Life—Strawberries, Nuts, &c. also offers insight into the artist's life. The unusual combination of winter and summer fruits reflects his family's botanical experiments: among the plants raised in their greenhouse were such precious products as these out-of-season strawberries. A luxury item of a different sort is the piece of Chinese export porcelain. Peale's emphasis on consumer goods, both food and decorative objects, made his paintings particularly attractive to the increasingly commercial society of nineteenth-century America.

THOMAS COLE

American, born England, 1801–1848

Distant View of Niagara Falls, 1830

Oil on panel 47.9×60.6 cm (18 $^{7}/_{8} \times 23$ $^{7}/_{8}$ in.) Friends of American Art Collection, 1946.396

In mid-nineteenth-century America, a love of the "sublime" landscape, inspiring in the viewer an almost spirited sense of destiny, was nowhere felt more powerfully than at Niagara Falls, New

York, by far the most frequently depicted and visited natural spectacle in the United States. Thomas Cole, founder of the Hudson River School of landscape painting, visited Niagara Falls for the first time in May 1829. He sketched the falls, writing of his experience there: "I anticipated much—but the grandeur of the falls far exceeds anything I had been told of them—I am astonished that there have been no good pictures of them—I think the subject a sublime one."

The Art Institute's canvas expresses the untamed spirit of the waterfall that so impressed Cole. As was typical, he did not execute the

painting directly before his motif; his letters indicate that he finished it in London the next year. The completed image bears little resemblance to the actual site in the 1830s, which included factories, scenic overlooks, and hotels to accommodate a growing number of tourists. In his romanticized depiction of the pristine landscape—definitively identified as American by the Native American figures—Cole created a wistful look back at the vanishing wilderness of the United States.

WILLIAM SIDNEY MOUNT

American, 1807-1868

Bar-Room Scene, 1835

Oil on canvas

57.4 × 69.7 cm (22 ⁵/8 × 27 ⁷/16 in.)

The William Owen and Erna Sawyer Goodman Collection, 1939.392

In contrast to the panoramic, heroic landscapes of Thomas Cole and Frederic Edwin Church (see pp. 80 and 82, respectively), the genre paintings of William Sidney Mount depict activities of everyday life in the early to mid-nineteenth-

century United States. Mount learned to paint signs and portraits from his brother in New York City and then attended more formal art classes, copying prints and casts at the National Academy of Design. He became one of the most successful American painters of his age. In the 1830s, in fact, prints of several of Mount's pictures were distributed throughout Europe, making him one of the few American artists known outside the United States at that time.

Bar-Room Scene is typical of Mount's socially engaged work. In the painting, a boisterous figure, raising a drinking vessel over his head, stamps his feet along the floor line as others clap a beat or watch his feet. The illuminated central

area contrasts sharply with the shadowed right side, where an African American man watches the activity. He does not participate in the revelry as an equal, and his facial features are broadly stereotyped. Yet *Bar-Room Scene* also shows the public house as a site of Jacksonian populism in action—a space open to all types. The painting alludes to the issue of temperance as well. The notice for a temperance meeting posted on the back wall appeals to the viewer's sense of irony that such an event should be advertised in a bar. As is typical of Mount's work, *Bar-Room Scene* offers a complex view of antebellum social politics in the guise of a humorous genre painting.

FREDERIC EDWIN CHURCH

American, 1826-1900

View of Cotopaxi, 1857

Oil on canvas

 62.2×92.7 cm ($24^{-1}/2 \times 36^{-1}/2$ in.) Gift of Jennette Hamlin in memory of Mr. and Mrs.

Louis Dana Webster, 1919.753

A leading American landscape painter of the mid-nineteenth century, Frederic Edwin Church studied for four years with Thomas Cole (see p. 80), absorbing his descriptive, yet Romantic landscape style. While Church, like Cole, found inspiration in the wilderness of his homeland, he also became fascinated by the natural beauty of the dense rainforests and mountainous terrain of Latin America. He made his first voyage there in 1853, inspired by the writings of the German naturalist Alexander von Humboldt. Humboldt had described his scientific explorations of South America in his book *Cosmos* (first published in English in 1849). He encouraged painters to turn their gaze to this untamed New World, presenting the region as both a symbol of primordial nature and a source for spiritual renewal.

Church executed the Art Institute's landscape

almost four years after he viewed Cotopaxi, the famed Ecuadorian volcano, working from sketches and his memory of the place. With carefully rendered detail, he depicted the area's lush flora, waterfall, and hills leading to the distant peak. An elevated vantage point permits us to witness an awesome vista filled with contrasts—abundant, green foliage and rugged, barren slopes; calm and explosive water; great warmth and extreme cold. In this panoramic composition, Church evoked the new Eden of South America that Humbolt described.

ALBERT BIERSTADT

American, born Germany, 1830-1902

Mountain Brook, 1863

Oil on canvas

111.8 × 91.4 cm (44 × 36 in.)

Restricted gift of Mrs. Herbert A. Vance; fund of an anonymous donor; Wesley M. Dixon, Jr., Fund and Endowment; Henry Horner Straus and Frederick G. Wacker endowments; through prior acquisitions of various donors, including Samuel P. Avery Endowment, Mrs. George A. Carpenter, Frederick S. Colburn, Mr. and Mrs. Stanley Feinberg, Field Museum of Natural History, Mr. and Mrs. Frank Harding, International Minerals and Chemicals Corp., Mr. and Mrs. Ralph Loeff, Mrs. Frank C. Miller, Mahlan D. Moulds, Mrs. Clive Runnells, Mr. and Mrs. Stanley Stone, and the Charles H. and Mary F. S. Worcester Collection, 1997:365

By 1861 German-born Albert Bierstadt's majestic paintings of the American West had earned him the respect of his peers and the status of full academician at New York's prestigious National Academy of Design. To expand his reputation, Bierstadt also painted New England subjects. When he created *Mountain Brook*, set in New Hampshire's White Mountains, this area rivaled tourist spots such as Niagara Falls and the Catskills in popularity. Bierstadt probably developed his composition during an 1860 trip to the region with his younger brothers, Charles and Edward, both of whom were photographers.

In this painting, Bierstadt traced a mountain stream's path through the heart of a forest. He conveyed the depth of the scene with a subdued palette of dark russet, browns, and greens. Shafts of sunlight pierce the canopy of the forest, highlighting the central boulder and white ribbon of the stream. A small, blue-and-white bird perched above the waterfall provides a means to gauge scale, and adds a note of delicacy to this image of wilderness.

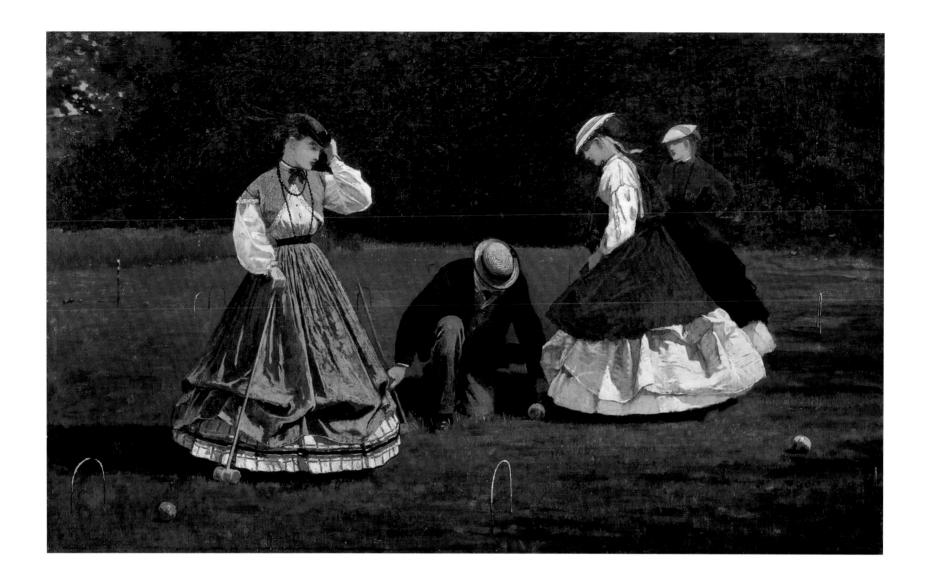

WINSLOW HOMER

American, 1836-1910

Croquet Scene, 1866

Oil on canvas 40.3×66.2 cm (15 $^{7}/_{8} \times 26$ $^{1}/_{16}$ in.) Friends of American Art Collection; Goodman Fund, 1942.35

Employed as an illustrator during the Civil War, Winslow Homer began to work in oil in 1862, remaining, for the most part, a self-taught artist. His early paintings demonstrate how his skills as a draftsman and printmaker informed his art: graphic qualities such as broad planes and carefully constructed spatial organization appear in many of these works, including *Croquet Scene*. After the war, Homer focused on the leisure pursuits of the upper class. In oil paintings such as this example, he portrayed these subjects with acute observational skills, without sentimentalizing them.

Croquet was introduced to America at midcentury from Ireland and England. Homer portrayed people engaged in the game in a series of paintings, of which the Art Institute's is an outstanding example. Despite the attention given to the players' clothing, in the bright sunlight the forms of the four figures seem to flatten out against the lawn and trees behind them. Indeed, the contrast of the dense, dark foliage and the bright hues of the women's fashionable dresses seems to silhouette the figures against the background. As the woman in red prepares to place her foot upon the croquet ball (presumably to knock away that of her opponent), the male figure in the center leans down to adjust the placement of the ball. While this gesture represents a chivalrous effort to help the female player maintain her modest pose, it also provides him with a rare view of her ankle. Croquet Scene embodies Homer's consummate ability to capture both the visual and societal details of his world.

JAMES MCNEILL WHISTLER

American, 1834-1903

Nocturne: Blue and Gold—Southampton Water, 1872 Oil on canvas 50.5×76 cm (19 $^{7}/8 \times 29$ $^{15}/_{16}$ in.) Stickney Fund, 1900.52

A celebrated spokesman for the Aesthetic movement in art, James McNeill Whistler insisted that the primary task of the painter is to present a harmonious arrangement of color and form on a flat surface rather than to depict a narrative subject. To underscore this approach, as well as suggest a relationship between art and music, he titled his paintings "Arrangements," "Symphonies," and "Nocturnes," which mystified the public.

Nocturne: Blue and Gold—Southampton Water is one of the first compositions to which Whistler gave such an appellation. Writing to thank his patron Frederick Leyland for suggesting this term to him, Whistler enthused:

"I say I can't thank you too much for the name 'Nocturne' as a title for my moonlights! You have no idea what an irritation it proves to the critics and consequent pleasure to me—besides, it is really so charming and does so poetically say all I want to say and no *more* than I wish." Rather than emphasizing the ships one can discern in an inlet, here Whistler concentrated on capturing the mood created by a specific time of day (a moonlit night) and the dominant color harmony (blue and gold). In fact he relegated the ships to either side of the composition, creating a kind of visual frame for the tranquil expanse of water and sky at the painting's center.

EASTMAN JOHNSON

American, 1824-1906

Husking Bee, Island of Nantucket, 1876 Oil on canvas 69.3×137 cm $(27^{-1/4} \times 54^{-3/16}$ in.) Potter Palmer Collection, 1922.444 Late on a fall day, the American portrait and genre painter Eastman Johnson was riding with his wife through the island of Nantucket, where they had a vacation home. As Elizabeth Johnson later recalled, they came upon the scene that would inspire the Art Institute's painting, complete with "the yellow corn and husks, the bright chickens running about [and] the old sea captains with their silk hats of better days."

Reflecting his training abroad in the 1850s, Johnson imbued the indigenous American activity of the husking bee with the directness and naturalism of French mid-nineteenth-century landscape painting, creating a somewhat romanticized view of rural life. In the Art Institute's work, broadly applied patches of red, blue, and green and the shimmering gold of the husks of corn establish a sense of the season. Images of harvest and Thanksgiving abound. Two rows of figures face each other as they compete to husk

corn for winter storage. A woman on the right finds a red ear of corn, which, according to folk tradition, allows her to kiss the person of her choice; on the far right, in the middle distance, people prepare a feast to celebrate the event.

In fact, when Johnson painted *Husking Bee, Island of Nantucket*, industrialization was revolutionizing American agriculture, forcing small farmers to abandon their land and seek work in cities; yet this painting reveals none of these sweeping economic and social changes. The year in which he executed this canvas, 1876, marked the United States' centennial; *Husking Bee, Island of Nantucket* celebrates the sort of deeply treasured American values—hard work, democracy, and economic independence—that were honored during the nation's hundredth year. The painting depicts a nostalgic vision of American life, with a pre-industrial, classless society engaged in a communal task.

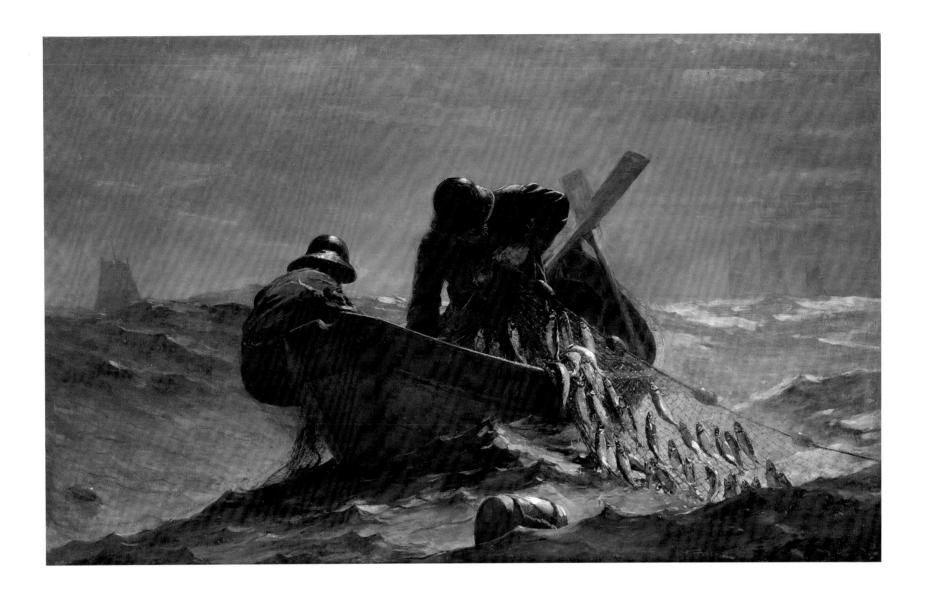

WINSLOW HOMER

American, 1836-1910

The Herring Net, 1885

Oil on canvas 76.5×122.9 cm $(30^{-1}/8 \times 48^{-3}/8$ in.) Mr. and Mrs. Martin A. Ryerson Collection, 1937.1039

During the 1870s, Winslow Homer often represented the lives of fishermen and their families, which he witnessed during visits to Gloucester, Massachusetts, and other small villages along the New England coast. While these summer excursions encouraged his interest in the sea, a trip in 1881–82 to Cullercoats, England, fundamentally changed his work and way of life. From this date forward, Homer attempted to capture the unceasing hardship of men and women struggling to survive in the face of the enormous forces of nature.

The year after Homer returned from England, he moved to an isolated cottage overlooking the Atlantic at Prout's Neck, Maine. There

he observed the powerful ocean and the heroic efforts of those who depended on it for their livelihood. Homer painted *The Herring Net* after spending hours at sea sketching fishermen. Riding in a small boat that hovers precariously between high waves, two anonymous, statuesque figures loom large against the horizon, along which appear mist-shrouded forms of distant ships. The men's haul, the netted herring—a staple of the New England fishing industry—glistens in the misty atmosphere. Like so many of Homer's paintings on this theme, the image evokes humanity's complex relationship with nature.

WILLIAM MERRITT CHASE

American, 1849-1916

A City Park, c. 1887

Oil on canvas 34.6 × 49.9 cm (13 ⁵/8 × 19 ⁵/8 in.) Bequest of Dr. John J. Ireland, 1968.88

William Merritt Chase was one of the most influential painters in the United States at the turn of the twentieth century. After an extended stay in Europe, which ended when he established his studio in New York City in 1878,

Chase demonstrated his extraordinary versatility, painting portraits, landscapes, still lifes, and genre scenes. His vigor as a painter was equaled by his long and successful career as a teacher: his classes at the Art Students League in New York and the Shinnecock Hills Summer School on Long Island attracted many students.

In the mid-1880s, Chase embarked on a group of paintings inspired by the parks of New York City. Influenced by the brilliant colors and unorthodox compositional formats of the French Impressionists, he often countered a broad, comparatively empty foreground with a detailed background. In the Art Institute's

painting, which probably depicts Brooklyn's Tompkins Park, almost half of the canvas is filled by the wide, empty walkway, which, with its strong diagonal borders, carries the eye into the composition. This swift movement into space is slowed by the woman on the bench, who appears to gaze expectantly toward someone approaching along the path. To the left, colorful flowers provide a contrast to the bare walk at the right. This informal, seemingly spontaneous work, capturing the sparkle, light, and activity of a summer day, testifies to the freshness and vitality Chase brought to the painting of such scenes.

MARTIN JOHNSON HEADE

American, 1819-1904

Magnolias on Light-Blue Velvet Cloth, 1885/95

Oil on canvas

 $38.6 \times 61.8 \text{ cm} \left(15^{-1/4} \times 24^{-3/8} \text{ in.}\right)$

Restricted gift of Gloria and Richard Manney;

Harold L. Stuart Endowment, 1983.791

Never settling in one place long enough to pursue formal artistic training, Martin Johnson Heade lived in New York City, Philadelphia, St. Louis, Chicago, Trenton, Providence, Boston, and finally in St. Augustine, Florida. In addition to trips to England and the Continent, Heade traveled three times to Brazil to study exotic flora and fauna. Over his long career, he painted a wide range of subjects, including pristine, sensitive views of East Coast salt marshes, romantic images of South American forests, and still lifes of both native and foreign flowers and birds, most famously in a series of Brazilian orchids and hummingbirds.

In St. Augustine, Heade executed carefully rendered arrangements of the local flora, including roses, orange blossoms, water lilies, and lotus blossoms. The Art Institute's *Magnolias on Light-Blue Velvet Cloth* is one of at least five sensuous and decorative compositions by Heade featuring this lemon-scented flower. Here the shiny leaves, rough bark, and smooth petals lying on blue velvet present a variety of rich textures. Heade's depiction of magnolias captures the curvaceous flower's delicate texture and subtle, pale hues.

WILLIAM MICHAEL HARNETT

American, born Ireland, 1848–1892

For Sunday's Dinner, 1888

Oil on canvas 94.3 × 53.6 cm (37 ½ × 21 ⅙ in.) Wilson L. Mead Fund, 1958.296

In nineteenth-century America, where still-life painting was not as highly regarded as anecdotal scenes or landscapes, William Harnett became an adept painter of deceptively real pictures, called trompe l'oeil (fool the eye). In 1880, after studying in Philadelphia and New York, Harnett settled in Munich, Germany, where he remained for six years. There he sold small, increasingly lavish trompe-l'oeil paintings to tourists. By the time Harnett returned to the United States, collectors had learned to appreciate—and to pay high prices for—such detailed still lifes, associating them with Old Master paintings they could not afford.

Harnett painted For Sunday's Dinner when his reputation was at its peak. While he tended to fill his composition with a number of carefully arranged objects, this work represents a single, plucked chicken, ready to be cooked. The bird is shown life-size, its remaining feathers catching the light and appearing to float off into the air. The weathered surface against which it hangs, with its chipped and cracked boards and brass hinges, is depicted with emphatic presence and clarity. The rough door, along with the painting's title, suggests an unpolished country meal, hinting at nostalgia for a simpler past.

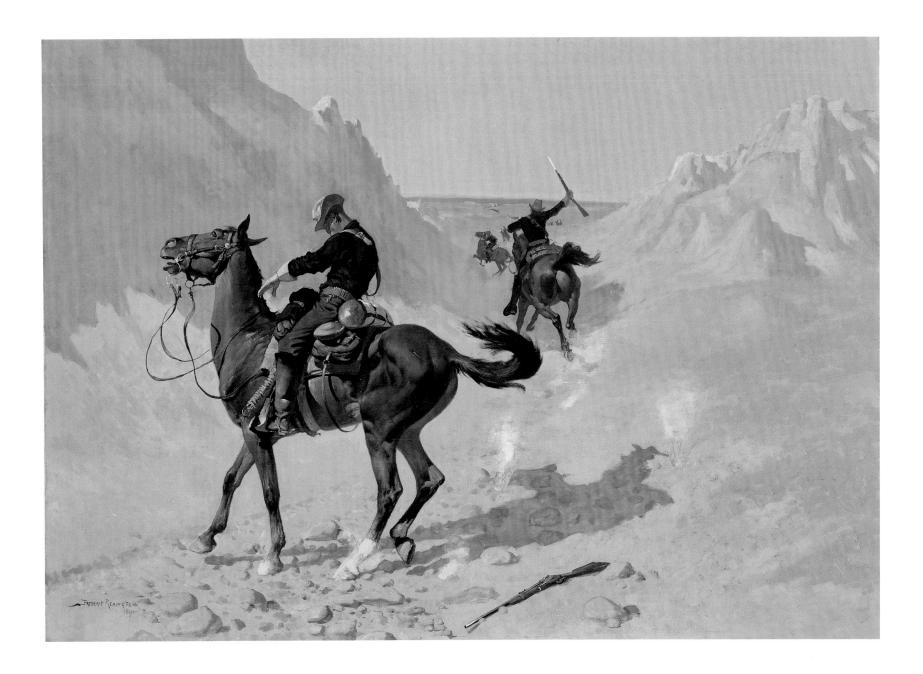

FREDERIC REMINGTON

American, 1861-1909

The Advance Guard, or The Military Sacrifice, 1890 Oil on canvas

 87.3×123.1 cm $(34^{-3}/8 \times 48^{-1}/2$ in.) George F. Harding Collection, 1982.802

Born in Canton, New York, and later a student at the Yale School of Art in New Haven, Connecticut, and the Art Students League in New York City, Frederic Remington gained widespread distinction for his heroic, even

mythic, vision of life in the American West. Remington lived in Montana and Kansas, working as a ranch hand in the early 1880s. He traveled across the West and Southwest, where he observed Native American customs, ranch life, and soldiers on horseback patrolling the frontier. Capturing the individuality and self-determination of these populations with a superb sense of drama, Remington romanticized the vanishing life of the Old West in bronze sculptures, magazine illustrations, and etchings, as well as oil paintings.

During the late 1880s, Remington worked as an illustrator for *Harper's Weekly* and

accompanied the U.S. Sixth Cavalry as it pursued the Sioux, Native Americans of the northern plains, across the canyons of the Badlands. To protect the regiment from ambush, commanders sent single cavalrymen far ahead to draw their adversaries' fire. *The Advance Guard* depicts the moment when the regiment's forward-most sentinel is shot by a Sioux warrior hidden in the rocky ravine. Remington meticulously represented the cavalryman's self-sacrifice in the brightly lit foreground. The stricken soldier's companions retreat hastily to warn the regiment of the imminent danger.

GEORGE INNESS

American, 1825-1894

Early Morning, Tarpon Springs, 1892

Oil on canvas

107.2 × 82.1 cm (42 ¹/₄ × 32 ³/₈ in.) Edward B. Butler Collection, 1911.32

In 1878 the painter George Inness wrote in *Harper's* magazine:

Details in the pictures must be elaborated only enough fully to reproduce the impression that the artist wishes to reproduce.

When [there are more details], the impression is weakened or lost, and we see simply an array of external things which may be cleverly painted and may look very real, but which do not make an artistic painting. . . . The one is poetic truth, the other is scientific truth; the former is aesthetic, the latter is analytic.

In the course of his lengthy career, Inness increasingly eschewed precision of detail in his paintings, conveying mood and emotion through richness of tone and broadness of handling. He first visited Florida about 1890, and subsequently established a house and studio in Tarpon Springs, where he executed the Art Institute's painting. In a pink-and-blue morning light, a lone man studies a cluster of buildings in the middle distance. Through blurred outlines and delicate, subtle tonalities, as well as the solitary presence of the figure, Inness masterfully evoked the brightening day and peaceful mood of this moment.

MARY CASSATT

American, 1844-1926

The Child's Bath, 1893

Oil on canvas 100.3 × 66.1 cm (39 ½ × 26 in.) Robert A. Waller Fund, 1910.2

Mary Cassatt grew up in a wealthy family and studied at the Pennsylvania Academy of the Fine Arts from 1861 to 1865. In 1866 she traveled to Paris to study with the fashionable and influential painter Jean-Léon Gérôme, and to copy works in the Musée du Louvre. She sent her first painting to the official French Salon in 1868 and, two years later, traveled to Italy and Spain. Eventually, she settled in Paris and became one of America's foremost expatriate painters. By 1877 Cassatt had met Edgar Degas; she later accepted his invitation to exhibit with the French Impressionists, becoming the only American to do so.

The Child's Bath reflects Cassatt's interest in exploring unorthodox compositional devices, which she learned in part from her study of Japanese prints. In this case, the elevated perspective works to flatten the composition, making the patterns of the wallpaper, painted chest, striped garment, and carpet play off one another. Even more boldly, the torso and bare, pale legs of the child dramatically cut across the diagonal stripes of the woman's dress. The tender rapport between the two figures—the woman assured, supportive, and the child tentative, wary—commands our attention. As one critic wrote of Cassatt's 1893 solo exhibition in Paris, at which The Child's Bath was first exhibited: "Here we find work of rare quality, which reveals an artist of lively sentiment, exquisite taste, and great talent."

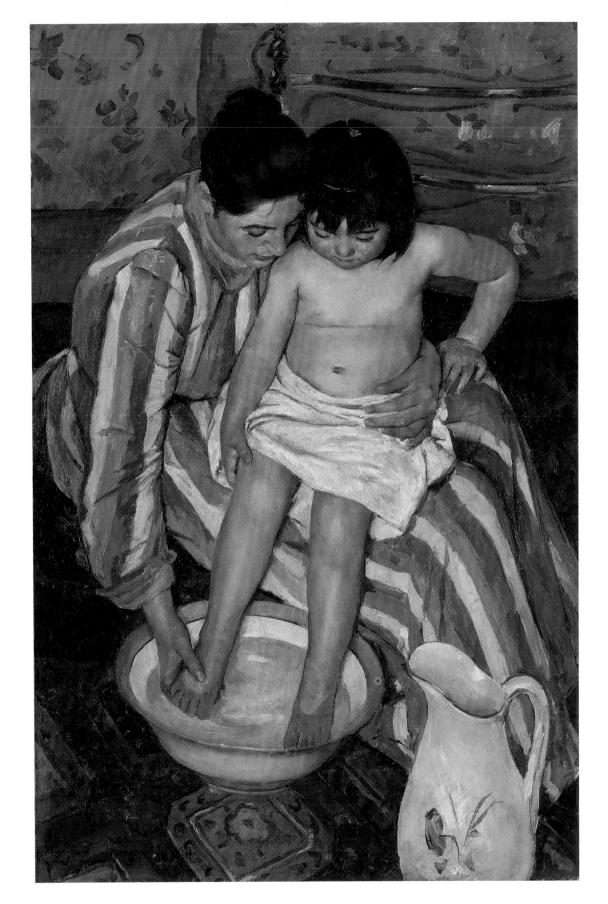

JAMES MCNEILL WHISTLER

American, 1834–1903

Arrangement in Flesh Color and Brown: Portrait of Arthur Jerome Eddy, 1894

Oil on canvas 209.9 \times 92.4 cm (82 5 /s \times 36 3 /s in.) Arthur Jerome Eddy Memorial Collection, 1931.501

By the early 1890s, James McNeill Whistler had begun to earn recognition for his art on both sides of the Atlantic, and received many commissions to portray prominent Americans and Europeans. Sensitive and understated in their characterization of the sitter, his portraits were also conceived as compositions of subtle color and form, as the first part of the title of the Art Institute's work, *Arrangement in Flesh Color and Brown*, demonstrates.

This portrait depicts Arthur Jerome Eddy, a Chicago lawyer. Eddy asked Whistler to paint his likeness after seeing the artist's work in the World's Columbian Exposition, held in Chicago in 1893. Eddy traveled to Whistler's Paris studio, where the two apparently formed a lasting friendship. The year of Whistler's death, Eddy wrote *Recollections and Impressions of James A. McNeill Whistler* (1903) as a memorial to the painter.

In the portrait, Whistler used a muted palette and placed his subject against a subdued, gray background. Eddy commented on the artist's technique: "It was as if the portrait were hidden within the canvas and the master by passing his wand day after day over the surface evoked the image." In 1913 Eddy purchased many works from the famous Armory Show, which introduced Americans to avant-garde art from Europe and the United States (and enraged many in the process). This exhibition, which Eddy helped bring to the Art Institute of Chicago, prompted him to write the first book by an American on modern European art, Cubists and Post-Impressionism (1914). The Arthur Jerome Eddy Memorial Collection, including this portrait, was presented to the Art Institute in 1931.

THOMAS EAKINS

American, 1844-1916

Mary Adeline Williams, 1899

Oil on canvas $61\times51~cm~(24\times20~^{1/16}~in.)$ Friends of American Art Collection, 1939.548

One of the leading American artists of his time, Thomas Eakins studied art in his native Philadelphia before spending three years at the École des Beaux-Arts, Paris. After his return to the United States in 1870, he lived, taught, and painted in Philadelphia until his death in 1916. Convinced that scientific knowledge of anatomy and perspective is essential for an artist, Eakins insisted that all his students, female as well as male, practice drawing from the nude. This revolutionary stand contributed to his dismissal from the teaching staff of the Pennsylvania Academy of the Fine Arts in 1886.

Eakins's uncompromising realism is apparent in his portraits. These works were not popular in their day, which explains why many of them were private in nature featuring the painter's

ofessional acquaintances.

Adeline Williams, a

Deventually moved

the dark background

Diffure throw into reses. Her erect posture,

brow are softened

hat casts her left side

that illuminates her

ful, inward gaze and

eanor. In such por
ensitivity to subtleties

exities of the human

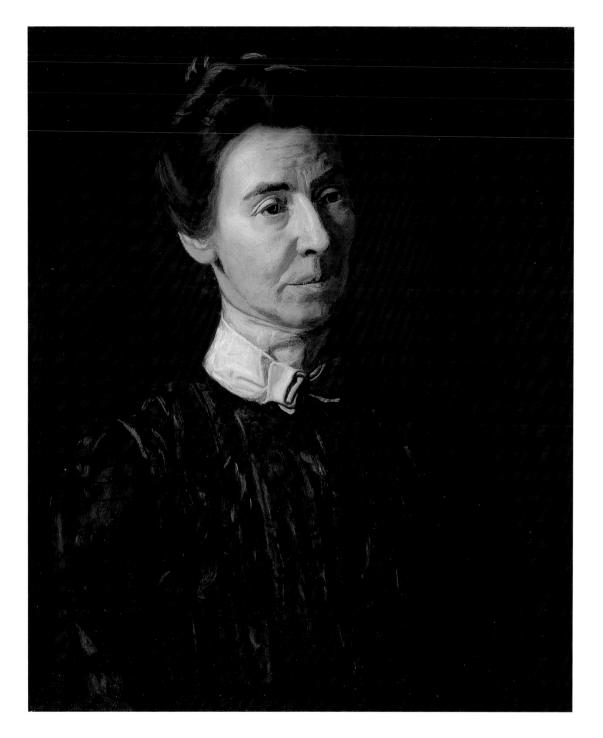

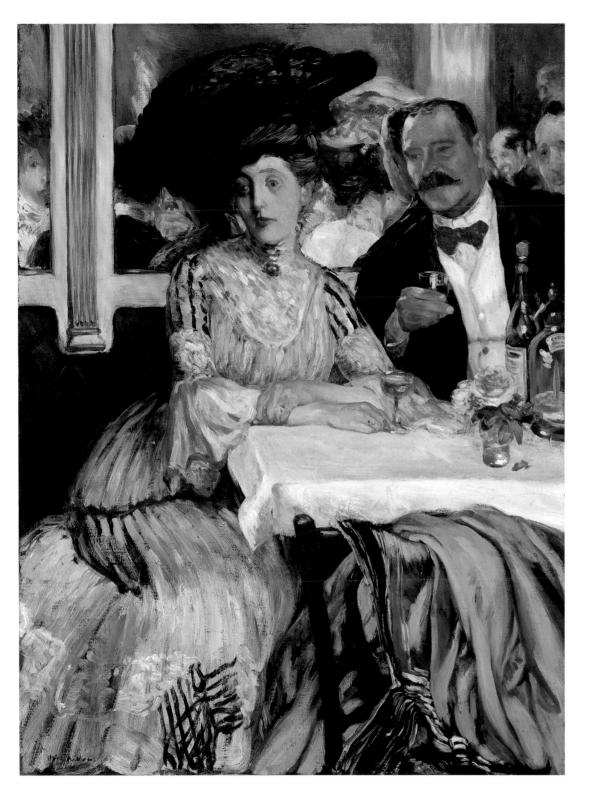

WILLIAM GLACKENS

American, 1870-1938

At Mouquin's, 1905

Oil on canvas $122.4 \times 92.1 \text{ cm } (48 \text{ } \frac{1}{8} \times 36 \text{ } \frac{1}{4} \text{ in.})$ Friends of American Art Collection, 1925.295

William Glackens was a founder of the New York-based group of artists known as the Eight, or the Ashcan School. Active in the early years of the twentieth century, these painters focused on city life, including its most gritty aspects. Glackens differed from his peers in his preference for more bourgeois subjects and in his reverence for French art. In the mid-1890s, the artist spent one year in Paris, and returned to France regularly after that.

Henri Mouquin's restaurant in New York dazzled customers with snails, bouillabaisse, and vintage wines. Immortalized in this 1905 painting, the restaurant was as fashionable and French as Glackens's technique, which he derived from the Impressionists' exuberant and spontaneous method of directly observing and painting everyday life. In Mouquin's mirrored café (there was a formal dining room upstairs), Glackens portrayed his friend James Moore, a lawyer and man-about-town, with a woman who has been identified as Jeanne-Louise Mouquin, wife of the proprietor. Art critic Charles Fitzgerald and Glackens's wife, Edith, are visible in the mirror. Despite the gaiety and glitter of the setting, the two principal figures seem preoccupied, even withdrawn. A similar note of detachment can be seen in the café scenes of Édouard Manet and Henri de Toulouse-Lautrec (see pp. 57 and 69, respectively). In the late nineteenth century, artists often depicted aloofness and introspection in their figures, perhaps reflecting the psychological dislocation of a world in rapid change. In this work, a major example of American painting of the pre-World War I era, Glackens achieved a delicate equilibrium of subject and technique.

JOHN SINGER SARGENT

American, 1856-1925

The Fountain, Villa Torlonia, Frascati, Italy, 1907 Oil on canvas 71.4×56.5 cm $(28^{-1}/8 \times 22^{-1}/4$ in.) Friends of American Art Collection, 1914.57

A celebrated portraitist of high society, John Singer Sargent depicted with elegance and verve the cosmopolitan world to which he belonged. Born in Italy to a wealthy American expatriate couple, Sargent spent most of his career abroad. He developed his acclaimed, fluid technique in the Parisian studio of portrait painter Charles-Emile-Auguste Carolus-Duran and was deeply influenced by the breathtaking brushwork of both the Spanish Baroque master Diego Velázquez and the nineteenth-century French painter Édouard Manet (see p. 57). By the age of twenty-three, Sargent was already exhibiting his work at the official Paris Salon.

Considering London his home after the mid-1880s, the peripatetic artist made frequent sojourns to sunny locales to master painting outdoors. Joining Sargent on an autumn holiday to Italy in 1907 were fellow artists from the United States, Wilfrid and Jane Emmet von Glehn. One of their stops was Villa Torlonia in Frascati, a popular hillside resort near Rome. Sargent painted this charming portrait of the Von Glehns in the villa's elaborately landscaped gardens. One of the artist's most accomplished informal, outdoor portraits, The Fountain, Villa Torlonia, Frascati, Italy celebrates the act of painting. Not only did Sargent show Jane von Glehn creating her own picture, but the sun-drenched setting enabled him to employ thick impasto and virtuoso brushwork to indicate the play of bright light on a variety of textures. By dragging a dry brush down the canvas, he even captured the way spray issues from a fountain. The work's fresh and spontaneous quality belies the artist's careful orchestrating of the Von Glehns' poses, so that figures, architecture, and landscape—as well as light and shade—are perfectly balanced.

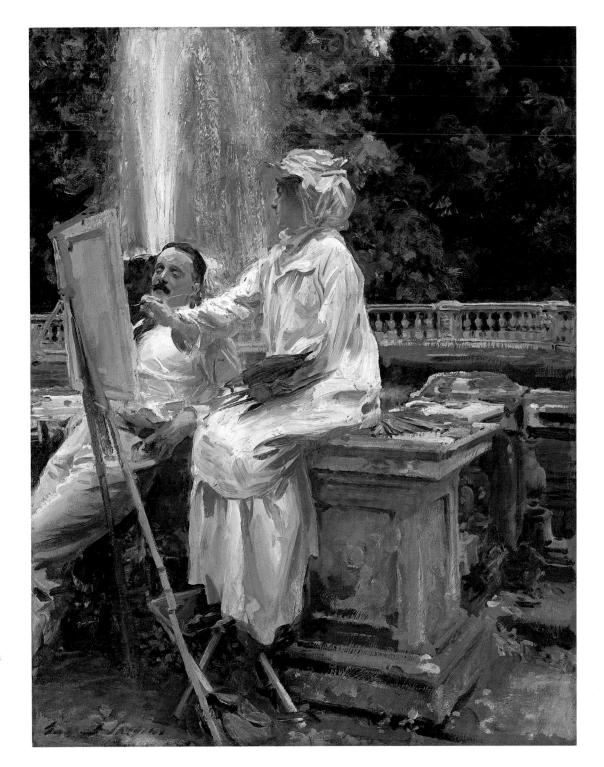

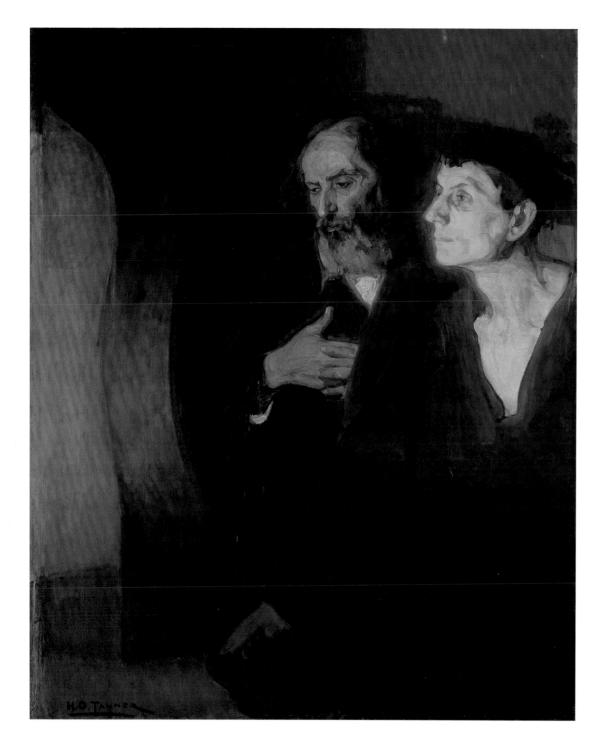

HENRY OSSAWA TANNER

American, 1859-1937

The Two Disciples at the Tomb, c. 1906 Oil on canvas 129.5 × 105.7 cm (51 × 41 ⁷/s in.) Robert A. Waller Fund, 1906.300

The Two Disciples at the Tomb was acquired by the Art Institute in 1906 after the canvas was declared "the most impressive and distinguished work of the season" at the museum's annual exhibition of American painting and sculpture. At that time, Henry Ossawa Tanner was at the height of his reputation, enjoying international fame and winning prizes on both sides of the Atlantic. The son of an African American bishop, Tanner was raised in Philadelphia, where he studied with Thomas Eakins (see p. 95) before working as an artist and photographer in Atlanta. Repelled by the racial prejudice he encountered in the United States, he chose to spend nearly all of his adult life in France.

Tanner's early subjects included many scenes of African American life, but later he specialized in religious paintings. The Two Disciples at the Tomb is one of the most concentrated and austere of these works. The somber spirituality of the moment when two of Jesus's followers realize that he has risen from the dead is conveyed by Tanner's use of dark tones and compressed space and his avoidance of superfluous incident. Although the artist painted in a relatively conservative representational manner throughout his life, the sinuous lines and simplified, harsh modeling here suggest his awareness of Art Nouveau and Expressionist currents in contemporary European painting. Likewise, his emphasis on psychological rather than physical experience has many parallels in advanced art of the same period, including Pablo Picasso's early work, such as The Old Guitarist, painted two years earlier (see p. 101).

MODERNISM TO 1948

PABLO PICASSO

Spanish, 1881–1973

The Old Guitarist, 1903-04

Oil on panel 122.9 \times 82.6 cm (48 $^3/8$ \times 32 $^1/2$ in.) Helen Birch Bartlett Memorial Collection, 1926.253

Pablo Picasso painted *The Old Guitarist*, one of his most haunting images, when he was twenty-two years old. In the paintings of his Blue Period (1901–04), of which this is a prime example, Picasso worked with a monochromatic color palette, flattened forms, and pensive themes. The works he produced in these years reflect the influence on the artist of the Symbolist movement, whose advocates, such as Edvard Munch (see p. 68), used color and abstracted form to impart a sense of emotion and psychology in their art.

The emaciated figure of the blind musician in this painting reflects Picasso's artistic roots in Spain. The old man's elongated limbs and angular posture recall the figures of the great sixteenth-century artist El Greco (see p. 22). The image also reflects Picasso's sympathy for the plight of the downtrodden; he produced many canvases at this time depicting the miseries of the destitute, the ill, and the outcasts of society. Picasso knew what it was like to be poor, having been nearly penniless during all of 1902.

With the simplest means, Picasso presented in *The Old Guitarist* a timeless expression of human suffering. The bent and sightless man holds close to him his large, round guitar—its brown body the painting's only shift in color. This emphasis on the instrument, as well as the man's total absorption in his playing, may reflect Picasso's own belief in the power of art even in the face of adversity.

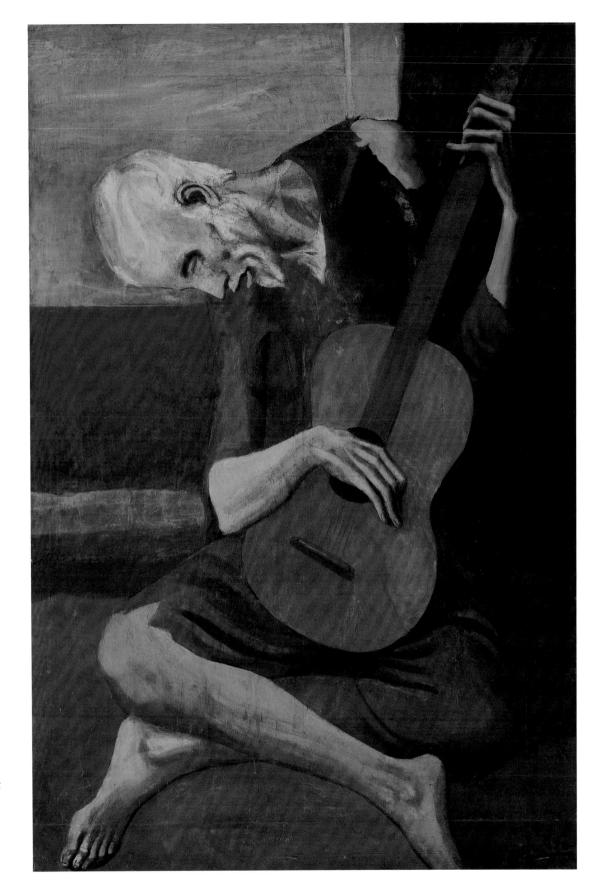

GEORGES BRAQUE

French, 1882-1963

Landscape at L'Estaque, 1906

Oil on canvas

 60.3×72.7 cm $(23^{3}/4 \times 28^{5}/8$ in.)

Restricted gift of Friends of the Art Institute of Chicago in honor of Mary Block; Walter Aitken, Martha Leverone, and Major Acquisition Centennial endowments, 1981.65

Born into a family of decorative and house painters, Georges Braque once remarked that his decision to become a painter was no more premeditated than his choosing to breathe. After apprenticing in his father's shop and studying at an art school in his hometown of Le Havre, he went to Paris. In 1905, at the annual Salon d'Automne, he was confronted by the arresting paintings of Henri Matisse and others who had begun to employ vibrant, unmixed colors, and energetic, rhythmic brushwork. The unbridled intensity of these works prompted a disapproving critic to call the artists "fauves" (wild beasts). Braque quickly joined the group.

Braque painted *Landscape at L'Estaque* on his first trip to this town on the French Mediterranean coast. He and other young artists were drawn to Provence, in southeastern France, because of its clear light and because of their reverence for the art of Paul Cézanne, who

worked in and around the area until his death in 1906. Braque drew upon Cézanne's use of faceted brushwork, distorted perspectives, and color to structure his compositions for this view down a steep, tree-lined road. Using a palette of highly saturated reds, oranges, and yellows, Braque evoked a sense of turbulent heat, despite the shade provided by the trees. Cézanne's influence continued to exert itself over Braque in other, critical ways: in early 1908, he would join Pablo Picasso in the development of a revolutionary new style based on the formal construction that constitutes the core of Cézanne's vision. That style would come to be known as Cubism.

GEORGES BRAQUE

French, 1882-1963

Little Harbor in Normandy, 1909

Oil on canvas

 81.1×80.5 cm (31 $^{15}/_{16}\times31$ $^{11}/_{16}$ in.)

Samuel A. Marx Purchase Fund, 1970.98

Georges Braque's study of Paul Cézanne's art intensified in early 1908, when he began a new artistic collaboration with the Spanish artist Pablo Picasso. Beginning in 1909 and lasting until Braque was drafted to serve in World War I, the two artists sought to break down and reformulate the representation of things and their structure and, in doing so, pioneered Cubism, a radical artistic revolution that would greatly influence artists for many decades of the twentieth century.

Little Harbor in Normandy, painted from memory in his Paris studio, is the first fully realized example of Braque's early Cubist style. Here the artist used severe geometries and a sober palette to describe a coastal scene. Framed by a pair of lighthouse structures, two sailboats—their strongly defined hulls and swelling sails punctuated by spars and masts—enter a harbor and approach a wharf. Braque's compressed treatment of space seems to propel the boats forward to the front edges of the picture. A turbulent, steel-blue sea with a fringe of whitecaps and a stormy blue sky with dashes of white clouds further energize the powerful composition. Documentation suggests that *Little Harbor in Normandy* was exhibited in Paris in March 1909 at the Salon des Indépendants. If so, this painting was the first major Cubist work to have been shown in such a prominent venue of the Paris art world.

PABLO PICASSO

Spanish, 1881-1973

Daniel-Henry Kahnweiler, 1910

Oil on canvas 101.1×73.3 cm $(39^{-13}/_{16} \times 27^{-7}/_{8}$ in.) Gift of Mrs. Gilbert W. Chapman, in memory of Charles B. Goodspeed, 1948.561

It may be difficult at first to see the subject of this painting by Pablo Picasso. Yet, despite its highly abstract character, the artist provided clues to direct the eye and focus the mind: a wave of hair, the knot of a tie, a watch chain. From flickering, partially transparent planes of brown, gray, black, and white emerges the upper torso of a seated man, hands clasped in his lap. To the left is an elongated sculpture similar to a figure from New Caledonia that hung in Picasso's studio, and below this is a small still life.

The process by which we discover and read these details is an important part of the experience of Cubist paintings. No longer seeking to create the illusion of appearances, Picasso invited the viewer to probe the forms that he broke down and recombined in totally new ways. In this work, we are presented with objects whose volumes the artist fractured into various planes, shapes, and contours and presented from several points of view. This early phase of the new style is known as Analytic Cubism.

The portrait's subject, Daniel-Henry Kahnweiler (1884–1979), was a dealer who championed this radical, new style. He opened an art gallery in Paris in 1907; in 1908 he began to represent Picasso, whom he introduced to Braque. Kahnweiler purchased the majority of the paintings they produced between 1908 and 1915. He also wrote an influential book, *The Rise of Cubism* (1920), in which he offered a theoretical framework for the movement.

JUAN GRIS (JOSÉ VICTORIANO GONZÁLEZ)

Spanish, 1887–1927

Portrait of Pablo Picasso, 1912

Oil on canvas 93.3 × 74.4 cm (36 ³/₄ × 29 ⁵/₁₆ in.) Gift of Leigh B. Block, 1958.525

José Victoriano González, known as Juan Gris, traveled to Paris in the summer of 1906 and soon moved to the Bateau-Lavoir, an artist's colony in Montmartre. There he met Pablo Picasso and Georges Braque and eventually joined their circle, which comprised avant-garde artists, writers, and critics, and he witnessed the emergence of Cubism. By January 1912, when Gris began *Portrait of Pablo Picasso*, he too was known as a Cubist, and he was identified by at least one critic as Picasso's "disciple."

Gris's style draws upon the hallmarks of Analytic Cubism (see p. 104)—with its deconstruction and simultaneous viewpoints of objects—but is distinguished by a more systematic geometry and crystalline definition of forms. Gris fractured his sitter's head, neck, and torso into various planes and simple, geometric shapes, but organized them within a compositional structure of repeated diagonals. He further imposed order on the composition by limiting his palette to cool blue, brown, and gray tones that, in juxtaposition, appear luminous and produce a gentle, undulating rhythm across the painting's surface.

Depicted as a painter, palette in hand, Picasso appears here as a formidable presence. The inscription "Hommage à Pablo Picasso," at the bottom right of the painting, demonstrates Gris's respect for his subject as an inventor of Cubism and as artistic leader in Paris. At the same time, the painting and its inscription helped Gris to solidify his own place in the Paris art world when he exhibited the work at the Salon des Indépendents in the spring of 1912.

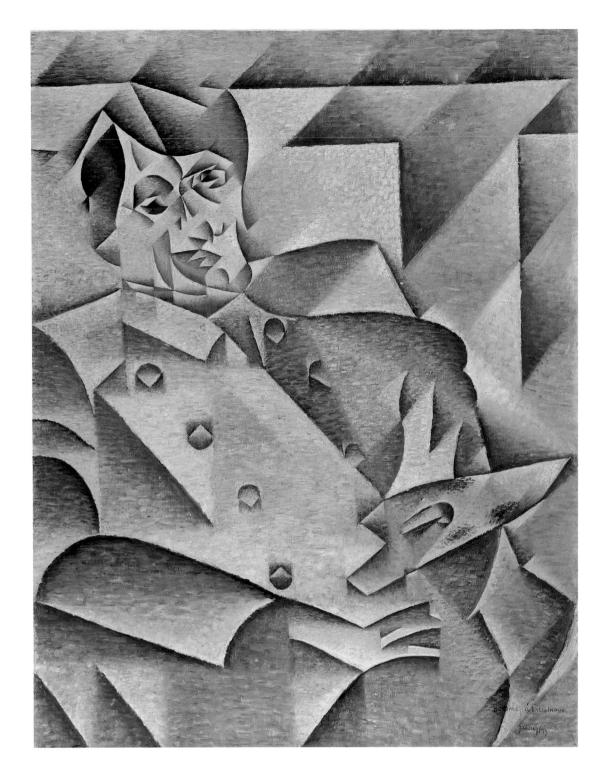

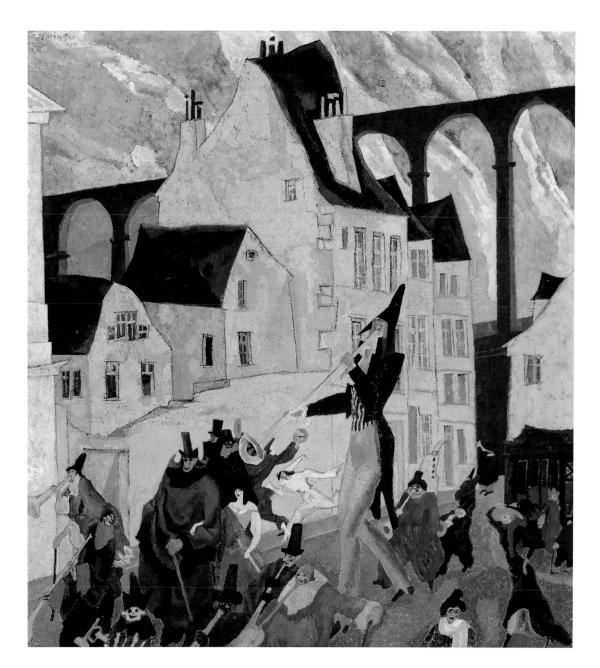

LYONEL FEININGER

American (worked in Germany), 1871-1956

Carnival in Arcueil, 1911

Oil on canvas 104.8 × 95.9 cm (41 ¹/₄ × 37 ³/₄ in.) Joseph Winterbotham Collection, 1990.119

The son of German immigrants, Lyonel Feininger was born in New York and moved to Germany in 1887. By the 1890s, he had become an accomplished cartoonist (his series "Wee Willie Winkie's World" and "Kin-der-Kids" ran for many years in many newspapers, including the *Chicago Tribune*). Feininger began to paint in 1907 and quickly became associated with the German Expressionists. He taught at the famed art school the Bauhaus, until the Nazis closed the school in 1933; four years later, he left Germany for the United States.

Feininger's 1911 Carnival in Arcueil is important not only for the considerable skill it exhibits but also for the way it combines past and future interests of the artist. Feininger spent several months each year in the French city of Arcueil. Depicting its famed Roman viaduct soaring over a row of tall, narrow houses, the composition reveals a fascination with architectural forms that would continue throughout the artist's life. Against this expressive, colorful backdrop, Feininger set a scene of revelry. With their elongated and angular bodies, whimsical costumes, and antic behavior, the fantastic characters in the foreground—like the toy figures and houses Feininger fashioned at the same time—are rooted in the artist's cartooning, in which he was then still involved. While his subsequent work retains the elegance of draftsmanship and keen sense of observation he developed as a cartoonist, Feininger became increasingly committed to expressing universal and spiritual ideas in the color-saturated meditations on architecture, landscapes, and sea scenes for which he is now best known.

ROBERT DELAUNAY

French, 1885-1941

Champs de Mars: The Red Tower, 1911/23

Oil on canvas $160.7 \times 128.6 \text{ cm} (63^{-1/4} \times 50^{-5/8} \text{ in.})$ Joseph Winterbotham Collection, 1959.1

Robert Delaunay was four years old when the Eiffel Tower was erected in Paris in the public green space known as the Champ de Mars. The structure, an engineering triumph, became a symbol for that city and the modern age. One of many artists to depict the landmark, Delaunay infused the dynamism of modern life into this image (which he chose to title "Champs") by employing multiple viewpoints, rhythmic fragmentation of form, and strong color contrasts.

Delaunay accented the structure's commanding presence by framing it with tall, dark buildings and by placing smaller, shorter buildings, seen from above, at its base. The tower's girders are broken and interrupted by planes depicting clouds, walls, and patches of light-filled sky. Its top and struts seem to lean, tumble down, and soar simultaneously. The vigor and strength of the iron structure, which commands the city over which it stands, seems to have affected the surrounding buildings and park, whose fragmented forms appear to dance and merge on the canvas.

The artist first exhibited this painting in the winter of 1912 at the Galerie Barbazanges, Paris. The poet and critic Guillaume Apollinaire described it as "unfinished, whether by design or accident." In 1923 *Champs de Mars* was illustrated in a publication. The reproduction shows that at some point the artist repainted portions of the canvas and filled in areas which had apparently been left blank. Delaunay's reasons for doing this are not recorded, but he did not change the painting again. It looks today as it did in 1923.

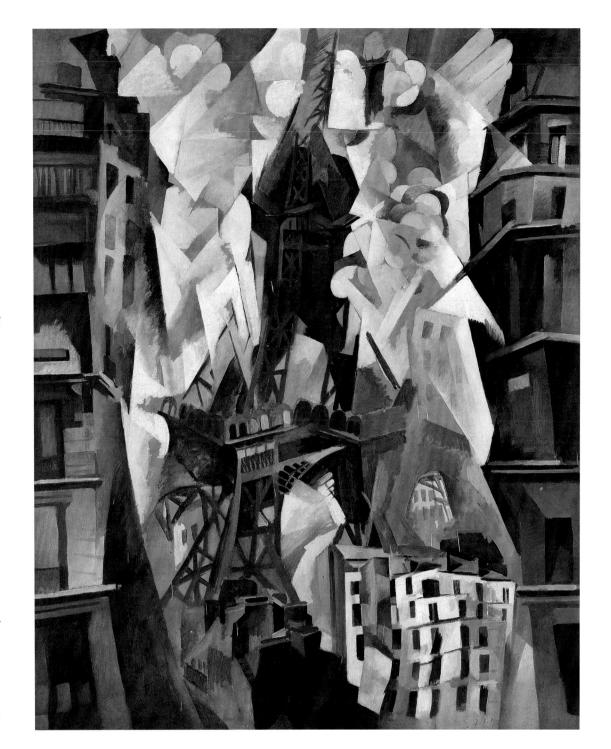

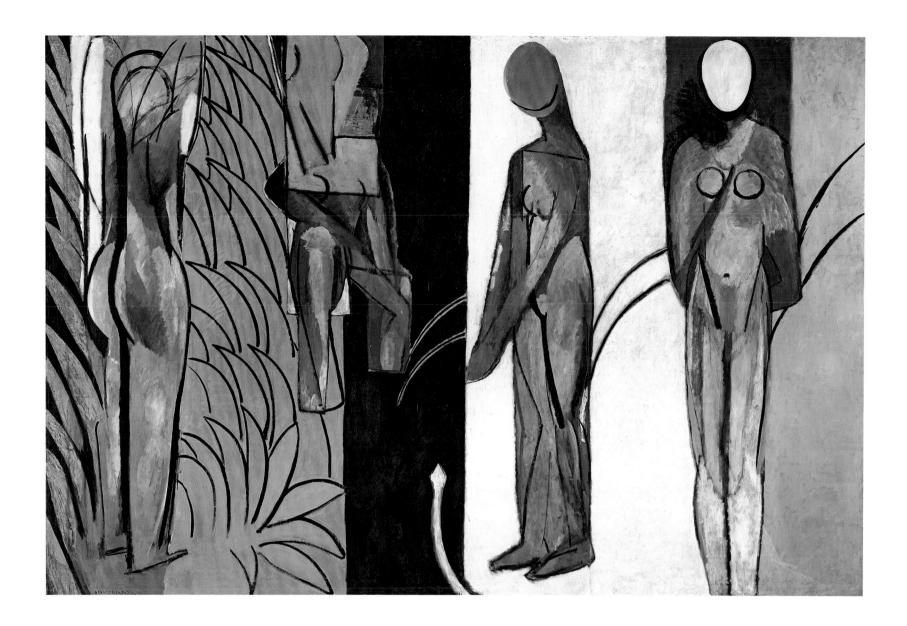

HENRI MATISSE

French, 1869-1954

Bathers by a River, 1909, 1913, and 1916

Oil on canvas 259.7 \times 389.9 cm (102 $^{1}/_{4}$ \times 153 $^{1}/_{2}$ in.) Charles H. and Mary F. S. Worcester Collection, 1953.158

Henri Matisse considered *Bathers by a River* one of the five most "pivitol" works of his career, and with good reason. It played an important role in the evolution of the artist's style over the course of at least seven years. Originally,

the painting was connected to a 1909 commission from the Russian collector Sergei Shchukin, who wanted three murals to decorate the main staircase of his Moscow mansion. Matisse proposed three pastoral images, but in the end Shchukin decided to purchase only two, *Dance II* and *Music* (both now in the State Hermitage Museum, St. Petersburg).

Four years later, Matisse returned to his third canvas, which probably had remained in his studio. He altered the idyllic scene and changed the original pastel palette to reflect his interest in the reigning avant-garde style, Cubism. He reordered the composition and made the figures more rigid and stonelike, with faceless,

ovoid heads. Later Matisse transformed the background into four vertical bands and turned the formerly blue river into a thick, black stripe that divides the canvas. One bather wades into the water, oblivious of the white serpent lurking below. Two bathers, standing on each side of the river, watch her. A fourth figure faces the viewer. With its restricted palette and severely abstracted forms, *Bathers by a River* is far removed from *Dance II* and *Music*, both of which convey a graceful, hedonistic lyricism. The sobriety and hint of danger in the composition may in part reflect the artist's reaction to the devastating, war-torn period during which he completed it.

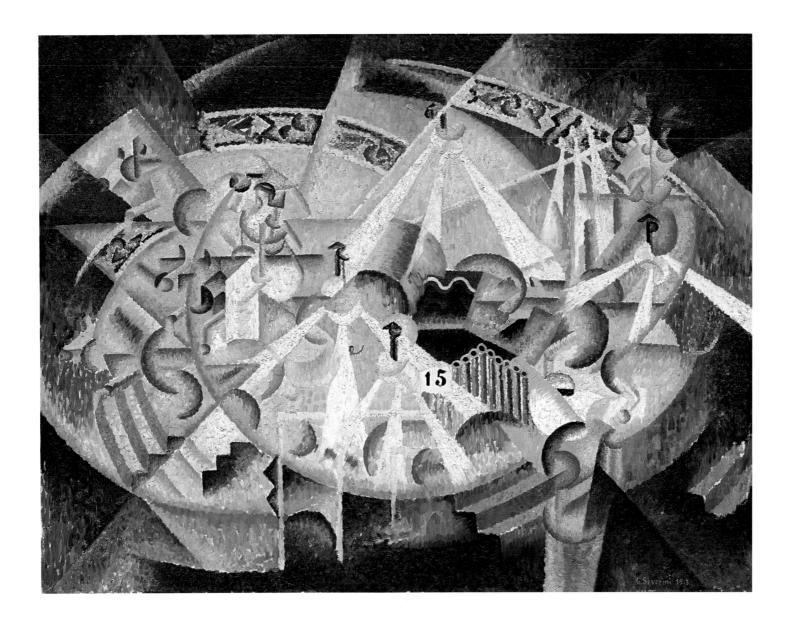

GINO SEVERINI

Italian, 1883-1966

Festival in Montmartre, 1913

Oil on canvas 88.9×116.2 cm $(35 \times 45^{3/4}$ in.) Bequest of Richard S. Zeisler, 2007.281

Gino Severini was a member of the Futurists, a group of Italian artists determined to ignore the past and to focus on the aesthetic power of contemporary life. In their works, they celebrated modernity—the speed and thrill of airplanes, automobiles, and locomotives; the force of machines and factories; the frenetic pace

and cacocphony of the city. They worked in a Divisionist style (painting with "divided," rather than mixed, colors applied directly to the canvas in dots or patches), combined with the interpenetration of chromatic planes and lines of force derived from Cubism.

Severini approached his own work with a touch that was lighter than that of other Futurists; he focused on Parisian entertainments, nightlife, and street activities. In *Festival in Montmartre*, he depicted the centrifugal motion of a carousel and the liberating, yet destabilizing, effects of color, speed, and sound, each indistinguishable from the other. The artist included this work in his first solo exhibition, in 1913. In the catalogue, he stated:

My object has been to convey the sensation of a body, lighted by electric lamps and gyrating in the darkness of the boulevard. The shape of the pink pigs and the women seated on them are the subordinate factors to the whole, whose rotary movement they follow, while undergoing displacement from head to foot and vice-versa.

This celebration of perpetual movement was actually painstakingly executed. The overall effect of blurred velocity belies Severini's meticulously constructed composition, a virtual tapestry of intricately woven daubs of color that overlap in rhythmic patterns.

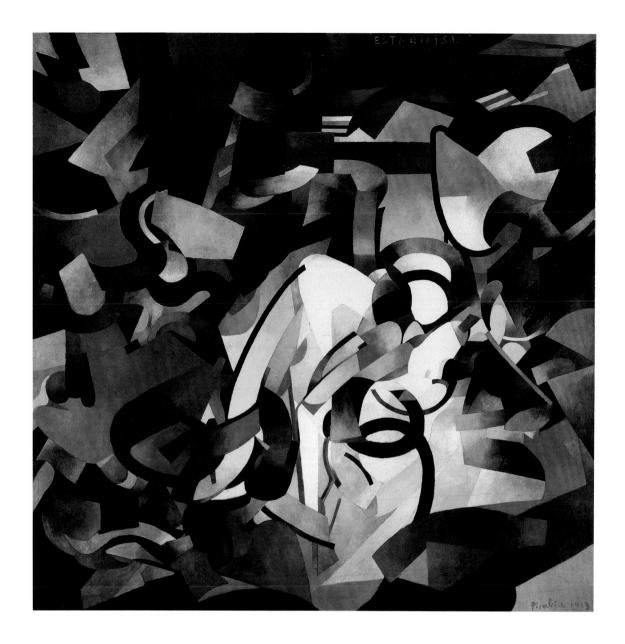

FRANCIS PICABIA

French, 1879–1953

Edtaonisl (Ecclesiastic), 1913

Oil on canvas 300.4×300.7 cm (118 $^{1}/_{4} \times 118$ $^{3}/_{8}$ in.) Gift of Mr. and Mrs. Armand Bartos, 1953.622

Francis Picabia, the son of a Cuban father and a French mother, was one of the most versatile artists of the twentieth century. He abandoned an Impressionist painting style after he met the artist Marcel Duchamp in 1911. Inspired by Duchamp's inventive and humorous Cubist-

influenced style, Picabia developed a new visual language, of which *Edtaonisl* is a prime example.

According to Picabia, this large painting relates to an experience he had aboard a ship in 1913, on his way from Europe to the opening in New York City of the Armory Show, North America's first major exhibition of modern art (see p. 94). The composition reflects his observations of two fellow passengers, an exotic dancer named Stasia Napierskowska, who was well known in Paris, and a Dominican priest who could not resist the temptation of watching her rehearse with her troupe. While the tumultuous shapes suggest fragments of bodies

and costumes, as well as nautical structures, the identification of specific forms is less relevant than the work's expression of constant motion, evoking both dance and the sensation of a ship moving through rolling seas.

Picabia painted the word "Edtaonisl" at the top right of the canvas. It is an acronym made by alternating the letters of two French words, étoile (star) and dans[e] (dance), a process analogous to his shattering and recombining the composition's forms. He subtitled the work Ecclesiastic, thereby juxtaposing the sensual with the spiritual.

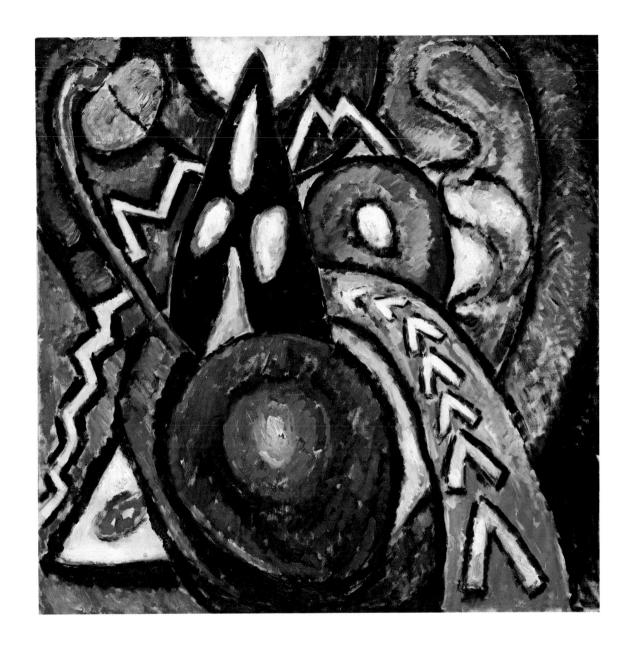

MARSDEN HARTLEY

American, 1877-1943

Movements, 1913/15

Oil on canvas 119.5 × 119 cm (47 × 46 ⁷/s in.)

Alfred Stieglitz Collection, 1949.544

Marsden Hartley was among the most talented, and restless, of the avant-garde American artists exhibited at 291, photographer and dealer Alfred Stieglitz's gallery in New York City. Hartley's work underwent frequent changes in style and subject, reflecting a life of continual

physical displacement. After mixing in New York's avant-garde circles, in 1912 Hartley moved to Paris and befriended the American expatriate writer Gertrude Stein, whose collection of works by Paul Cézanne, Henri Matisse, and Pablo Picasso, among other avant-garde artists, had a great impact on him, particularly Matisse's use of strong colors and emphatic decorative patterns. Hartley probably executed *Movements* between 1913 and 1915 in Germany, where he was influenced by the abstract art of Vasily Kandinsky (see p. 112) and German Expressionism.

Inspired by Kandinsky's association of color and sound, the nearly abstract forms of

Movements, rhythmically orchestrated around a central red circle and black triangle, suggest the flow of a musical arrangement. But Hartley also drew on his time in Berlin, where one could experience, as he described it, "the intense flame-like quality of life." He evoked this powerful sensation by filling the composition with bursting, overlapping shapes in vivid colors that suggest the stimulating, even overwhelming cacophony of the city. Heavy outlines weave these elements together, while active brushstrokes call attention to the rich, painterly surface. The charged energy of this painting remained constant in Hartley's subsequent work, even when he adopted a less abstract approach.

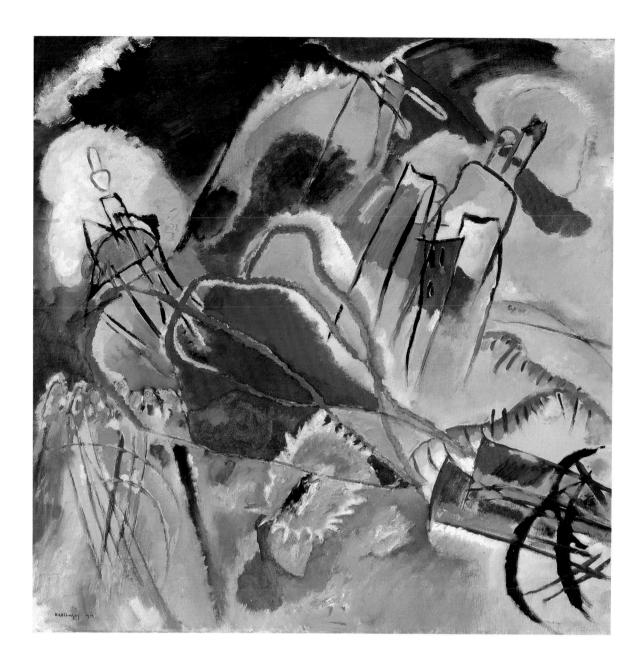

VASILY KANDINSKY

French, born Russia, 1866-1944

Improvisation No. 30 (Cannons), 1913

Oil on canvas

111 \times 111.3 cm (43 $^{11}/_{16}$ \times 43 $^{13}/_{16}$ in.) Arthur Jerome Eddy Memorial Collection, 1931.511

In his seminal *Concerning the Spiritual in Art*, first published in Munich in 1912, Vasily Kandinsky advocated an art that—like music—could move beyond imitation of the physical world, inspiring, as he put it, "vibrations in the

soul," and heightening the viewer's consciousness. Between 1910 and 1914, he produced a revolutionary group of increasingly abstract works, with titles such as *Fugue* and *Improvisation*, which he hoped illustrated how the act of painting could be brought closer in line with that of making music.

Kandinsky's works were, in his words, "largely unconscious, spontaneous expressions." While *Improvisation No. 30 (Cannons)* at first appears to be a random assortment of brilliant colors, shapes, and lines, one can discern leaning buildings, a crowd of people, and a smoking cannon on wheels. In a letter to the Chicago

lawyer Arthur Jerome Eddy, who purchased the painting in 1913 and later bequeathed it to the Art Institute, Kandinsky explained that "the presence of the cannons in the picture could probably be explained by the constant war talk that has been going on throughout the year. The title 'cannons'... is not to be conceived as indicating the picture's 'contents.'... Rather, the true contents are what the spectator experiences while under the effect of the forms and color combinations...." Eventually, Kandinsky eliminated all literal references to the material world and devoted himself wholly to pure abstract painting.

GIORGIO DE CHIRICO

Italian, 1888-1978

The Philosopher's Conquest, 1913–14
Oil on canvas $125.1 \times 99.1 \text{ cm } (49^{-1/4} \times 39 \text{ in.})$ Joseph Winterbotham Collection, 1939.405

An early painting by the Italian artist Giorgio de Chirico, *The Philosopher's Conquest* is one of six in a series that combines a Mediterranean cityscape with a variety of objects. Those seen here include oversized artichokes, a cannon and cannonballs, a running train, and a squarerigged sailing ship. The stage set for this extraordinary combination of elements—an arcaded piazza, a brick factory chimney, a clock, and a monumental tower—is virtually deserted except for the menacing shadows that indicate the approach of unseen figures.

De Chirico typically represented the objects in his paintings with a matter-of-fact, though intentionally rough, kind of exactness. He painted his scenes flatly, in bright colors, without nuance or personal touch, and illuminated them with a cold, white light. Rendered in this clear and legible style, works such as *The Philosopher's Conquest* would seem rife with psychological, philosophical, and art-historical meaning, but they remain resolutely enigmatic. Indeed, by juxtaposing incongruous objects, the artist sought to produce a metaphysical quality, what he called "art that in certain aspects resembles . . . the restlessness of myth."

De Chirico's works, somewhat outside the mainstream movements and styles of his time, would profoundly affect the Surrealists, a group of artists who attempted to portray dreams and images of the subconscious.

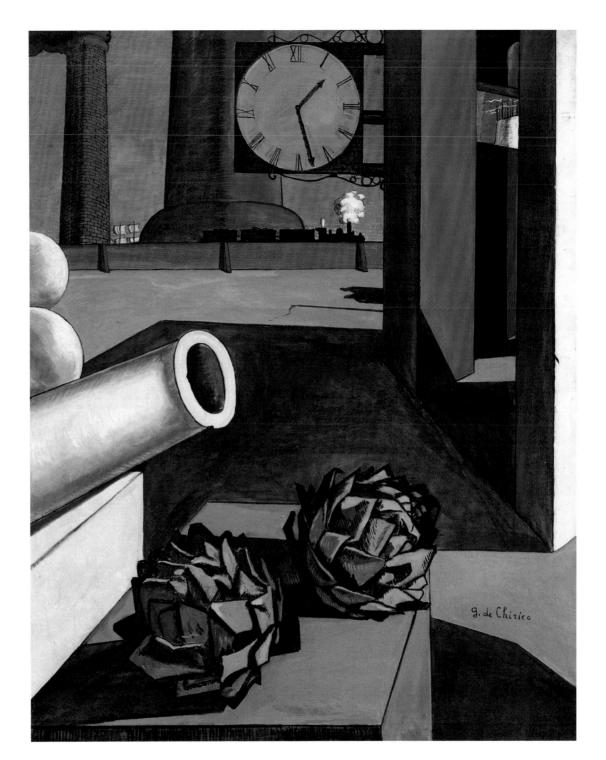

GEORGE WESLEY BELLOWS

American, 1882-1925

Love of Winter, 1914

Oil on canvas

 81.6×101.6 cm (32 $^{1}/_{2} \times 40$ $^{1}/_{2}$ in.) Friends of American Art Collection, 1914.1018

In January 1914, George Bellows wrote to a friend, "There has been none of my favorite snow. I must always paint the snow at least once a year." Soon after, on February 13, a major blizzard hit New York City, inspiring the artist

to paint *Love of Winter*. Bellows is usually associated with the artists of the so-called Ashcan School, a group of urban realists active in the early twentieth century who conveyed their enthusiasm for scenes of contemporary city life using thick, animated brushwork. Here Bellows enjoyed the challenge of representing snow, employing a palette knife to create varying degrees of texture in the built-up pigment.

Renowned for his rough-and-tumble images of boxing matches, the artist also excelled at landscapes and city views. *Love of Winter* depicts an energetic group of skaters and onlookers in what scholars believe to be a public

park, although the scene could be a composite of several sites. The crowd, comprising a range of ages and social classes, reflects the diversity of the frequenters of the recreational places that still characterize New York. The painting also reveals the artist's recent exploration of new theories that suggested color combinations based on musical notation. Bellows employed a series of intensely saturated warm shades of red, orange, and yellow throughout *Love of Winter*, offsetting them with cool blue, green, and lavender tones. Broad, slashing brushstrokes convey movement, wind, and speed, enhancing the vigor and liveliness of the composition.

AMEDEO MODIGLIANI

Italian, 1884-1920

Jacques and Berthe Lipchitz, 1916

Oil on canvas $81.3\times54.3~{\rm cm}~(32\times21^{-3}/{\rm s}~{\rm in.})$ Helen Birch Bartlett Memorial Collection, 1926.221

After receiving artistic training in his native Italy, Amadeo Modigliani moved to Paris in 1906. Three years later, he led a migration of artists to the neighborhood of Montparnasse, which remained the center of avant-garde activity in the city until World War II. Among his neighbors were the Lithuanian-born sculptor Jacques Lipchitz and his wife, Berthe Kitrosser, whom Modigliani depicted in this work. While Modigliani and Lipchitz were not close friends, they shared their Jewish backgrounds and émigré status. Lipchitz commissioned this painting to celebrate his recent marriage and as a way to help financially strapped Modigliani.

Modigliani struck a careful balance in this double portrait—one of only three in his oeuvre—between wry caricature and psychological insight. Nothing in the image is really plumb, from the features of Lipchitz's face to the inscription of his name in crude block letters. Despite the distance separating the sitters' heads, there is a strong connection between them, especially in the way Lipchitz protectively envelops his wife with his arm.

According to Lipchitz, the painting required two days from start to finish. During the first, Modigliani made about twenty drawings; during the second, he executed the painting and then declared it complete. Since the Italian artist was charging a modest price of "ten francs per sitting and a little alcohol," a mere two days would not yield him much money. Realizing this, Lipchitz persuaded him to work on the portrait for another two weeks, in an effort to provide him with a larger stipend. Despite Modigliani's gifts, his art only found a market after his death, which was hastened by tuberculosis and his legendary bohemian existence.

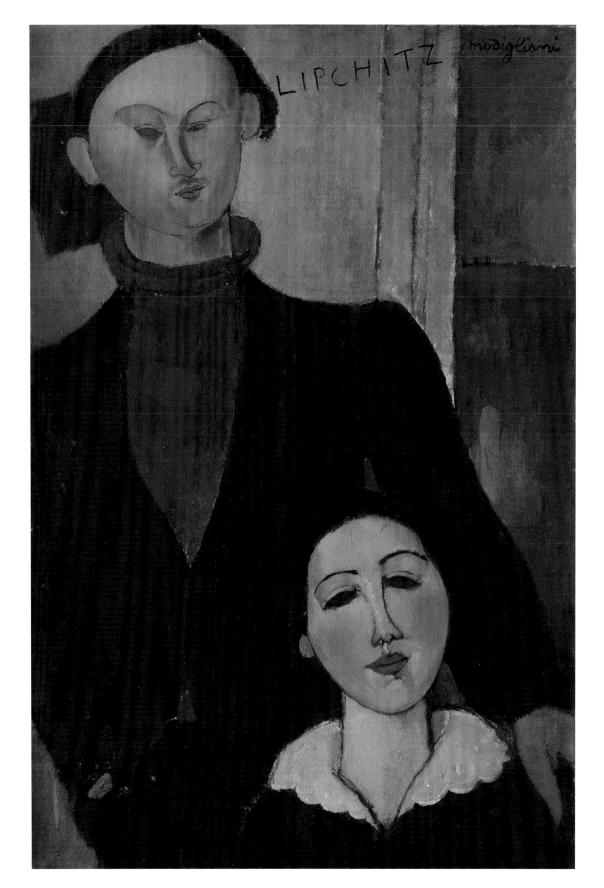

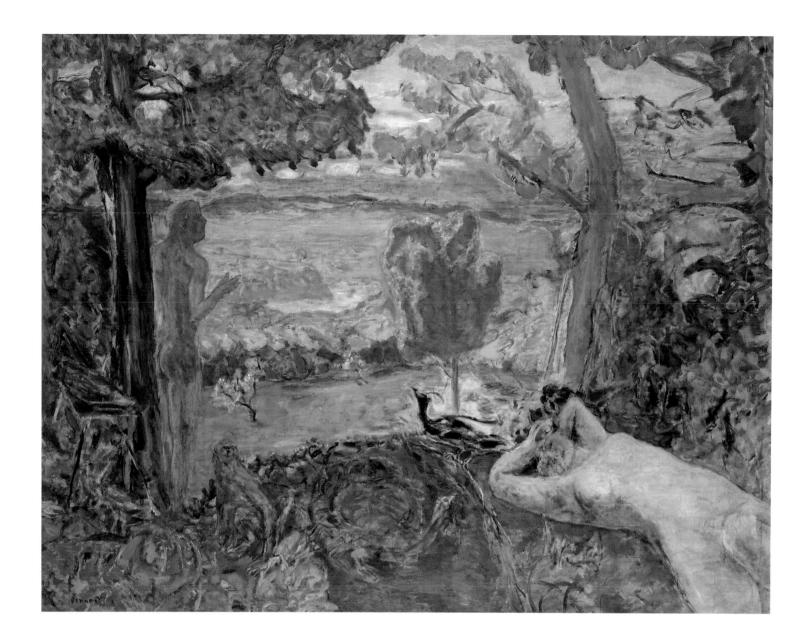

PIERRE BONNARD

French, 1867-1947

Earthly Paradise, 1916-20

Oil on canvas

 $130 \times 160 \text{ cm} (51^{1/4} \times 63 \text{ in.})$

Estate of Joanne Toor Cummings; Bette and Neison Harris and Searle Family Trust endowments; through prior gifts of Mrs. Henry Woods, 1996.47

Following a period of producing lithographs, paintings, and posters of Parisian scenes in the style of Édouard Vuillard and Henri de Toulouse-Lautrec, Pierre Bonnard virtually

reinvented his art around 1905. The artist's new emphasis on large-scale, expansive compositions, bold forms, and above all brilliant colors shows his awareness of the work of contemporaries Henri Matisse and Pablo Picasso, as does his focus on Arcadian landscapes, a theme he had not previously explored.

One of a series of four canvases painted for his dealers, Josse and Gaston Bernheim, between 1916 and 1920, *Earthly Paradise* demonstrates Bonnard's daring investigations into light, color, and space. Here the artist used foliage to create a proscenium-like arch for a drama involving a rigid, brooding Adam and a recumbent, languorous Eve. The contrast Bonnard set up

between the two figures seems to follow a tradition according to which the female, seen as essentially sexual, is connected with nature, while the male, seen as essentially intellectual, is able to transcend the earthly. Heightening the image's ambiguity is a panoply of animals, including birds, a monkey, rabbits, and the requisite serpent—here reduced to a garden snake. The scene, presented as a less-than-Edenic paradise, may reflect the artist's reponse to the destruction of Europe during World War I, which was raging when he began the painting. Too old to enlist, Bonnard may have been expressing the power-lessness he felt in not being able to defend this melancholic, yet hauntingly beautiful, landscape.

HENRI MATISSE

French, 1869-1954

Interior at Nice, 1919 or 1920

Oil on canvas 132.1 × 88.9 cm (52 × 35 in.) Gift of Mrs. Gilbert W. Chapman, 1956.339

Beginning in 1917, Henri Matisse spent most winters in Nice, on the Mediterranean coast. He often stayed at the Hôtel Mediterranée, a Rococo-style building he later fondly termed "faked, absurd, delicious!" Interior at Nice is perhaps the most ambitious of a series of images the painter created using the hotel as a backdrop, all done in the realistic style to which he had returned around this time. The pink-tiled floors and yellow, arabesque-patterned wallpaper are present in many of these works, as are the skirted dressing table, oval mirror, shuttered French window, and balcony. The balcony in fact was one of the artist's favorite themes, allowing him to link internal and external space into a continuum structured by patterns and modulated light.

Additionally, Matisse often included a young woman somewhere in the scene. Here, his favorite model at the time, Antoinette Arnoux, plays an important role. Not only is she the subject of the painting on the wall, but the composition's high viewpoint and plunging, wide-angled perspective draws all attention to her as she sits on the balcony, her back to the sea. Framed by shimmering curtains, she gazes directly at the viewer.

Pinks, honeyed grays, silvery blues, and smoky corals all create a gently pulsating atmosphere of light and radiant warmth. The overpainting and loose, fluid brushstrokes make the artist's process—his painterly choices—palpable to the viewer. These visible marks fix the momentary act of painting, just as the painting fixes on canvas the fleeting atmosphere of an afternoon in Nice.

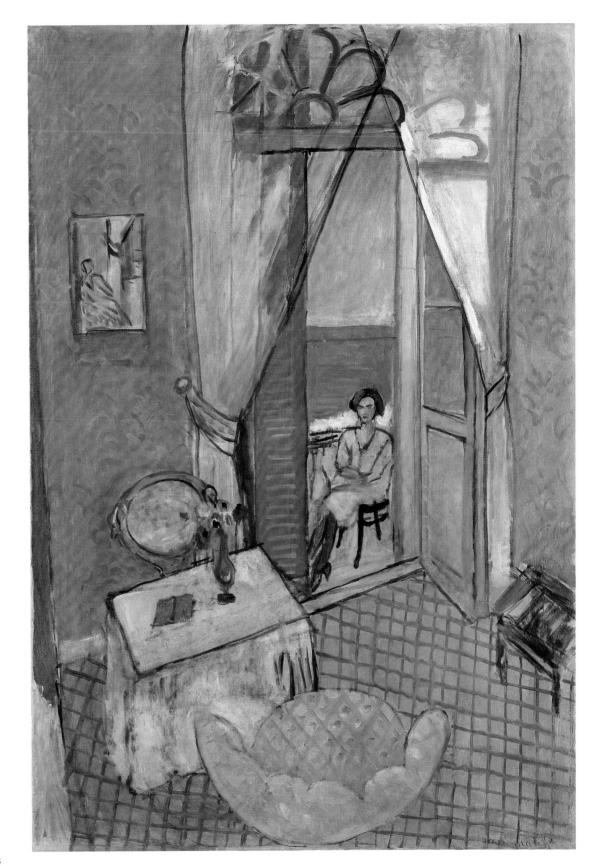

FERNAND LÉGER

French, 1881-1955

1953.341

The Railway Crossing (Sketch), 1919

Oil on canvas 54.1×65.7 cm ($21^{-5}/_{16} \times 25^{-7}/_{8}$ in.) Joseph Winterbotham Collection, gift of Patrick Hill in memory of Rue Winterbotham Carpenter,

Fernand Léger first saw the work of Georges Braque and Pablo Picasso at the Paris gallery of Daniel-Henry Kahnweiler (see p. 104). Around 1909 Léger began to paint in a Cubist style, although his compositions in this mode are more colorful and curvilinear than works by Braque and Picasso of the same period, with their angular forms and subdued tones. An artist with farranging interests and talents, Léger later became a designer for theater, opera, and ballet, as well as a book illustrator, filmmaker, muralist, ceramist, and teacher.

Typically, Léger would develop a major composition by preparing studies in a variety of media. *The Railway Crossing* is an oil study for *The Level Crossing* (1919; Basel, Switzerland, private collection). When he took up this subject in 1919, he made a number of drawings and oil sketches, including the present work. Like many

of his contemporaries, Léger was fascinated by the machine age. He maintained that machines and industrial objects were as important to his art as figures. References to such elements pervade *The Railway Crossing*. In the midst of a complex scaffolding of cylinders and beams, an arrow appears on a brightly outlined signboard. A network of solid volumes and flat forms seems to circulate within the shallow space, just as pistons move within a motor. The precise definition of his forms and brilliance of his palette express Léger's belief that the machine, and the age it created, was one of the triumphs of modern civilization.

PIET MONDRIAN (PIETER CORNELIS MONDRIAAN)

Dutch, 1872-1944

Lozenge Composition with Yellow, Black, Blue, Red, and Gray, 1921

Oil on canvas
60 × 60 cm (23 5/8 × 23 5/8 in.)
Gift of Edgar Kaufmann, Jr., 1957.307
© 2009 Mondrian/Holtzman Trust c/o HCR
International, Warrenton VA USA

Although Piet Mondrian's abstractions may seem far removed from nature, his basic vision

is rooted in landscape, especially the flat geography of his native Holland. Beginning with representational landscapes, over time he reduced natural forms to their purist linear and colored equivalents, in order to suggest their unity and order. Finally, he eliminated natural forms altogether, developing a pure visual language of verticals, horizontals, and primary colors that he believed expressed universal forces.

In Lozenge Composition with Yellow, Black, Blue, Red, and Gray, Mondrian turned a square canvas on edge to create a dynamic relationship between the composition and the diagonal shape that contains it. This painting is the fifth of the artist's sixteen diamond-shaped ("losangique")

works. Deceptively simple, they are the result of constant adjustment to achieve absolute balance and harmony: to change one thing would upset the subtle equilibrium of lines, shapes, and colors. Mondrian hoped that his art would point the way to a utopian future in which the principles of global harmony would be embodied in all facets of life and art. This goal was first formulated in Holland around 1916–17 by Mondrian and a small group of like-minded artists and architects, who collectively formed a movement known as De Stijl ("the style"). Their ideas have been extraordinarily influential on all aspects of modern design, from architecture and fashion to household objects.

PABLO PICASSO

Spanish, 1881-1973

Mother and Child, 1921

Oil on canvas

142.9 × 172.7 cm (56 ½ × 68 in.)

Restricted gift of Maymar Corporation,

Mrs. Maurice L. Rothschild, Mr. and Mrs. Chauncey

McCormick; Mary and Leigh Block Fund; Ada

Turnbull Hertle Endowment; through prior gift of

Mr. and Mrs. Edwin E. Hokin, 1954.270

In 1917 Pablo Picasso traveled to Rome to design sets and costumes for Sergei Diaghilev's famed Ballet Russe. Deeply impressed by the ancient and Renaissance art of that city, he began experimenting with the forms and styles of antiquity, developing a new, classical manner.

Mother and Child reflects not only this new approach to form but also a new stage in Picasso's life. In 1918 he married Olga Koklova, a Russian dancer, with whom he fathered his first child, Paolo, born in 1921. Between 1921 and 1923, Picasso produced at least twelve variations on the mother-and-child theme, which he had explored at the turn of the century in

his Blue Period style. Whereas the figures in these earlier works are attenuated and frail, the protagonists in his Classical Period paintings, with their sculptural solidity and monumental scale, are majestic in proportion and feeling. In the Art Institute's work, an infant reclines on his mother's lap and reaches up to touch her. The mother, dressed in a simple gown with Grecian folds, gazes intently at her child. Behind them stretches a simplified background of sand, water, and sky. Picasso's treatment of the mother and child is not sentimental, but the relationship of the figures expresses a serenity and stability that characterized his life at this time.

MARC CHAGALL

French, born Belarus, 1887–1985

The Praying Jew, 1923

Oil on canvas 116.8 × 84.9 cm (46 × 35 ³/16 in.) Joseph Winterbotham Collection, 1937.188

Marc Chagall had a prolific career that spanned more than eight decades of the twentieth century. While his work often exhibits influences of the contemporary movements he encountered in France and Germany, his subjects and decorative lyricism reveal his love of Russian folk art and his roots in Hasidic Judaism.

In his 1931 autobiography, *My Life*, Chagall related how, while visiting Vitebsk (present-day Belarus), the city in which he was born, he realized that the traditions in which he had grown up were fast disappearing and that he needed to document them. He paid a beggar to pose in his father's prayer clothes and then painted him, limiting his palette primarily to black and white as befit the solemnity of the subject. This portrait is noteworthy for the simplicity of its execution; nonetheless, its striking patterns, abstract background, and the slightly distorted features of the model demonstrate Chagall's absorption of modern trends, especially Cubism.

Chagall often painted variants or replicas of works he particularly loved. The Art Institute's *Praying Jew* is one of three versions of this composition. He painted the original canvas in 1914, while still in Belarus. When he traveled back to Paris in 1923, he took the 1914 painting with him. He learned upon his return that much of the work he had left in France had been lost during World War I. This prompted him to make two versions of *The Praying Jew* before it left his studio (the original is now in the Kunstmuseum, Basel); they are the present work and another in the Ca' Pesaro, Venice. They differ from the original only in small details.

JOAN MIRÓ

Spanish, 1893-1983

The Policeman, 1925

Oil on canvas 248 × 194.9 cm (97 × 77 ³/₄ in.) Bequest of Claire Zeisler, 1991.1499

Soon after the Catalan artist Joan Miró moved to Paris from his native Barcelona in 1920, he met avant-garde painters and writers who advocated delving into dreams and the subconscious in order to express an absolute reality, or surreality. To unleash the imagination, the Surrealists embraced a spontaneous approach to their working method, a process of free association that they termed automatism. Miró described his work in this style: "Rather than setting out to paint something,' he wrote, "I begin painting and, as I paint, the picture begins to assert itself, or suggest itself under my brush. . . . Even a few casual wipes in cleaning my brush may suggest the beginning of a picture." Between 1925 and 1927, he produced a revolutionary series of works known as the "dream paintings," which straddle abstraction and representation to a haunting and at times hilarious effect.

In The Policeman, a large composition from this group, two biomorphic shapes spring to life as a policeman and a horse, their forms defined by thinly applied white paint against a loosely brushed, neutral ocher ground. The policeman's features are defined with economy and wit: black circles demarcate the eyes; thin lines indicate the figure's eyebrows, nose, neck, and arm; a wavy line of black brushstrokes becomes a flamboyant moustache. The bright red hand at the end of his arm resembles a clown's glove. The horse's rearing form is accented at the top by a black-dot eye and three strands of black to indicate the mane; his hoof, at the bottom, is bright blue. In works such as this, Miró seems to have been pondering the irrational and improbable with delight and a simplicity of means that belies the work's high level of sophistication.

PAUL KLEE

German, born Switzerland, 1879-1940

Sunset, 1930

Oil on canvas 46.1 × 70.5 cm (18 ½ × 27 ¾ in.) Gift of Mary and Leigh B. Block, 1981.13

The imaginative and prolific Paul Klee worked in many media and styles, each of which he made unmistakably his own. After World War I, he was invited to join the faculty of the Bauhaus, the famed art school in Dessau,

Germany. Klee resigned his position in 1931 and left Germany for good in 1933, after the Nazis came to power, returning to his native Switzerland. Klee's art—inventive, mystical, and technically masterful—and his great teaching skills made him one of the twentieth century's most important artists.

Sunset, like much of Klee's work, is small in scale and deceptively simple. His interest in ethnographic art and in the art of children, which he believed to be closest to the purist sources of creativity and to truthful expression, is apparent in the composition's seeming straightforwardness. Over a neutral, loosely painted

background, Klee applied small dots of pigment within contained shapes to create an overall abstract pattern. An odd, schematic face in the upper left balances the small, red sun in the lower right; a quirky little arrow (a favorite device of Klee's to indicate direction and energy) traces the sun's descent in the sky. Although hardly a conventional depiction of a sunset, Klee's composition evokes essential landscape elements—sky, water, horizon. As in all his work, using understatement, brevity, and wit, Klee created a microcosm that magically embodies life's great forces.

GEORGIA O'KEEFFE

American, 1887-1986

Black Cross, New Mexico, 1929

Oil on canvas 99.1 × 76.2 cm (39 × 30 in.) Art Institute Purchase Fund, 1943.95

Georgia O'Keeffe differed from most other American pioneers of modernism in that she was trained entirely in the United States (including a brief period at the School of the Art Institute of Chicago). O'Keeffe first exhibited her work in 1916 at 291, the New York gallery established by photographer Alfred Stieglitz that was a forum for avant-garde European and American art. O'Keeffe soon joined the roster of American artists who became known as the Stieglitz Circle; she married Stieglitz in 1924. O'Keeffe lived to the age of ninety-eight, and, in spite of failing eyesight, worked almost until the end of her life. She is best known for her paintings of flowers and plants, enlarged beyond life-size and precisely painted with bold colors, as well as for her spare and dramatic images inspired by the landscape of the Southwest.

Black Cross, New Mexico dates from O'Keeffe's first visit to Taos, New Mexico, in the summer of 1929. She said that she saw many such crosses, spread "like a thin, dark veil of the Catholic Church . . . over the New Mexico landscape." The large, black shape in this canvas is probably one of the Penitente crosses, "large enough to crucify a man," that O'Keeffe described as having encountered during an evening walk in the hills. She painted the cross against the Taos mountains, with a vivid sunset below the object's horizontal arm. The somber cross greatly enlarged so that even the nail heads are visible—adds an insistent abstraction to the scene. The power of an image such as this lies in the way O'Keeffe connected abstracted forms to nature and infused them with powerful visual and spiritual qualities.

ARTHUR DOVE

American, 1880-1946

Silver Sun, 1929

Oil and metallic paint on canvas 55.3×74.9 cm ($21\frac{3}{4} \times 29\frac{1}{2}$ in.) Alfred Stieglitz Collection, 1949.531

In 1912 Arthur Dove made news when he exhibited in New York City and Chicago ten pastels that were the first abstract works by an American to be seen by the public. Beginning with themes from nature, Dove had simplified and rearranged them, creating patterns,

rhythms, and color harmonies that demonstrated how artists could dispense with representational subjects in order to communicate through form and color alone. From then on, Dove dedicated himself to exploring how he might depart from illusionism without abandoning nature.

Silver Sun reveals with particular clarity Dove's method of recasting nature into art. The artist's sense of wonder at the force and beauty of the world is apparent, but so is his control over his artistic means and, ultimately, over our aesthetic experience. Dove imparted a metaphysical radiance through expanding rings of blue and green, and through his use of glowing metallic-silver paint. He simplified, adjusted,

and accented the landscape until the pulsating image no longer represented the thing seen but rather conveys feeling, impact, and meaning.

Dove remained committed to a personal vision. Nevertheless, he was well informed about current art trends, and a web of interconnections link his work to that of other artists. For example, *Silver Sun* relates to the art of two of Dove's friends, the painter Georgia O'Keeffe (see p. 124) and the photographer Alfred Stieglitz: they, like Dove, sometimes depicted transcendent skies in order to communicate a vision of the wholeness of nature.

IVAN ALBRIGHT

American, 1897-1983

Into the World There Came a Soul Called Ida, 1929–30 Oil on canvas $142.9\times119.2~{\rm cm}~(56^{-1/4}\times47~{\rm in.})$ Gift of Ivan Albright, 1977.34

Ivan Albright was born and lived most of his life in the Chicago area; because of these ties, he left many of his paintings to the Art Institute, which as a result boasts the largest public collection of the artist's works. While Albright's unique style has been called Magic Realism, it defies categorization. His painstaking creative process, driven by his need to meticulously record detail. involved designing sets for his paintings and creating studies of models and props—even making diagrammatic plans for colors. Albright's desire to present the minutest subtleties of human flesh or the tiniest elements of a still life often required that he spend years on a single painting. His experience as a medical illustrator during World War I is often cited as a determinant of his later, haunting portrayals of aging and decay.

Albright began Into the World There Came a Soul Called Ida in 1929 after Ida Rogers, then about twenty years old, answered Albright's advertisement for a model. Ida was an attractive young wife and mother, whom Albright transformed into a sorrowful, middle-aged woman sitting in her dressing room, her flesh drooping and the objects surrounding her worn and bare. With characteristic precision, the artist delineated even the single hairs in the comb on the table. The material lightness and precarious placement of her possessions on the dressing table and floor seem to symbolize the vulnerability of the sitter, making this a modern vanitas painting. Ida gazes forlornly and poignantly into the mirror and, with all the dignity she can muster, powders her aging flesh.

GRANT WOOD

American, 1891-1942

American Gothic, 1930

Oil on beaverboard 78×65.3 cm $(30^{3}/4 \times 25^{3}/4$ in.) Friends of American Art Collection, 1930.934

Grant Wood's American Gothic caused a sensation in 1930 when it was displayed for the first time in an exhibition at the Art Institute of Chicago and awarded a prize of three hundred dollars. Newspapers across the country carried the story, and the picture of the farm couple posed with a pitchfork before a white house brought instant fame to the artist. The Iowa native, then in his late thirties, had been enchanted by a simple Carpenter Gothic cottage he had seen in the small, southern Iowa town of Eldon. Wood envisioned a painting in which, as he put it, "American Gothic people . . . stand in front of a house of this type." He asked his dentist and his sister to pose as a farmer and his daughter. The highly detailed, polished style and rigid, frontal arrangement of the pair were inspired by Flemish Renaissance art, which Wood studied during three trips to Europe between 1920 and 1926. After returning to Iowa, he became increasingly appreciative of the traditions and culture of the Midwest, which he chose to celebrate in such works as this.

One of the Art Institute's most famous paintings, *American Gothic* has become part of our popular culture and the subject of endless parodies. Wood was accused of satirizing in this work the intolerance and rigidity brought about by the insular nature of rural life—an accusation he denied. Instead, in *American Gothic* he created an image that epitomizes the virtues, dignity, and ethics that he believed defined the midwestern character.

JOSÉ CLEMENTE OROZCO

Mexican, 1883-1949

Zapata, 1930

Oil on canvas 198.8×122.6 cm $(78^{1}/4 \times 48^{1}/4$ in.) Gift of Joseph Winterbotham Collection, 1941.35

José Clemente Orozco was a leader of the Mexican mural movement of the 1920s, which was inspired by the Mexican Revolution of 1910–20. After an uproar over the murals depicting mass slaughter and upheaval that he created for the Escuela Nacional Preparatoria in Mexico City, Orozco decided to seek work in the United States. It was during this self-imposed exile that he painted *Zapata*.

Emiliano Zapata was a revolutionary leader who struggled to return the enormous land holdings of the wealthy to Mexico's peasant population. After his death by ambush in 1919, he became a national hero. Framed by the open doorway of a hut, the figure of Zapata appears specterlike against a patch of bright sky. Solemn and unmoved, he seems to stare beyond the drama before him of the two kneeling figures who, with outstretched arms, beg for their lives. Such menacing details as the exaggerated peaks of the sombreros, the ammunition, and the weapons especially the knife aimed at the eye of Zapata symbolize the danger of the fight in which the revolutionaries engaged and the eventual deadly outcome for Zapata himself. The painting's dark reds, browns, and blacks evoke both the land that was being fought over and the bloodletting of the Mexican people. Orozco was ambivalent about the revolution; his vision of class struggle as inevitable, eternal, and hopeless explains the compassion, defiance, and despair expressed in this painting.

GEORGIA O'KEEFFE

American, 1887–1986

Cow's Skull with Calico Roses, 1931

Oil on canvas $91.4\times61~\text{cm}~(36\times24~\text{in.})$ Alfred Stieglitz Collection, gift of Georgia O'Keeffe, 1947.712

In 1930 Georgia O'Keeffe witnessed a drought in the Southwest that resulted in the starvation of many animals, whose skeletons littered the landscape. She was fascinated by these bones and shipped a number of them back to New York. She later wrote, "To me they are as beautiful as anything I know. To me they are strangely more living than the animals walking around.... The bones seem to cut more sharply to the center of something that is keenly alive on the desert even tho' it is vast and empty and untouchable—and knows no kindness with all its beauty." The bones provided her with interesting shapes and textures, and she painted them frequently, intrigued as much by their symbolism as by their formal potential.

In Cow's Skull with Calico Roses, O'Keeffe decorated the skull with artificial flowers, the kind used to adorn graves in New Mexico. Tucked against the ear and the jaw, the flowers appear less morbid than simply decorative—a whimsical addition that relies on the soft, ruffled petals to alleviate the hard, polished severity of the skull. O'Keeffe then exquisitely balanced the subtle modulations of the white and gray tones of the skull and flowers with a bold vertical streak of dark brown that irregularly bisects the composition. With the skull positioned against a muted, layered ground in close proximity to the picture plane, the composition conveys a sense of the organic yet abstracted beauty typical of O'Keeffe's art.

CHARLES DEMUTH

American, 1883-1935

... And the Home of the Brave, 1931

Oil and graphite on fiber board 74.8 \times 59.7 cm (29 1 /2 \times 23 1 /2 in.) Alfred Stieglitz Collection, gift of Georgia O'Keeffe, 1948.650

Charles Demuth's still lifes and architectural studies display astonishing technical skill and testify to the refinement with which he manipulated abstract design. In his paintings of the early 1930s, Demuth often interpreted structures in his hometown, Lancaster, Pennsylvania. Obviously not a literal representation of Lancaster, . . . And the Home of the Brave—with its compressed and discontinuous space, emphasis on two-dimensional patterns, and rearrangement of observed facts into a new pictorial reality—is derived from Cubism. The accent on American urban and commercial forms acknowledges Demuth's roots: specifically, the double water towers at the apex of the composition are adapted from those atop a Lancaster cigar factory, while the number seventy-two at the lower edge of the painting refers to a state highway—the Manheim Pike—running north from town.

Demuth derived the title from the last line of the "Star-Spangled Banner," which was adopted as the national anthem in 1931, the year in which he executed the painting. The ambiguity suggested by the title is characteristic of the artist's ironic temperament. Like other American artists and intellectuals of the early twentieth century, he was simultaneously attracted to the vitality of contemporary civilization and the beauty and power of the machine, but conflicted about the inhuman aspects and utilitarian coarseness of the expanding industrial landscape of the United States.

HORACE PIPPIN

American, 1888-1946

Cabin in the Cotton, 1933/37

Oil on canvas mounted on Masonite 46×84 cm (18×33 in.) Restricted gift in memory of Frances W. Pick from her children Thomas F. Pick and Mary P. Hines, 1990.417

The self-taught artist Horace Pippin began painting as a means of therapy, hoping to regain mobility of his right arm, which had been injured in World War I. He became one of the most celebrated African American artists of the mid-twentieth century, as critics acclaimed the power and authenticity of his "primitive" style. *Cabin in the Cotton*, the work that brought him to the attention of the art world, displays Pippin's vivid, saturated palette and feeling for intense pattern.

Living in Pennsylvania, Pippin probably never saw a cotton field, but instead drew on popular culture for inspiration. The way of life in the rural South enjoyed a great vogue in the 1930s, with the premiere of George Gershwin's opera *Porgy and Bess* in 1935 and the publication of Margaret Mitchell's *Gone with the Wind* in 1936. The painting's composition recalls the opening and closing sequences of the 1932 film

Cabin in the Cotton, starring Bette Davis. In that year, both Bing Crosby and Cab Calloway made recordings of a song titled "Cabin in the Cotton."

In 1937 Christian Brinton, an influential art critic, and N. C. Wyeth, the famous illustrator, discovered *Cabin in the Cotton* in the window of a shoe-repair shop in West Chester, Pennsylvania, and convinced Pippin to begin exhibiting. Newspapers then widely reported that the actor Charles Laughton had purchased the painting, prompting other celebrities and art collectors, as well as museums, to acquire Pippin's work, which assured his lasting fame.

SALVADOR DALÍ

Spanish, 1904-1989

Inventions of the Monsters, 1937

Oil on canvas

 51.4×78.4 cm ($20^{1/4} \times 30^{7/8}$ in.) Joseph Winterbotham Collection, 1943.798

Salvador Dalí, Surrealism's most publicized practitioner, created often-monstrous visions of a world turned inside out, which he made more compelling through his extraordinary technical skills. These qualities can be seen in his 1937 *Inventions of the Monsters*. After the

Art Institute acquired the work, Dalí wrote to the museum that the "apparition of monsters presages the outbreak of war. The canvas was painted... near Vienna a few months before the Anschluss and has a prophetic character. Horsewomen equal maternal river monsters. Flaming giraffe equals masculine apocalyptic monster. Cat angel equals divine heterosexual monster. Hourglass equals metaphysical monster. Gala and Dalí equal sentimental monster..."

While the artist's description is as enigmatic as the painting, it does help to decipher this bizarre but haunting work. Indeed, the specter of World War II loomed large after the Anschluss, Germany's annexation of Austria in March 1938.

The painting is rife with threats of danger, from the giraffe on fire in the distance to the sibylline figure who holds an hourglass and gazes at a butterfly, both memento mori, or symbolic reminders of the transience of life. In their midst sit Dalí and his wife, Gala, the artist's muse, collaborator, and emotional anchor for much of his creative life. With his native Catalonia embroiled in the Spanish Civil War, Dalí must have felt great anxiety as he surveyed a world without safe haven, a world that was indeed the invention of monsters.

MATTA (ROBERTO MATTA ECHAURREN)

French, born Chile, 1911 or 1912-2002

The Earth Is a Man, 1942

Oil on canvas

182.9 × 243.8 cm (72 × 96 in.)

Gift of Mr. and Mrs. Joseph Randall Shapiro (after her death, dedicated to the memory of Jory Shapiro by her husband), 1992.168

Trained as an architect, the Chilean-born Matta moved to France in 1933, where he worked in the studio of Le Corbusier. The following year, he met the poet Federico García Lorca in Spain. After Lorca was assassinated by agents of Francisco Franco in 1936, Matta began a screenplay, *The Earth Is a Man*, which he wrote in tribute to the slain hero. The play's apocalyptic imagery, rapidly shifting perspectives, and emotionally charged language became the principal source of Matta's visual art over the next five years. The painting *The Earth Is a Man* represents the culmination of this project and draws upon the artist's earlier compositions, which he called "Inscapes" or "Psychological Morphologies." In these, using a technique of psychic automatism developed by the Surrealists, Matta created turbulent forms that serve as visual analogues for states of consciousness.

In this powerful, enigmatic work, forces of brilliant light seem to battle those of darkness. Matta spilled, brushed, and wiped on vaporous washes of paint to render the invisible waves of energy that shape and dissolve a molten, primordial terrain. The painting's visual intensity evokes the tumultuous eruption of a volcano, such as one Matta had witnessed in Mexico in 1941. Exhibited shortly after its completion in New York City, where the artist had immigrated at the onset of World War II, the mural-size canvas, with its abstract and visionary qualities, enthralled and influenced a new generation of American artists, who would come to be known as the Abstract Expressionists.

MAX BECKMANN

German, 1884-1950

Self-Portrait, 1937

Oil on canvas 192.5×89 cm $(76 \times 35$ in.) Gift of Lotta Hess Ackerman and Philip E. Ringer, 1955.822

Max Beckmann was one of the Weimar Republic's most honored artists, and—although neither Jewish nor Communist—became one of the most vilified by the Nazis. This self-portrait is perhaps the last painting Beckmann completed in Berlin before he and his wife fled to the Netherlands on July 20, 1937. They left two days after Adolf Hitler delivered a speech condemning modern art, and one day after the opening of the "Degenerate Art" exhibition, the Nazis' infamous official denigration of the avant-garde, which included twenty-two of Beckmann's works.

The sense of fear and doom Beckmann felt are strikingly conveyed here. The artist had a predilection for portraits, particularly of himself. In this, perhaps the most brilliantly colored and aggressive of the eighty self-portraits he painted, Beckmann portrayed himself near life-size, on the staircase of a hotel lobby. Despite the elegance of his appearance and his surroundings, he appears tense and isolated. This is expressed in the position and size of his body, filling the composition and pressing forward toward the left, front edge of the picture as if trapped; by his pale, inscrutable face, which is withdrawn from us in half shadow; and by his separation from the two figures, in animated conversation, who are discernible behind a potted plant on the landing. Beckmann's hands hang down, large, limp, and helpless, against his black tuxedo. Everything—curtains, flowers, staircase, and banisters—seems to slide off to the right. The artist departed Germany just in time; in the same year, over five hundred of his works were confiscated from the country's public collections.

RENÉ MAGRITTE

Belgian, 1898-1967

Time Transfixed, 1938

Oil on canvas $147\times98.7~cm~(57~^{7}/s\times37~^{7}/s~in.)$ Joseph Winterbotham Collection, 1970.426

René Magritte developed an individual and eccentric manner of painting that evokes the world of the supernatural. Employing a precise manner, he explored the poetry of shadows, the surprising affinities and disparities between people and things, and the profound mystery and absurdity of life. Magritte fashioned his personal brand of Surrealism from commonplace objects whose altered sizes and surprising juxtapositions create an atmosphere of ambiguity and wonder.

Magritte described the conception of Time Transfixed as follows: "I decided to paint the image of a locomotive. . . . In order for its mystery to be evoked, another immediately familiar image without mystery—the image of a diningroom fireplace-was joined." Indeed, the juxtaposition has resulted in a metamorphosis: into the deep stillness of a sparsely furnished room, a tiny locomotive chugs incongruously out of the fireplace, emerging from the vent customarily used for a stovepipe. The time is literally fixed, as the clock on the mantelpiece indicates, at 12:43. The painting derives its power not only from the combination of these elements and the exactitude of their representation but also from the unexpectedness of the vision.

Magritte painted *Time Transfixed* for the ballroom of the English collector Edward James. He took great pains with the titles of his works, expressing dissatisfaction with the English translation of the original French, *La durée poignar-dé*, which literally means "ongoing time stabbed by a daggar." When the artist sent the painting to James, he hoped it would be installed at the bottom of the collector's staircase, so that the train would "stab" guests on their way upstairs. Instead, James hung it over the ballroom's fireplace.

EDWARD HOPPER

American, 1882-1967

Nighthawks, 1942

Oil on canvas 84.1 × 152.4 cm (33 ½ × 60 in.) Friends of American Art Collection, 1942.51 In paintings of city streets, interiors, architectural exteriors, country roads, and the Atlantic coastline, Edward Hopper presented with clarity and forcefulness familiar aspects of American life, using a factual approach and dramatic lighting. The all-night diner in Hopper's *Nighthawks* has become one of the most famous images of twentieth-century American art. Hopper said the work was inspired by a "restaurant on New York's Greenwich Avenue where two streets meet." As is true of most of his paintings, the image is a composite, not a literal translation of a place: he simplified the scene and enlarged the restaurant.

An oasis of light on a dark corner, the diner draws us to it. But Hopper eliminated any reference to an entrance, forcing us to observe the three customers and waiter through the window. Sealed off by a seamless wedge of glass and lit by an eerie glow, the four anonymous, uncommunicative figures appear as separate from one another as they are from a passerby, evoking myriad questions about their lives and this moment that cannot be answered.

Hopper always maintained that he did not infuse his paintings with symbols of human isolation and urban emptiness. By leaving interpretation up to the viewer, however, he invited such speculation. The artist summed up the essential ambiguity of this image when he said, "Nighthawks seems to be the way I think of a night street. I didn't see it as particularly lonely. . . . Unconsciously, probably, I was painting the loneliness of a large city."

ARCHIBALD JOHN MOTLEY, JR.

American, 1891-1981

Nightlife, 1943

Oil on canvas

91.4 × 121.3 cm $(36 \times 47^{3/4} in.)$

Restricted gift of Mr. and Mrs. Marshall Field,
Jack and Sandra Guthman, Ben W. Heineman,
Ruth Horwich, Lewis and Susan Manilow, Beatrice
C. Mayer, Charles A. Meyer, John D. Nichols, and
Mr. and Mrs. E. B. Smith, Jr.; James W. Alsdorf
Memorial Fund; Goodman Endowment, 1992.89

Archibald Motley, a pioneering African American artist, dedicated his career to depicting the lively world of Chicago's Black Belt from the 1920s through the 1940s. At a time when African Americans had few opportunities as artists and were rarely depicted in art without negative connotations, he deliberately focused on them as the subjects of elegant portraits and dynamic genre paintings, swiftly garnering acclaim in the largely white art world.

Nightlife is one of Motley's most celebrated works. Painted in a hot magenta palette, the composition conveys the vigor and excitement of a night out in the South Side neighborhood of Bronzeville. The clock over the bar reads nearly one a.m., and this "juke joint" is full of life; dancers pack the floor, while other patrons sit at tables or the bar. Bartenders keep the ample array of liquor bottles well stocked, providing a steady source of alcohol to fuel the merriment.

Motley carefully drew attention to the human dramas unfolding in the nightclub through a subtle narrative of gestures and glances that can be interpreted in a variety of ways. The interactions begin with the standing man in the blue suit, who motions behind him, his body twisting expansively. Does this indicate an invitation to dance, addressed to the woman in green? Or is he signaling to the dancing woman in pink, who appears to make eye contact with him? Motley left the narrative uncertain, befitting this fleeting glimpse of nightlife. Ultimately, the painting allows us to enjoy watching his figures caught up in the spirit of the moment, as they laugh, talk, drink, and dance into the night.

BALTHUS (COUNT BALTHASAR KLOSSOWSKI DE ROLA)

French, 1908-2001

Solitaire, 1943

Oil on canvas $161.3\times163.5~cm~(63~^1/2\times64~^3/8~in.)$ Joseph Winterbotham Collection, 1964.177

A reclusive artist who rarely allowed himself to be photographed or interviewed, Balthus was born into an educated, artistic, but impoverished family of Polish aristocrats who had fled political and economic turmoil to settle in Paris. Balthus had little formal training, which permitted him to develop a unique artistic vision. As a young man, he traveled in Italy and France to study such Old Master paintings in museums and churches. In 1933 Balthus began painting the erotically charged images for which he is best known—mysterious and discomfitting scenes of young, dreamy girls in provocative poses that make the viewer into a voyeur. Such images—coupled with the generally naturalistic style in which they are rendered—caused a scandal when first exhibited.

Balthus spent most of World War II in Switzerland, where in 1943 he painted one of his masterpieces, *Solitaire*. The striking posture of the girl, who is deep in thought as she bends over the table to consider the cards, is one the artist had used in a number of earlier works. The counterpoint created by the insistent verticals of the patterned wallpaper against the diagonal of the girl's back, and by the mysterious expression of her shadowed face in contrast to the strong, raking light that defines her delicate, long fingers and her left leg, produces an unsettling emotional tenor. This tension has been alternatively interpreted as an adolescent's repressed sexual energy, and as a metaphor for the restlessness of refugees such as Balthus, waiting out World War II.

CHARLES SHEELER

American, 1883-1965

The Artist Looks at Nature, 1943

Oil on canvas 53.3 × 45.7 cm (21 × 18 in.) Gift of Society for Contemporary American Art, 1944.32

A photographer as well as a painter, Charles Sheeler considered the purposes of art as carefully as anyone of his generation of earlytwentieth-century modernists. In both media, his subjects were usually drawn from the world of man-made objects: urban architecture, factories, barns, as well as interiors often furnished with the spare and elegant Shaker furniture he admired. These subjects were rendered (or, in the case of his most abstract paintings, suggested) in a hard-edged, controlled technique indicative of the artist's restrained and intellectual point of view and interest in formal values.

For the typically objective Sheeler, *The Artist* Looks at Nature is an unusual work because it represents an imaginary scene. Here we see the artist outdoors, but what is before him is not what is on his easel. The unfinished work reproduces Interior with Stove (private collection), a much earlier Conté-crayon drawing based on an even earlier photograph by the artist. Thus, in the Art Institute's painting, we see Sheeler almost playfully reconstructing his own past over a period of more than twenty-five years, emphasizing the self-referential nature of his art, and suggesting the interchange between the representational modes of photography and painting. One of Sheeler's most complex yet charming works, The Artist Looks at Nature implies much about the ironies and ambiguities of art in the last century.

PETER BLUME

American, born Russia, 1906–1992

The Rock, 1944–48

Oil on canvas $146.4 \times 188.9 \text{ cm } (57^{5/8} \times 74^{3/8} \text{ in.})$ Gift of Edgar Kaufmann, Jr., 1956.338

Unlike the Surrealism practiced by many Europeans, with its preponderance of sexual motifs and dreamlike images, the unique brand of Surrealism of Peter Blume, one of the first American artists to embrace the movement, was based on the juxtaposition of disjunctive and unrelated objects and figures, all rendered in an accomplished and painstaking technique that echoes northern European painting of the fifteenth and sixteenth centuries. Blume typically labored tirelessly over his paintings, creating many sketches, which explains the relative rarity of large-scale works by the artist.

Although Blume's deeply personal iconography eludes clear interpretation, images of decay and rebirth occur again and again, especially in response to the aftermath of World War II. *The Rock* shows a group of men and women, perhaps representing humankind, in the process of rebuilding civilization out of its own destruction. They labor at the task of cutting the stone

for the new structures that are to be raised on the rubble of the old. Looming above the figures is a monumental rock, scarred and blasted, yet enduring, itself a symbol of humanity's tenacity and capacity to survive. At the left rises a new structure, a clear indication of hope in the future. The building under construction resembles Frank Lloyd Wright's famous Falling Water residence of 1935–37, near Pittsburgh, which the original owners of *The Rock*, Liliane and Edgar Kaufmann, commissioned, and for which the painting was intended. Their son, Edgar Kaufmann, Jr., donated *The Rock* to the Art Institute in 1956.

MODERN AND CONTEMPORARY TO 2003

1			

JACOB LAWRENCE

American, 1917-2000

The Wedding, 1948

Egg tempera on hardboard 50.8 × 61 cm (20 × 24 in.) Restricted gift of Mary P. Hines in memory of her mother, Frances W. Pick, 1993.258

"I paint the things I have experienced," Jacob Lawrence stated. Raised in Harlem, Lawrence studied at various federally funded, community cultural centers and art workshops, where his talent was quickly recognized. The young artist soon applied his bold, unique style to the creation of narrative cycles devoted to African American history, leaders, and life. His sixty-panel *Migration* series (1940–41), depicting the resettlement of blacks from the rural South to the industrial North in the first half of the twentieth century, debuted in 1941 at the prestigious Downtown Gallery, New York. This exhibition bought national attention to the artist, then only in his early twenties. The cycle was acquired later by the Museum of Modern Art, New York, and the Phillips Collection, Washington, D.C.

In addition to his series, Lawrence also executed individual genre scenes, such as *The Wedding*, throughout his long career. With its

bright, flat colors, bold patterning, and economical, yet suggestive, forms, this vibrant 1948 composition shows a bride and groom, flanked by two attendants, standing before a stern-faced minister. This arrangement makes us, like the attendants, participants in a major life event. Befitting both the solemnity and joy of a wedding, the composition combines the symmetrical rigidity of the standing figures with a riotous profusion of intensely colored stained-glass panels and flowers. *The Wedding* demonstrates well what one writer described as Lawrence's unwavering commitment "to make his subject a testament, an expression of his belief in [humanity's] continuing strength."

STUART DAVIS

American, 1892-1964

Ready-to-Wear, 1955

Oil on canvas 142.6 × 106.7 cm (56 ½ × 42 in.)

Restricted gift of Mr. and Mrs. Samuel W. Kunstadter; Goodman Fund, 1956.137

Stuart Davis was acquainted from an early age with John Sloan and Robert Henri, leaders of the Ashcan School, a group of artists committed to depicting all aspects of modern urban life. Davis studied at Henri's New York school, but he eventually came to disagree with his teacher's beliefs in the preeminence of content over composition and form, and instead created a style in which he generalized and abstracted his shapes and the spaces between them.

Nonetheless, Davis's art is never totally abstract. Twentieth-century America is reflected in the shapes and colors he chose and in the sheer vitality of his compositions. His style—big, bright, bold, and clear—is completely appropriate to his subject matter. Forms have been reduced to large colored planes; words or numbers are simplified and offered as elements of design. In Ready-to-Wear, the bright, unmixed colors recall those of the French artist Fernand Léger (see p. 118). The way in which they intersect and interrupt one another, however, conveys a mood that is distinctly American—energetic, jazzy, mass-produced, all qualities summed up by the title. The planes, reminiscent of overlapping, pasted-down paper cutouts, even suggest the garment patterns from which ready-to-wear clothes are assembled.

ARSHILE GORKY

American, born Armenia, 1904–1948

The Plow and the Song (II), 1946

Oil on canvas

 132.7×156.2 cm $(52^{1/4} \times 61^{1/2} in.)$

Mr. and Mrs. Lewis Larned Coburn Fund, 1963.208

Born in Armenia, Arshile Gorky moved to the United States in 1920, and eventually became an important member of the New York avant-garde. Profoundly interested in modern European art, he experimented with a variety of styles and was particularly stimulated by the European Surrealists, many of whom moved to the city before and during World War II. The 1940s, especially between 1944 and 1947, marked the creation of Gorky's most significant work, produced in a kind of stream-of-consciousness, or automatic manner of painting.

The Plow and the Song (II) reflects the artist's indebtedness to the lyrical Surrealism of Joan Miró (see p. 122); however, the sketchy handling of paint, translucent color, and tumbling pile of shapes are hallmarks of Gorky's mature work. A delicate contour line delineates the biomorphic forms in the center of the composition, in marked contrast to the loose brushwork that defines the background. Deeply earthbound and poetic, the painting is at once a still life, a landscape, and a fantasy.

The Plow and the Song (II) is the title for a group of works Gorky produced in the mid-1940s. The phrase reminded him of his native Armenia, judging from the following excerpt from a letter he wrote to his sister in 1944:

You cannot imagine the fertility of forms that leap from our Armenian plows, the plows our ancestors used for thousands of years in toil and gaiety and hardship and poetry. . . . And the songs, our ancient songs of the Armenian people, our suffering people. So many shapes, so many shapes and ideas, happily a secret treasure to which I have been entrusted the key.

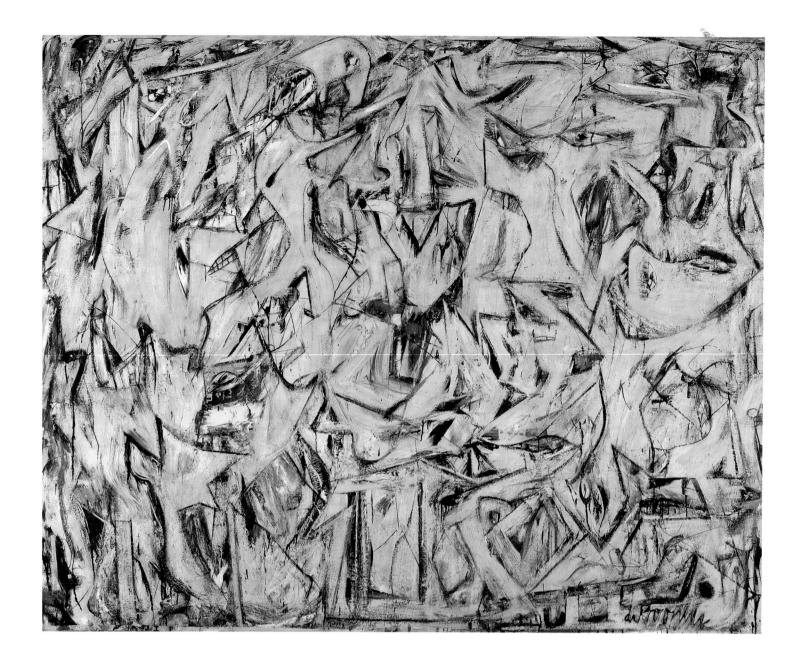

WILLEM DE KOONING

American, born Netherlands, 1904-1997

Excavation, 1950

Oil on canvas

205.7 × 254.6 cm (81 × 101 ½ in.)

Mr. and Mrs. Frank G. Logan Purchase Prize Fund; restricted gift of Edgar J. Kaufmann, Jr., and Mr. and Mrs. Noah Goldowsky, Jr., 1952.1

Willem de Kooning was a central figure in Abstract Expressionism, an art movement that espoused the painterly actions of the artist as signs of his or her emotions. De Kooning completed *Excavation* in June 1950, just in time for it to be exhibited in the twenty-fifth Venice Biennale. His largest painting to date, it exemplifies the Dutch-born innovator's style, with its expressive brushwork and distinctive organization of space into loose, sliding planes with open contours.

According to the artist, the point of departure for this canvas was an image of women working in a rice field in *Bitter Rice*, a 1949 Neorealist film by the Italian director Giuseppe de Santis. A loose structure of hooked calligraphic lines defines anatomical parts—bird

and fish shapes, human noses, eyes, teeth, necks, and jaws—that seem to dance across the painted surface, revealing the particular tension between abstraction and figuration that is inherent in de Kooning's art. The original white pigment has yellowed over the years, diluting somewhat the flashes of red, blue, yellow, and pink that punctuate the composition. Aptly titled, *Excavation* reflects de Kooning's technically masterful painting process: an intensive building up of the surface and scraping down of its paint layers, often for months, until the desired effect was achieved.

JACKSON POLLOCK

American, 1912-1956

Greyed Rainbow, 1953

Oil on linen 182.9×244.2 cm $(72 \times 96^{1}/s \text{ in.})$ Gift of the Society for Contemporary American Art, 1955.494

In the late 1940s, Jackson Pollock developed a revolutionary form of Abstract Expressionism by dripping, pouring, and splashing paint onto large-scale canvases. Pollock emphasized the expressive power of the artist's gestures, materials, and tools, often applying paint with sticks, trowels, and palette knives instead of brushes. He also challenged the concept of easel painting by working on canvases placed either on the floor or fixed to a wall. With no apparent beginning or end, top or bottom, his paintings imply expansion beyond the edges of the canvas, engulfing the viewer.

Among the last great purely abstract paintings Pollock made before his untimely death in 1956, *Greyed Rainbow* is a quintessential example of action painting. The paint application ranges from thick chunks squeezed directly from a tube to thin, meandering lines poured from a container with a small hole or squirted from a baster. While this work is predominantly black, white, gray, and silver, in the bottom third of the canvas Pollock thinly concealed orange, yellow, green, blue, and violet. The title of the work presumably refers to these grayed sections of hidden color.

MARK ROTHKO

American, born Russia (present-day Latvia), 1903–1970

Untitled (Purple, White, and Red), 1953 Oil on canvas 197.5×207.7 cm $(77^{3/4} \times 81^{3/4}$ in.) Gift of Sigmund E. Edelstone, 1983,509

Known for his impassioned works predicated on the poetics of color, Mark Rothko was one of the leading proponents of color-field painting, a type of non-gestural Abstract Expressionism that entailed large canvases distinguished by monumental expanses of form and tone.

Untitled (Purple, White, and Red) follows the characteristic format of Rothko's mature work, according to which three stacked rectangles of color appear to float within the boundaries of the canvas. By directly staining the fabric of the canvas with many thin washes of pigment and by paying particular attention to the edges where the fields interact, he achieved the effect of light radiating from the image itself. This technique suited Rothko's metaphysical aims:

to offer painting as a doorway into purely spiritual realms, making it as immaterial and evocative as music, and to directly communicate the most essential, raw forms of human emotion.

Rothko described his art as the "elimination of all obstacles between the painter and the idea, between the idea and the observer." In place of overt symbolism, he used color, overwhelming scale, and surface luminosity to encourage an emotive, profound response from the viewer. This painting was executed in 1953, the year before the Art Institute of Chicago gave Rothko his first solo museum exhibition.

ELLSWORTH KELLY

American, born 1923

Red, Yellow, Blue, White, and Black, 1953
Oil on canvas, seven joined panels
99.1 × 350.2 cm (39 × 138 in.)
Anstiss and Ronald Krueck Fund for Contemporary
Art, 2001.157

Emphasizing the basics of line, shape, and color, Ellsworth Kelly's exquisitely spare paintings and sculpture influenced the development of Minimalist art and affected the course of colorfield and hard-edge painting and post-painterly abstraction. Among the Art Institute's rich holdings of Kelly's works, *Red*, *Yellow*, *Blue*, *White*, *and Black* stands apart: with startling clarity, this work marks the moment at mid-century when Kelly's pure abstraction emerged in its mature form.

After serving in World War II, Kelly returned to Europe in 1948, living and working in France for the following six years. While abroad, he expanded his practice of direct observation of nature and architectural forms into an experimental, rigorous study of abstraction. He made

Red, Yellow, Blue, White, and Black in 1953 while still in France, creating it just as he was beginning to uncover the nearly infinite possibilities of monochrome, color spectrum, chance ordering, and multipanel composition. In the painting, Kelly centered the black panel so that it both divides and joins the three panels on either side of it, while the white panels simultaneously separate colors and pair them off. The blue panels at either end close and unify the sequence. Kelly's multipanel monochromes rely on the edges where sections meet, instead of handmade marks, to express their form. This sevenpanel painting is the largest in a sequence of works widely considered to be the artist's finest and most influential early statements on canvas.

FRANCIS BACON

English, born Ireland, 1909–1992

Figure with Meat, 1954

Oil on canvas 129.9 × 121.9 cm (51 ½ × 48 in.) Harriott A. Fox Fund, 1956.1201

Surrealism was an early influence on the self-taught English painter Francis Bacon, but philosophical and literary sources provided more significant stimuli, especially the bleak visions of Friedrich Nietzsche and T. S. Eliot. Like many of his generation who lived through the rise of fascism and the destruction of World War II, Bacon came to believe that each person must confront the void of meaning in order to wrest any significance out of existence. In his powerful, nihilistic works, tortured and deformed figures become players in dark dramas for which there appears to be no resolution.

Bacon often referred in his paintings to the history of art, interpreting borrowed images through his own bleak perspective. Figure with Meat is part of a now-famous series he devoted to Diego Velázquez's Portrait of Pope Innocent X (c. 1650-51; Rome, Galleria Doria-Pamphili). Here he transformed the Spanish Baroque artist's iconic portrayal of papal authority into a nightmarish image, in which the blurred figure of the pope, seen as if through a veil, seems trapped in a glass-box torture chamber, his mouth open in a silent scream. Instead of the noble drapery that frames Velázquez's pontiff, Bacon framed his figure with two sides of beef. quoting the work of the seventeenth-century Dutch artist Rembrandt van Rijn and of the twentieth-century Russian artist Chaim Soutine, both of whom painted brutal and haunting images of raw meat. Framed by the two halves of the carcass, Bacon's pope can be seen alternately as a depraved butcher, or as much a victim as the slaughtered animal hanging behind him.

JOAN MITCHELL

American, 1925-1992

City Landscape, 1955

Oil on linen 203.2 × 203.3 cm (80 × 80 in.) Gift of Society for Contemporary American Art, 1958.193

Joan Mitchell's large, vibrant paintings have always been anchored in the particularities of place. Born and raised on Chicago's North Shore and a graduate of the School of the Art Institute of Chicago, the artist settled in New York City in 1950 and joined the Abstract Expressionists. The gestural brushwork of Willem de Kooning particularly impressed her (see p. 146). Soon Mitchell was painting big, light-filled abstractions, animated by loosely applied skeins of bright color, infused with the energy and excitement of a large metropolis.

In *City Landscape*, a tangle of pale pink, scarlet, mustard, sienna, and black hues threatens to coagulate or erupt. The painting's title suggests that this ganglia of pigments evokes

the nerves or arteries of a city. Stabilizing this energized center are the white, roughly rectangular forms of fore- and background, modulated with touches of gray and violet, which resemble blocks of buildings that channel the street activity surging between and around them. The sense of spontaneity conveyed in *City Landscape* belies Mitchell's painting methods. Unlike many of her contemporaries, who were dubbed Action Painters, Mitchell worked slowly and deliberately. "I paint a little," she said. "Then I sit and look at the painting, sometimes for hours. Eventually, the painting tells me what to do."

CLYFFORD STILL

American, 1904-1980

Untitled, 1958 (PH-774)

Oil on canvas

292.2 × 406.4 cm (114 ¹/₄ × 160 in.)

Mr. and Mrs. Frank G. Logan Purchase Prize Fund; Roy J. and Frances R. Friedman Endowment; through prior gift of Mrs. Henry C. Woods; gift of Lannan Foundation, 1997.164

In the late 1940s, Clyfford Still, along with Barnett Newman and Mark Rothko, originated the type of Abstract Expressionism known as color-field painting, a term used to describe large canvases dominated by monumental expanses of intense, homogeneous color. Like others working in this mode, he wished his art to express a sense of the sublime, or, as he put it, "to achieve a purpose beyond vanity, ambition, or remembrance."

Like most of Still's mature work, *Untitled* is a sheer wall of paint, imposing and self-sustaining, that makes no concessions to conventional notions of beauty or pictorial illusionism. This painting's textural effects give it an insistent, complex materiality. Dominated by blacks that the artist applied with both a trowel and brushes, the surface is by turns reflective and chalky, granular and smooth, feathery and leaden. These variegated black surfaces are even

more emphatic because their continuity is broken by areas of blank canvas and white paint. Like veins in igneous rock, streaks of orange, yellow, and green paint are embedded in the black voids. Mediating between the light and dark masses are areas of crimson, heightened at the edges, as if enflamed, by bright orange. These mat encrustations of paint have the huge scale and weight of landscape forms, while their upward expansion suggests transcendance. The artist, however, disavowed all such associations for his work. "I never wanted . . . images to become shapes," he declared. "I wanted . . . all [color, texture, image] to fuse together into a living spirit."

CY TWOMBLY

American, born 1928

The First Part of the Return from Parnassus, 1961 Oil paint, lead pencil, wax crayon, and colored pencil on canvas

240.7 × 300.7 cm (94 ³/₄ × 118 ³/₈ in.) Through prior gift of Mary and Leigh Block, the Marian and Samuel Klasstorner Fund, Major Acquisitions Endowment Income Fund, Wirt D. Walker Trust, Estate of Walter Aitken, Director's Fund, Helen A. Regenstein Endowment, and Laura T. Magnuson Acquisition Fund, 2007.63 Cy Twombly's distinctive canvases merge drawing, painting, and symbolic writing in the pursuit of a direct, intuitive form of expression. The artist employed his inimitable visual language of scribbles, scratches, and scrawls—more performative than illustrative in nature—to both suggestive and sublime effects.

A resident of Italy since 1959, Twombly produced works from the early 1960s on that are florid evocations of art, myth, and allegory. *The First Part of the Return from Parnassus* refers to Mount Parnassus, the fabled home of Apollo and the Muses that ancient Greeks considered to be the center of poetry, music, and learning. The title is likely taken from one of

the *Parnassus Plays*, a series of sixteenth- and seventeenth-century scholarly entertainments that presented a satirical look at the adventures of two educated characters troubled by the lack of both employment opportunities and respect for learning in the larger world. Mixing visual references to corporeal processes with schematic forms and numbers, this painting is part of a general practice in which Twombly juxtaposes motifs of the irregular, organic, and intuitional with marks connoting the systematic, unyielding, and cerebral. A related work, *The Second Part of the Return from Parnassus* (1961), is also in the museum's collection.

GERHARD RICHTER

German, born 1932

Woman Descending the Staircase, 1965

Oil on canvas 198 × 128 cm (79 × 51 in.) Roy J. and Frances R. Friedman Endowment; gift of Lannan Foundation, 1997.176

Throughout his career, Gerhard Richter has alternated between very different modes of figuration and abstraction, indicating that an artist cannot be characterized according to style. Woman Descending the Staircase is one of Richter's most iconic Photo paintings, figurative works in which the artist transferred found photographs, such as personal snapshots or media images, onto canvas and then dragged a dry brush through the wet pigment, thus blurring the image and making the forms appear elusive. Here the slightly out-of-focus quality reinforces the motion of an unknown, glamorously dressed woman descending a set of stairs. The work's silver-blue brushwork suits the elegance of the figure, with her glistening evening gown and diaphanous scarf.

The composition's subject and title evoke Marcel Duchamp's famous work *Nude*Descending a Staircase (1912; Philadelphia Museum of Art). When the painting was exhibited in the United States at the 1913 Armory Show, its radical abstraction shocked Americans. Rather than honoring this modernist icon, Richter protested it, stating that he "could never accept that it had put [an end], once and for all, to a certain kind of painting." Indeed, in the Art Institute's work, Richter produced a hauntingly sophisticated image that floats between reality and illusion.

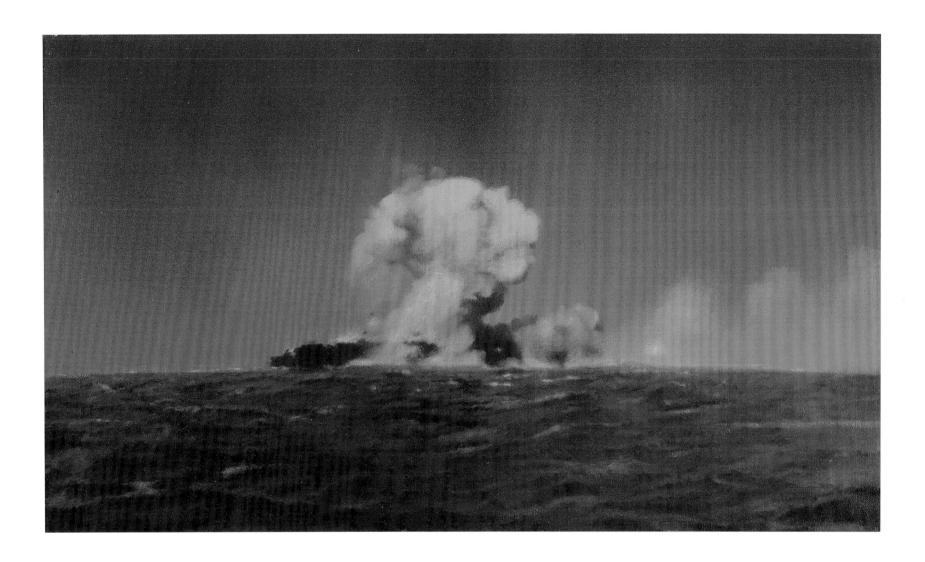

VIJA CELMINS

American, born Latvia, 1938

Explosion at Sea, 1966

Oil on canvas 34.3×59.7 cm ($13^{-1}/2 \times 23^{-1}/2$ in.) Gift of Lannan Foundation, 1997.138

In the mid-1960s, Vija Celmins began to use photographs from books, magazines, and newspapers that she found in secondhand stores as points of departure for her art. After locating a wealth of material on World War II—including photos of guns; assorted disasters; and American, German, and Japanese warplanes—she executed a number of paintings and

sculptures on the themes of war, technology, and devastation. It is to this group that *Explosion* at *Sea* belongs.

The meticulous and time-consuming methods Celmins used to portray war have been compared to the painstaking efforts required to construct model airplanes. In *Explosion at Sea*, she employed subtle layers of precise brushstrokes to execute a detailed image of an attack on an aircraft carrier. As in most of the works in the series, Celmins created here a disturbing contrast between the haunting seriousness of the subject and the intimacy of the painting's small format and careful brushwork. Moreover, although the artist's attention to detail links the image to the vintage photographs that served as her sources, her use of thinly applied, austere,

gray tonalities places the image at great remove from the violent realities of armed conflict.

Celmins's war images seem to be connected to her personal history. As a child, she and her family were forced to flee their native, war-torn Latvia. After seeking refuge in Eastern Europe and then in West Germany, they settled in Indianapolis. Celmins explained, "I generally think of my childhood as being full of excitement and magic, and terror, too—bombs fires, fear, escape—very eventful. It wasn't 'till I was ten years old and . . . in the U.S. that I realized living with these images was not everyone's experience." In works such as this, Celmin's intense childhood experiences seem to have been given focus, filtered, and transformed by the precision and concentration of the artistic process.

JIM NUTT

American, born 1938

Miss E. Knows, 1967

Acrylic on Plexiglas, aluminum, rubber, and enamel on wood frame

192.1 \times 131.1 cm (75 5 /s \times 51 5 /s in.) Twentieth-Century Purchase Fund, 1970.1014

Jim Nutt was a principal member of the Hairy Who, an irreverent group of artists that emerged in Chicago during the late 1960s. Exhibiting Surrealist-inspired work aimed at subverting artistic conventions and standards of taste, these artists became part of the Chicago Imagist movement. Although each member developed a distinct style, collectively they shared an emphasis on intuition and spontaneity, an affection for wordplay and humor, and a deep interest in popular culture.

In his earliest paintings, Nutt referenced popular culture, particularly painted store windows and pinball machines, through his choice of medium and support—acrylic paint on Plexiglas. In addition, many elements of his early style relate to comic strips: hard, crisp forms stand out boldly against simple backgrounds. In Miss E. Knows, he also appropriated a sequential format, incorporating small, framed images in the upper-left corner of the painting. The work depicts a grotesquely imagined, highly sexualized female figure—Nutt's satire of ideal beauty. The artist included the cartoonish light beam across her eyes as a reference to the cinema. By attaching objects such as rubber tubing and an upsidedown coat hook to the surface, Nutt heightened the surrealistic effect of this image.

AGNES MARTIN

American, born Canada, 1912-2004

Untitled #12, 1977

India ink, graphite, and gesso on canvas 182.9×182.9 cm (72×72 in.) Mr. and Mrs. Fred G. Logan Purchase Prize Fund, 1979.356

Agnes Martin mastered a rigorously pared idiom that combines the mediums of painting and drawing. The artist aligned herself with Abstract

Expressionists such as Mark Rothko, admiring their investigations of chromatic color schemes, all-over compositions, and emotional content. In the 1960s, she developed a vocabulary of grids and graphs that prompted critics to compare her work to the radical simplicity and intellectualism of Minimal and Conceptual artists such as Ellsworth Kelly and Sol LeWitt. Indeed, *Untitled* #12—a crisply stated graphite grid on a light gray ground—seems at first to be an exemplar of Minimalism. But close observation reveals a flickering light and extremely refined touch that suggest a spiritual, rather than purely aesthetic,

stance. Martin's deeply solitary nature led her to achieve a quiet, tenuous balance between the material and the immaterial, sensuality and austerity.

Martin stopped painting in 1969; she moved from New York City to a remote, rural area of New Mexico. In 1975 she began to paint again. Although she maintained that her art was not abstracted from nature ("Work like mine... describes the subtle emotions that are beyond words, like music"), the paintings she produced in the Southwest reflect the quiet landscapes, even light, and desert tonalities of her surroundings.

ROY LICHTENSTEIN

American, 1923-1997

Mirror in Six Panels, 1971

Oil and magna on canvas 305 × 335 cm (120 × 132 in.) Anstiss and Ronald Krueck Fund for Contemporary Art, facilitated by the Roy Lichtenstein Foundation, and temporary funding from the Frederick W. Renshaw Acquisition Fund, 2005.18 Roy Lichtenstein was perhaps the most consistently inventive artist among the group of individuals that rose to prominence as the progenitors of American Pop Art in the early 1960s. Throughout his career, he explored the functional simplicity and visual clichés that characterize processes of mechanical reproduction. Initially preoccupied with the visual immediacy of cartoons, Lichtenstein embraced the technical constraints of graphic illustration, applying them to painting.

Mirror in Six Panels is among the most ambitious, summarizing canvases in the artist's Mirror series (1969–72). Like his famous

cartoon images, these paintings were inspired by sources in popular culture. Studying illustrations from furniture- and glass-company catalogues, Lichtenstein familiarized himself with pictorial conventions used to represent reflections. The work also references the long tradition of rendering mirrors in art, a theme that was explored by artists from Diego Velázquez to Pablo Picasso. Lichtenstein was perhaps most invested, however, in broadly generic questions of surface and support. Only stylized gleam and shadow are reflected in his mirror; thus, the puzzling, fragmented, even conceptual abstraction becomes the real subject of the work.

ntemychoeludes
ange of
niques.
ed five
watchute's
ated
imrics:
ng

work

fowl, a reference underscored by a gaggle of geese in the painting's lower-right corner. The designs on the black fabric evoke the pleasures of leisure time at a beach and provide an association to another kind of raised chair, that of a lifeguard. More ominously, watchtowers are related to guard towers, prisons, concentration camps, and walled countries. Polke is one of a number of German artists who have confronted the collective trauma that characterizes the history of their nation in the twentieth century.

ANDY WARHOL

American, 1930-1987

Mao, 1973

Synthetic polymer paint and silkscreen ink on canvas 448.3×346.7 cm (176 $^{1}/_{2} \times 136$ $^{1}/_{2}$ in.) Mr. and Mrs. Frank G. Logan Prize and Wilson L. Mead funds, 1974.230

The most influential of the Pop artists, Andy Warhol cast a cool, ironic light on the pervasiveness of commercial culture and contemporary celebrity worship. Early in his career, he began to utilize the silkscreen process to transfer photographed images onto canvas, creating multiple portraits of celebrities such as Marilyn Monroe, Elvis Presley, and Jacqueline Kennedy, as well as duplicated images of mass-produced products such as Campbell's soup cans and Coca-Cola bottles.

In this example from his Mao series, Warhol melded his signature style with the scale of totalitarian propaganda to address the cult of Chinese ruler Mao Zedong (1893-1976). Although Warhol was apparently apolitical, he produced this canvas one year after Richard Nixon's famous visit to China (which signaled a renewal of Sino-American relations), and at the height of that nation's destructive Cultural Revolution. Nearly fifteen feet tall, this towering work mimics the representations of the political figure that were ubiquitously displayed throughout China. Warhol's looming portrait impresses us with the duality of its realistic qualities and its slick artificiality. In contrast to the photographic nature of the image, garish colors are applied like makeup to Mao's face. Ultimately, the gestural handling of color in the portrait shows Warhol at his most painterly.

161

PHILIP GUSTON

American, born Canada, 1913–1980

Couple in Bed, 1977

Oil on canvas

206.2 × 240.3 cm (81 ¹/₈ × 94 ⁵/₈ in.)

Through prior bequest of Frances W. Pick, and memorial gift from her daughter, Mary P. Hines, 1989.435

An established painter of some of the most poetic Abstract Expressionist works of the late 1950s, Philip Guston gradually abandoned abstraction in the 1960s in favor of seemingly

crude, cartoonish images drawn from memory. For the artist, these new paintings represented a return to his creative beginnings. From 1934 to 1940, he had worked on Works Progress Administration murals, bringing to bear upon these projects such wide-ranging interests as cartoons, Cubism, Italian Renaissance painting, and leftist politics. In this late phase of his career, Guston introduced a repertory of images that includes spindly, pink legs; odd, broadly defined shoes; the stylized face of his wife; and portrayals of himself with a stubbly, one-eyed head.

In *Couple in Bed*, the artist employed a gritty, graphic imagery to explore the ongoing

conflicts between his marriage and his allconsuming preoccupation with painting. In bed
with his wife, he wears work shoes and grasps
three paintbrushes that point to her tawny halo
of hair. Missing its hands, and thus unable to
track time, the artist's wristwatch symbolizes
the enduring nature of the couple's love for each
other, as well as their struggle over his priorities.
Head to head, they huddle under a pale gray
blanket in an inky-black cosmos that surrounds
but does not envelop them.

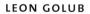

American, 1922-2004

Interrogation II, 1981

Acrylic on canvas 305×427 cm (120 × 168 in.)

Gift of Society for Contemporary Art, 1983.264

One sions th II was i

A nativ

School

pressed

art can

often-h

1970s,

of a pai

prevaili

It was

mental

critical

ANDY WARHOL

American, 1930-1987

Mao, 1973

Synthetic polymer paint and silkscreen ink on canvas 448.3×346.7 cm ($176^{-1/2} \times 136^{-1/2}$ in.) Mr. and Mrs. Frank G. Logan Prize and Wilson L. Mead funds, 1974.230

The most influential of the Pop artists, Andy Warhol cast a cool, ironic light on the pervasiveness of commercial culture and contemporary celebrity worship. Early in his career, he began to utilize the silkscreen process to transfer photographed images onto canvas, creating multiple portraits of celebrities such as Marilyn Monroe, Elvis Presley, and Jacqueline Kennedy, as well as duplicated images of mass-produced products such as Campbell's soup cans and Coca-Cola bottles.

In this example from his Mao series, Warhol melded his signature style with the scale of totalitarian propaganda to address the cult of Chinese ruler Mao Zedong (1893-1976). Although Warhol was apparently apolitical, he produced this canvas one year after Richard Nixon's famous visit to China (which signaled a renewal of Sino-American relations), and at the height of that nation's destructive Cultural Revolution. Nearly fifteen feet tall, this towering work mimics the representations of the political figure that were ubiquitously displayed throughout China. Warhol's looming portrait impresses us with the duality of its realistic qualities and its slick artificiality. In contrast to the photographic nature of the image, garish colors are applied like makeup to Mao's face. Ultimately, the gestural handling of color in the portrait shows Warhol at his most painterly.

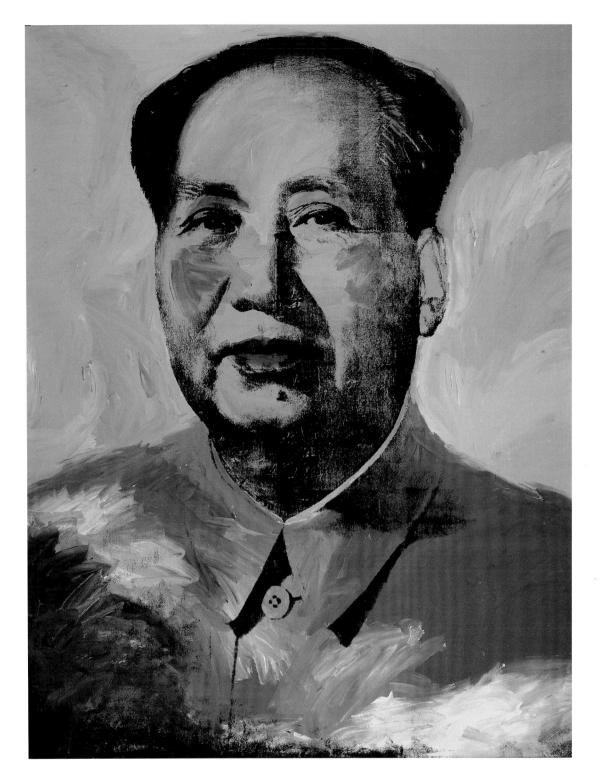

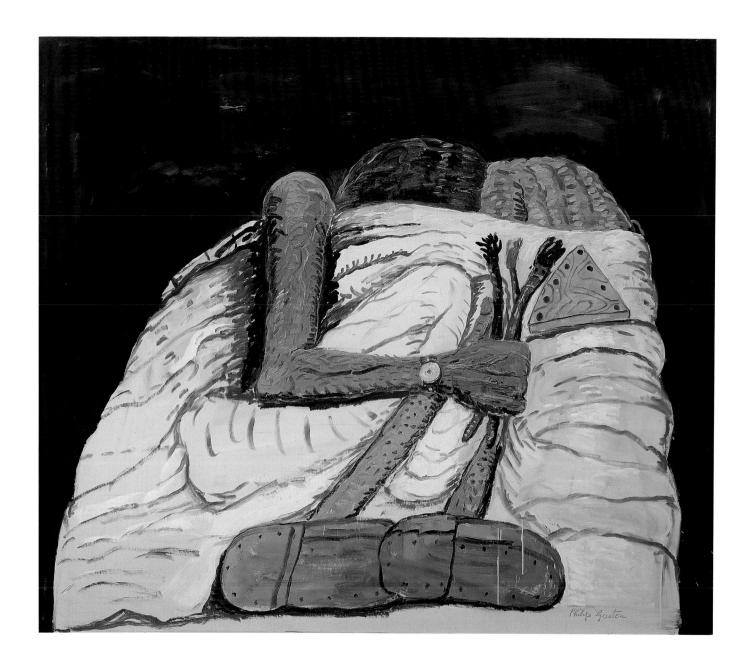

PHILIP GUSTON

American, born Canada, 1913-1980

Couple in Bed, 1977

Oil on canvas

206.2 × 240.3 cm (81 ¹/₈ × 94 ⁵/₈ in.)

Through prior bequest of Frances W. Pick, and memorial gift from her daughter, Mary P. Hines, 1989.435

An established painter of some of the most poetic Abstract Expressionist works of the late 1950s, Philip Guston gradually abandoned abstraction in the 1960s in favor of seemingly

crude, cartoonish images drawn from memory. For the artist, these new paintings represented a return to his creative beginnings. From 1934 to 1940, he had worked on Works Progress Administration murals, bringing to bear upon these projects such wide-ranging interests as cartoons, Cubism, Italian Renaissance painting, and leftist politics. In this late phase of his career, Guston introduced a repertory of images that includes spindly, pink legs; odd, broadly defined shoes; the stylized face of his wife; and portrayals of himself with a stubbly, one-eyed head.

In *Couple in Bed*, the artist employed a gritty, graphic imagery to explore the ongoing

conflicts between his marriage and his all-consuming preoccupation with painting. In bed with his wife, he wears work shoes and grasps three paintbrushes that point to her tawny halo of hair. Missing its hands, and thus unable to track time, the artist's wristwatch symbolizes the enduring nature of the couple's love for each other, as well as their struggle over his priorities. Head to head, they huddle under a pale gray blanket in an inky-black cosmos that surrounds but does not envelop them.

LEON GOLUB

American, 1922-2004

Interrogation II, 1981

Acrylic on canvas
305 × 427 cm (120 × 168 in.)
Gift of Society for Contemporary Art, 1983.264

A native Chicagoan and a graduate of the School of the Art Institute, Leon Golub expressed his commitment to the possibility that art can effect social and political change in often-harrowing images. In the 1960s and early 1970s, Golub's political activism and his pursuit of a painterly, figurative style ran counter to the prevailing Pop Art and Minimalist movements. It was not until the 1980s that Golub's monumental canvases finally received widespread critical and popular attention.

One of three depictions of brutal torture sessions that Golub painted in 1981, *Interrogation II* was inspired by human-rights violations in El

Salvador and elsewhere in Central America. The work depicts four mercenaries and their naked, hooded victim, who is bound to a chair. A bluish gray torture rack provides the only interruption to the intense, red-oxide color field, which creates a symbolically bloody backdrop for the heinous activity. The rawness of the action is reinforced by Golub's technique of scraping the applied paint down to the tooth of the canvas. An image of cruel intensity, *Interrogation II* is made even more disturbing by the torturers' grinning faces and the direct eye contact they make with us, drawing us into uncomfortable complicity with their terrible acts.

SIGMAR POLKE

German, born 1941

Watchtower with Geese, 1987-88

Artificial resin and acrylic on various fabrics 290×290 cm (114 $^3/_{16} \times 114$ $^3/_{16}$ in.) Restricted gift in memory of Marshall Frankel; Wilson L. Mead Fund, 1990.81

Sigmar Polke was born in Silesia, which, after World War II, became part of East Germany. After escaping with his family to West Germany, he studied art in Düsseldorf. In the 1960s, he began to produce work in response to contemporary art and to life in his bifurcated, psychologically damaged country. Polke's oeuvre eludes easy characterization: he has explored a range of styles and a variety of materials and techniques.

Between 1984 and 1988, Polke executed five paintings featuring the central image of a watchtower. The last in the series, the Art Institute's composition has a disjunctive quality, created partly by the superimposition of multiple images on a surface covered with diverse fabrics: a bright pink, quilted textile; striped awning material; and black cloth. The title of the work indicates an elevated seat frequently used in the

German countryside as a lookout for hunting fowl, a reference underscored by a gaggle of geese in the painting's lower-right corner. The designs on the black fabric evoke the pleasures of leisure time at a beach and provide an association to another kind of raised chair, that of a lifeguard. More ominously, watchtowers are related to guard towers, prisons, concentration camps, and walled countries. Polke is one of a number of German artists who have confronted the collective trauma that characterizes the history of their nation in the twentieth century.

KERRY JAMES MARSHALL

American, born 1955

Many Mansions, 1994

Acrylic on paper mounted on canvas 289.6 × 342.9 cm (114 × 135 in.) Max V. Kohnstamm Fund, 1995.147 Inspired by the names of urban housing projects, Kerry James Marshall explored the triumphs and failures of these much-maligned developments in a series entitled *Garden Project*. With these works, the Chicago-based artist—who early on lived in public housing in Birmingham, Alabama, and in Los Angeles—hoped to expose and challenge stereotypes. "These pictures," Marshall remarked, "are meant to represent what is complicated about life in the projects. We think of projects as places of utter despair . . . but [there] is also a great deal of hopefulness, joy, pleasure, and fun."

Set in Stateway Gardens, an immense Chicago development, *Many Mansions* depicts three men

tending an elaborate garden. Negating misperceptions of the black male, the dark-skinned trio—attired in white dress shirts and ties—enterprisingly beautify their harsh surroundings. Two bluebirds on the left support a banner proclaiming "Bless Our Happy Home," while the sun seems ready to dispel a raincloud. The red ribbon in the background bears the message "In My Mother's House There Are Many Mansions"; this feminist gloss on a famous biblical phrase (John 14:2) expresses an inclusive understanding of the idea of home.

JASPER JOHNS

American, born 1930

Near the Lagoon, 2002-03

Encaustic on canvas and wooden boards with objects 300 \times 198.1–214.6 (variable) \times 10 cm (118 \times 78 1 /₄–84 1 /₂ [variable] \times 4 in.)

Through prior gift of Muriel Kallis Newman in memory of Albert Hardy Newman, 2004.146

In his artistic practice, Jasper Johns repeatedly revisits certain images, motifs, and themes, as he did in his Catenary series (1997-2003). The term catenary describes the curve assumed by a cord suspended freely from two fixed points. The artist has often affixed objects to the surfaces of his paintings in an ongoing search for non-illusionistic ways of mediating between the flat plane of a canvas and a fully dimensional world. Johns formed his catenaries by tacking ordinary household string to the canvas or its supports. The string activates and engages the abstract, collaged field of multitonal gray behind it in several ways, both literally and figuratively. The string casts an actual shadow on the canvas, in addition to painted ones that Johns rendered by hand; it also appears as an indentation, where the artist embedded and later pulled it out of the encaustic. The catenaries can also be seen as Johns's playful attempt to show a work's front, side, and back from a single vantage point, as the cord strongly suggests a picture's hanging device.

Along the bottom edge, reading left to right, each letter of the painting's title is interspersed with the artist's name and the date he began the work. Johns has often inverted, transposed, or otherwise disordered letters and numerals to encourage viewers to consider the visual as well as literal qualities of each character. Epic and elegant, *Near the Lagoon* is the largest and last work in the *Catenary* series.

DAVID HOCKNEY

English, born 1937

American Collectors (Fred and Marcia Weisman), 1968

Acrylic on canvas

213.4 \times 304.8 cm (83 7 /s \times 120 in.) Restricted gift of Mr. and Mrs. Frederic G. Pick, 1984.182

One of England's most versatile artists of the postwar era, the painter, printmaker, set designer, and photographer David Hockney settled in Los Angeles in 1964. His work since then has often reflected, with wit and incision, the sun-washed flatness of southern California.

Perhaps the most iconic example from a group of double portraits of friends and associates from the 1960s, this large painting depicts contemporary-art collectors Fred and Marcia Weisman in the sculpture garden of their Los Angeles home. As Hockney said, "The portrait wasn't just in the faces, it was in the whole setting." As relentlessly stiff and still as the objects surrounding them, the couple stands tense and apart, his stance echoed in the totem pole to the right, hers in the figurative sculpture behind her. Mrs. Weisman's distorted mouth also mirrors that of the totem pole. Mr. Weisman's shadow falls possessively over the abstract sculpture at his feet. His hand is clenched so tightly it seems as if he were squeezing paint out of his

fist (Hockney deliberately retained the drips). Brilliant, raking light flattens and abstracts the scene. This pervasive aridity is reinforced by the segregation of living, green foliage, including the lonely potted tree, to the composition's left and right sides.

By depicting the couple almost as if they were sculptures themselves, the artist seemed to be considering the relationship between these two individuals, as well as their connection to the art with which they chose to surround themselves. Not surprisingly, the Weismans did not favor Hockney's harsh portrayal of them and did not keep the painting.

BRICE MARDEN

American, born 1938

Rodeo, 1971

Oil and wax on two canvases $243.8 \times 243.8 \text{ cm}$ ($96 \times 96 \text{ in.}$) Ada S. Garrett Prize Fund; estate of Katharine Kuh; through prior gift of Mrs. Henry C. Woods; gift of Lannan Foundation, 1997.160

During the past four decades, Brice Marden has played a key role in maintaining the vitality of abstract painting. *Rodeo*, a work of imposing scale and stark presence, represents a high point of his early career. Two rectangular canvas panels—one yellow, the other gray—are joined to form an eight-foot square. Each canvas is pulled across a deep (two and one-eighth-inch) stretcher and painted with a combination of oil and beeswax. The stretchers and thick, opaque pigment give the work a sense of weight and a sculptural presence. Like all of Marden's paintings, *Rodeo* is insistently handmade. The artist

laid multiple layers of the medium over his canvas panels, adding an extraordinary sense of tactility to this relatively simple composition. The line joining the two panels may suggest a horizon, and thus a landscape. The juxtaposition of two rectangular fields also recalls the work of Mark Rothko. However, in contrast to Rothko's luminous, floating fields of color (see p. 148), Marden's twin panels seem determinedly earthbound, presented as physical fact rather than as an expression of spiritual aspiration.

Index of Artists

ALBRIGHT, IVAN

Into the World There Came a Soul Called Ida, 126 BACON, FRANCIS Figure with Meat, 150

BALTHUS (COUNT BALTHASAR KLOSSOWSKI DE ROLA)

Solitaire, 138

BARTOLOMMEO, FRA (BACCIO DELLA PORTA)

Nativity, 19

BECKMANN, MAX Self-Portrait, 134
BELLOWS, GEORGE WESLEY Love of Winter, 114
BIERSTADT, ALBERT Mountain Brook, 83
BLECHEN, CARL

The Interior of the Palm House on the Pfaueninsel near Potsdam, 45

BLUME, PETER The Rock, 140

BÖCKLIN, ARNOLD In the Sea, 60

BONNARD, PIERRE Earthly Paradise, 116

BOUCHER, FRANCOIS

Are They Thinking about the Grape?, 37

BRAQUE, GEORGES

Landscape at L'Estaque, 102 Little Harbor in Normandy, 103

CAILLEBOTTE, GUSTAVE

Paris Street; Rainy Day, 54

CASSATT, MARY The Child's Bath, 93

CELMINS, VIJA Explosion at Sea, 155

CÉZANNE, PAUL

The Basket of Apples, 71

Madame Cézanne in a Yellow Chair, 66

CHAGALL, MARC The Praying Jew, 121

CHASE, WILLIAM MERRITT A City Park, 88

CHIRICO, GIORGIO DE The Philosopher's Conquest, 113

CHURCH, FREDERIC EDWIN View of Cotopaxi, 82

COLE, THOMAS Distant View of Niagara Falls, 80

CONSTABLE, JOHN Stoke-by-Nayland, 46

COPLEY, JOHN SINGLETON

Mrs. Daniel Hubbard (Mary Greene), 76

COROT, JEAN-BAPTISTE-CAMILLE

Interrupted Reading, 51

CORREGGIO (ANTONIO ALLEGRI)

Virgin and Child with the Young Saint John the Baptist, 18

COTÁN, JUAN SÁNCHEZ Still Life with Game Fowl, 23
COURBET, GUSTAVE Mère Grégoire, 48
DALÍ, SALVADOR Inventions of the Monsters, 132
DAVIS, STUART Ready-to-Wear, 144

DEGAS, HILAIRE-GERMAIN-EDGAR

Henri Degas and His Niece Lucie Degas (The Artist's Uncle and Cousin), 52 The Millinery Shop, 58

DE KOONING, WILLEM Excavation, 146
DELACROIX, EUGÈNE

The Combat of the Giaour and Hassan, 44

DELAUNAY, ROBERT

Champs de Mars: The Red Tower, 107

DEMUTH, CHARLES ... And the Home of the Brave, 130

DOVE, ARTHUR Silver Sun, 125

EAKINS, THOMAS Mary Adeline Williams, 95

FEININGER, LYONEL Carnival in Arceuil, 106

FRAGONARD, JEAN-HONORÉ Portrait of a Man, 39

GAUGUIN, PAUL

The Ancestors of Tehamana, or Tehamana Has Many Parents (Merahi metua no Tehamana), 70 The Arlésiennes (Mistral), 64

GIOVANNI DI PAOLO

The Beheading of Saint John the Baptist, 15
Saint John the Baptist Entering the Wilderness, 14

GLACKENS, WILLIAM At Mouquin's, 96

GOGH, VINCENT VAN

The Bedroom, 65 Self-Portrait, 63

GOLUB, LEON Interrogation II, 163
GORKY, ARSHILE The Plow and the Song (II), 145
GOYA Y LUCIENTES, FRANCISCO JOSÉ DE

Boy on a Ram, 41

GRECO, EL (DOMENIKOS THEOTOKOPOULOS)

The Assumption of the Virgin, 22 GRIS, JUAN Portrait of Pablo Picasso, 105 GUARDI, FRANCESCO

The Garden of the Palazzo Contarini dal Zaffo, Venice, 40

GUSTON, PHILIP Couple in Bed, 162

HARNETT, WILLIAM MICHAEL For Sunday's Dinner, 90

HARTLEY, MARSDEN Movements, 111

HEADE, MARTIN JOHNSON

Magnolias on Light-Blue Velvet Cloth, 89 HEMESSEN, JAN SANDERS VAN Judith, 20 HEY, JEAN (THE MASTER OF MOULINS)

The Annunciation, 17

HOBBEMA, MEINDERT

The Watermill with the Great Red Roof, 33

HOCKNEY, DAVID

American Collectors (Fred and Marcia Weisman), 157

HOMER, WINSLOW

Croquet Scene, 84

The Herring Net, 87

HOPPER, EDWARD Nighthawks, 136

INGRES, JEAN-AUGUSTE-DOMINIOUE

Amédée-David, Comte de Pastoret, 43

INNESS, GEORGE Early Morning, Tarpon Springs, 92

JOHNS, JASPER Near the Lagoon, 166

JOHNSON, EASTMAN

Husking Bee, Island of Nantucket, 86

JOHNSON, JOSHUA

Mrs. Andrew Bedford Bankson and Son,

Gunning Bedford Bankson, 77

KANDINSKY, VASILY

Improvisation No. 30 (Cannons), 112

KELLY, ELLSWORTH

Red, Yellow, Blue, White, and Black, 149

KLEE, PAUL Sunset, 123

LAWRENCE, JACOB The Wedding, 143

LAWRENCE, SIR THOMAS Mrs. Jens Wolff, 42

LÉGER, FERNAND The Railway Crossing (Sketch), 118

LICHTENSTEIN, ROY Mirror in Six Panels, 160

LORRAIN, CLAUDE (CLAUDE GELLÉE)

View of Delphi with a Procession, 34

MAGRITTE, RENÉ Time Transfixed, 135

MANET, ÉDOUARD

Jesus Mocked by the Soldiers, 49

Woman Reading, 57

MANFREDI, BARTOLOMEO Cupid Chastised, 25

MARDEN, BRICE Rodeo, 158

MARSHALL, KERRY JAMES Many Mansions, 165

MARTIN, AGNES Untitled #12, 159

MARTORELL, BERNART

Saint George Killing the Dragon, 13

MATISSE, HENRI

Bathers by a River, 108

Interior at Nice, 117

MATTA (ROBERTO MATTA ECHUARREN)

The Earth Is a Man, 133

MIRÓ, JOAN The Policeman, 122

MITCHELL, JOAN City Landscape, 151

MODIGLIANI, AMEDEO

Jacques and Berthe Lipchitz, 115

MONDRIAN, PIET (PIETER CORNELIS MONDRIAAN)

Lozenge Composition with Yellow, Black, Blue, Red, and Gray, 119

MONET, CLAUDE

Arrival of the Normandy Train, Gare Saint-Lazare,

55

The Beach at Sainte-Adresse, 50

Stacks of Wheat (End of Summer), 67

MOREAU, GUSTAVE

Hercules and the Lernaean Hydra, 53

MORONI, GIOVANNI BATTISTA

Gian Lodovico Madruzzo, 21

MOTLEY, ARCHIBALD JOHN, JR. Nightlife, 137

MOUNT, WILLIAM SIDNEY Bar-Room Scene, 81

MUNCH, EDVARD Girl Looking out the Window, 68

NUTT, JIM Miss E. Knows, 156

O'KEEFFE, GEORGIA

Black Cross, New Mexico, 124

Cow's Skull with Calico Roses, 129

OROZCO, JOSÉ CLEMENTE Zapata, 128

PEALE, RAPHAELLE

Still Life-Strawberries, Nuts, &c., 79

PHILLIPS, AMMI Cornelius Allerton, 78

PIAZZETTA, GIOVANNI BATTISTA Pastoral Scene, 35

PICABIA, FRANCIS Edtaonisl (Ecclesiastic), 110

PICASSO, PABLO

Daniel-Henry Kahnweiler, 104

Mother and Child, 120

The Old Guitarist, 101

PIPPIN, HORACE Cabin in the Cotton, 131

POLKE, SIGMAR Watchtower with Geese, 164

POLLOCK, JACKSON Greyed Rainbow, 147

POTTER, PAULUS

Two Cows and a Young Bull beside a Fence in a Meadow, 32

POUSSIN, NICOLAS

Landscape with Saint John on Patmos, 31

REMBRANDT HARMENSZ. VAN RIJN

Old Man with a Gold Chain, 29

REMINGTON, FREDERIC

The Advance Guard, or The Military Sacrifice, 91

RENI, GUIDO

Salome with the Head of Saint John the Baptist, 30

RENOIR, PIERRE-AUGUSTE

Acrobats at the Cirque Fernando (Francisca and

Angelina Wartenberg), 56

Two Sisters (On the Terrace), 59

REYNOLDS, SIR JOSHUA

Lady Sarah Bunbury Sacrificing to the Graces, 38

RICHTER, GERHARD

Woman Descending the Staircase, 154

ROTHKO, MARK Untitled (Purple, White, and Red), 148

RUBENS, PETER PAUL

The Holy Family with Saints Elizabeth and John the Baptist, 27

SARGENT, JOHN SINGER

The Fountain, Villa Torlonia, Frascati, Italy, 97

SEURAT, GEORGES-PIERRE

A Sunday on La Grande Jatte-1884, 61

SEVERINI, GINO Festival in Montmartre, 109

SHEELER, CHARLES The Artist Looks at Nature, 139

SMIBERT, JOHN Richard Bill, 75

SNYDERS, FRANS

Still Life with Dead Game, Fruits, and Vegetables in a Market, 26

STILL, CLYFFORD Untitled (PH-774), 152

TANNER, HENRY OSSAWA

The Two Disciples at the Tomb, 98

TIEPOLO, GIOVANNI BATTISTA

Rinaldo Enchanted by Armida, 36

TOULOUSE-LAUTREC, HENRI-MARIE-RAYMOND DE

At the Moulin Rouge, 69

Equestrienne (At the Cirque Fernando), 62

TURNER, JOSEPH MALLORD WILLIAM

Fishing Boats with Hucksters Bargaining for Fish,

47 TWOMBLY, CY

The First Part of the Return from Parnassus, 153

VUILLARD, ÉDOUARD

Landscape: Window Overlooking the Woods, 72

WARHOL, ANDY Mao, 161

WEYDEN, ROGIER VAN DER (AND WORKSHOP)

Jean Gros, 16

WHISTLER, JAMES MCNEILL

Arrangement in Flesh Color and Brown: Portrait of Arthur Jerome Eddy, 94

Nocturne: Blue and Gold—Southampton Water, 85

WOOD, GRANT American Gothic, 127

WTEWAEL, JOACHIM ANTONIZ.

The Battle between the Gods and the Giants, 24

ZURBARÁN, FRANCISCO DE The Crucifixion, 28